TALES FROM THE EROTIC EDGE

TALES from the
EROTIC EDGE
A Circlet Omnibus

edited by
Cecilia Tan

CIRCLET PRESS, INC.
CAMBRIDGE, MA

Contents

Telepaths Don't Need Safewords • *Cecilia Tan*

Introduction

Cecilia Tan, editor

This is not a book: it is four books—four books which share a place in the evolutionary timeline of fantastic literature and are collected here into one volume—books which have the distinction of being the first four publications of Circlet Press, the world's only book publisher dedicated exclusively to erotic science fiction and fantasy. Speculative fiction has always advanced on the technological and phantasmagorical frontiers, but has largely left the erotic edge unexplored.

As both a writer and an avid reader of science fiction, I have always felt that sexual fantasy, the most common form of human imaginative activity, could be a much more important and integral part of fantastic literature than it has been in the past. Combinations of sex and sf have existed before, of course. For some time now, erotica and pornography publishers have benefited from using science fictional and fantastic concepts to spice up the predictable permutations of human sex activity, but most use sf/f only as a crude prop, setting, or starting place. Likewise, previous uses of sex in science fiction have often been limited to window dressing, the subject of ridicule, or grotesquerie. But science fiction is at its best when it does what any great literature does, examine the human condition in new light. The genre can mature and break new ground if it can go beyond adolescent notions of sex and sexuality.

In 1992, when the earliest of the chapbooks contained here, *Telepaths Don't Need Safewords: And Other Stories of Erotic Science*

Fiction and Fantasy, appeared, there was no publisher dedicated to developing the erotic edge. I knew that the three stories I had written were too sexually explicit for traditional science fiction markets, and too involved with their science fictional plot elements and characterizations to be salable as pornography. Self-publishing seemed the only course for these works which could neither be "toned down" in sexual content nor purged of the science fictional aspects—the erotica and science fiction were inextricably linked. In my mind there was no separation between my erotic imagination and my science fictional vision; imagination and fantasy are all one. And my sexuality being itself inherently kinky, it seemed only natural that I would produce work of this kind, and yet there was no existing outlet for it. And I thought to myself, What are the chances that I could create such an outlet? Surely someone out there, besides me, must be interested in a serious exploration of both the fantastic and the erotic...

Looking back over the history of science fiction as a genre, we can find isolated examples of writers who did not just write fantastic works which happen to contain sex but who used science fiction as a tool to explore erotic possibilities, and who used eroticism as an integral part of their exploration of human life and development. But these examples are rare.

If we begin with the emergence of sf as a pulp genre, the fact that certain elements of sex and love were lacking will come as no surprise. The science fiction of the 1930s and '40s bore all the hallmarks of the adventure fiction from which it grew: overwhelmingly male, macho, and isolated from any social issues such as family or romance. Adventure plots revolved around all-male safaris, war stories, ship voyages, and other masculine milieu. Much early sf was less "science" fiction than it was adventure fiction transplanted from an unknown continent to an unknown planet: aborigines became aliens, enemy planes became UFOs, wild beasts became creatures from outer space. One might think that the generally repressive attitudes of the times might be

responsible for the lack of sex in science fiction, but the other pulp genres did not neglect sex—besides the many true love/romance magazines which, of course, had their element of the erotic, there were also publications like *Spicy Mystery Stories*. As Peter Nicholls points out in his entry on "Sex" in *The Encyclopedia of Science Fiction* (New York: St., Martin's Press, 1993), "Generally, [only] the sf magazines proved unable to link the two genres of the spicy and the technological with any conviction." The stereotypical Golden Age hero was a white male scientist/adventurer, emotionally stilted and unattached. As the genre developed, when true interest in the scientific aspects did take science fiction away from mere "blood and thunder" adventure, the stories began to revolve around math, physics, the Atom Bomb, the speed of light—topics that did not lend themselves to the exploration of intimacy.

"Emotion other than courageous fortitude or patriotism was unwarranted," says Anne McCaffrey in her article "Hitch Your Dragon to a Star: Romance and Glamour in Science Fiction" from the volume *Science Fiction: Today and Tomorrow* (ed. Reginald Bretnor, New York: Harper & Row, 1974). "Sweating out the results of experiments is nonemotional." She points out that science fiction of the time was aimed at a specific, fact-conscious audience made up almost exclusively of men. "Romance," on the other hand, was the mutually exclusive territory of women and with it all the attendant sex, love, and emotional intimacy.

In the early 1950s there was the first inkling of a change when Philip José Farmer and Theodore Sturgeon began to publish work that hinged on topics of sex and sexuality, including miscegenation with aliens, homosexuality, and applying technology to sexual ends. But it was not until the 1960s that a significant amount of science fiction appeared that contained graphically described sex. The "new wave" of science fiction was ushered in by the ongoing political and cultural revolution of the era, a revolution interested in universality and equality, breaking down gender and race lines, experimentation with sex, drugs, and rock and roll. In this fertile

creative environment, some writers like Samuel R. Delany, J. G. Ballard, Brian W. Aldiss and Norman Spinrad began to make explicit sex commonplace in their work. As Robert Sholes and Eric S. Rabkin note in their comments on "Sex and Race in Science Fiction" in their book *Science Fiction: History, Science, Vision,* (New York: Oxford University Press, 1977) in the 1960s science fiction began to catch up with other forms of literature in the sexual arena "in keeping with the trend in all literature toward a more explicit presentation of sex. Those who [came] in from the mainstream... often [brought] sex in with them [and] those ... starting out in science fiction [could] begin by assuming that their characters can indulge in graphically described sex." This freedom to explore sexual fantasies also brought many sf writers into the porn industry. Philip José Farmer, Robert Silverberg, and others produced work (much of it science fictional in nature) for porn publishers like Essex House and Nightstand Books who specialized in graphic material. Essex House, during its brief existence, sought out and published a significant number of sexually graphic works that had science fiction or fantasy themes. Women writers also began to enter the field in significant numbers—the beginning of the end of the pervasive all-male mentality.

By the 1970s, several women writers had come into the limelight with their explorations of sex and sexuality, including Ursula K. LeGuin, Marion Zimmer Bradley, and Joanna Russ, who also brought feminist discussions of sex and sexuality with them. The freedom to experiment with ideas about sex and to depict sexual acts openly allowed such writers as John Norman to flourish, and much significant work was produced by Delany, Bradley, and others such as Michael Moorcock, Tanith Lee, and Elizabeth Lynn. But this era of seeming openness was finite.

By the mid-1980s, the era of free love was over, and phobia of AIDS and a general conservative turn in American politics forced much sex back into the closet. By that time, science fiction as a genre had largely ossified into a mass market publishing machine

increasingly interested in repeating its past successes. The idea that science fiction was not meant for adults at all and was only fit to be "juvenile literature" began to gain ground again, even in the face of sales evidence that most science fiction is bought by adults. Thomas M. Disch, who had been heralded as a writer who depicted gay sexuality well and sensitively, espoused this idea in an article for the *Atlantic Monthly* ("Big Ideas and Dead End Thrills," *Atlantic Monthly*, February 1992). A few notable exceptions from this era are: the erotic fantasy work of Anne Rice, writing under the pseudonym A. N. Roquelaure, with her Claiming of Sleeping Beauty trilogy, which was packaged and marketed as high-class erotica for adults, not as fantasy; J. G. Ballard's continuing works, which were more akin to those of William S. Burroughs and other counterculture writers than to mainstream genre sf; the work of Storm Constantine, published in the U.K.

This was largely the state of the genre in 1992, and I wanted it to change. Several factors encouraged me to found Circlet Press as one way of trying to bring about this change.

First, at the time erotica was beginning to re-emerge as a popular, mainstream form of literature, a trend spurred by the growing interest in sexual expression by women readers and writers. Anthologies of erotica by women for women like *Herotica 2* (New York: Plume, 1992) and *Slow Hand: Women Writing Erotica* (New York: HarperCollins, 1992) had begun to appear in mainstream chain bookstores. These books, aimed at women and produced by women, were completely separate from the traditional male market of pornography, tending to celebrate sex as an enjoyable part of life and to lack the seedy, shame-ridden, often misogynistic tone of traditional pornography. Perhaps, I thought, I could enter this market with similar books with a science fictional bent.

Second, although science fiction might have still seemed somewhat lacking in significant erotic content, as an overall genre the face of it had changed significantly from the old scientist-hero

pulp mold. The literary demands of three-dimensional charac-terization as well as the continual rise of the "soft" sciences in science fiction have made families, spouses, and other interper-sonal relationships commonplace elements in the genre, as they always should have been. Surely, I thought, it could not be such a leap to include more overtly and explicitly sexual themes into the form.

And third, once I did self-publish *Telepaths*, I found an eager group of writers who had been turning out such material for quite some time and had never been able to find an outlet to publish it before. Manuscripts began arriving in the mail from amateurs and professionals alike, a fact I found amazing when the first printing of *Telepaths* had been only one hundred copies—all of which I stapled by hand, because I hadn't the money to perfect-bind them. The fact that established writers would send stories blind to me after seeing my patently home-grown publication attested to the need for such a market. The other testament to the need for the market was, of course, the fact that I sold almost the whole first print run in one weekend at a science fiction convention in New York.

The next month I had a perfect-bound edition of *Telepaths* in hand and our second book, *Mate: And More Stories from the Erotic Edge of SF/F*, by Lauren P. Burka, on press. We had no budget for publicity, so review copies were not mailed out. And yet some determined reviewers were impressed enough by the appearance of the chapbooks that they wrote reviews anyway. William Hen-kin reviewed both titles for the *Spectator*, an adult entertainment newspaper in the San Francisco Bay Area, saying, "Something new is happening folks ... And it's happening at the unexpected but perfectly obvious junction of sadomasochism and science fiction. Once you start role-playing with erotic power exchange, Harle-quin bodice-rippers, Dungeons and Dragons torture chambers, and the master/mistress–slave relations of a medieval future seem perfectly compatible: a Renaissance Faire mind-set in the midst of

a sexual Road Warrior world.... These two trios of stories are cheap to buy, easy to read, and set down by writers who know their SM as well as their SF." Susanna Sturgis included them in her science fiction review column in *Feminist Bookstore News* with the words "Both these three-story s/m erotic fantasy chapbooks are competently written and, more to the point, hot.... Must reads for those who thrill to the frontiers of 'slash' fiction (and, no, I don't mean 'slasher.')"

Sturgis brings up another point of evidence for the readership of erotic science fiction: "slash" being a form written and produced almost entirely by women fans in which popular copyrighted characters such as Captain Kirk and Mr. Spock are combined in highly explicit, usually homoerotic, sexual stories. (For a complete overview of the slash phenomenon, see *Enterprising Women*, Camille Bacon-Smith, Philadelphia: University of Pennsylvania Press, 1992.) The growing interest in sex and sexuality within the sf fan community I encountered at science fiction conventions in 1990 and 1991 also encouraged me greatly. The stereotype of the asexual nerdy bookworm has eroded just as that of the unemotional pulp scientist-hero has. At sf conventions, in addition to the usual autograph parties and Worldcon bid parties, fans host s/m "play" parties for adults where sexual activity intermingled with sadomasochistic role-playing is the main attraction. Groups like the Gaylaxians, an active group dedicated to gay and lesbian sf fans, host their own conventions and held a petition drive to get gay characters on *Star Trek: The Next Generation*. What was once a community that was rather shy of sexual issues is maturing into one that is truly concerned and interested in sex and sexuality, and like it hand in hand with their science fiction.

With this core readership on the science fiction side, and the post-feminist boom in erotica beginning to take off, I jumped in with both feet, and put out Circlet Press's first call for submissions with the plan to begin a series of anthologies, collecting erotic

science fiction stories together under common themes and topics. From the beginning, I was very clear that I wanted to see lots of sex in these stories. I had two reasons for this criterion: one, if a story didn't have that much sex in it, there was a good chance the author could find somewhere else to sell it and I wanted the things that were unsalable as sf/f solely because of the sex. Two, I was looking specifically for stories that would help accomplish that greater goal of expanding the boundaries of the genre. *Forged Bonds: Erotic Tales of High Fantasy* and *Feline Fetishes,* the other two books in this volume, were released in March 1993.

Since that time, Circlet has published over a dozen such anthologies, some gay-themed, some without s/m themes, including stories by such established genre writers as Shariann Lewitt and Yvonne Navarro and s/m erotica writers such as Laura Antoniou and Mason Powell. The mainstream erotica anthology boom has continued, with volume 3 of *Herotica* (New York: Plume, 1994) out now and volumes 4 and 5 on the way, the annual Best American Erotica series edited by Susie Bright (New York: Touchstone, 1994, 1995) stacked up in chain bookstores, and dozens more I could name. And now, at last, we are seeing more erotic fantastic fiction beginning to issue from the big publishing houses.

Masquerade Books has emerged as the preeminent publisher of sexual writing in the United States, with gay, lesbian, heterosexual, and literary imprints, with writers like John Preston and Pat Califia, with old work by Marco Vassi and new work by Samuel R. Delany. Masquerade has made successful forays into erotic science fiction, bringing some of the old Essex House titles back into print, Delany's *Equinox* and Farmer's *The Image of the Beast,* and with new work such as Gary Bowen's *Diary of a Vampire,* as well as *SM Visions,* ten s/m-themed stories collected from ten Circlet Press books. On the genre side, publishers have offered several anthologies of erotic horror including *Love in Vein* (ed. Poppy Z. Brite, New York: HarperCollins, 1994), *Killing Me Softly* (ed. Gardner Dozois, New York: HarperCollins, 1995), the

Hot Blood series (ed. Jeff Gelb, New York: Pocket Books, 1989, 1991, etc.), *Forbidden Acts* (ed. Nancy Collins & Ed Kramer, New York: Avon Books, 1995), and the various sequels to these books.

But are erotic elements acceptable to the mainstream in horror only because of that genre's usage of sex as a negative element? Horror is meant to shock, appall, gross out, and scare, to break taboos and push limits. By including sex in the list of elements which horror can use to achieve these aims, it reinforces sex as a taboo subject. With Circlet Press I hoped to break that trend. As Peter Nicholls writes in his essay on "Sex" in the *Encyclopedia of Science Fiction*, "Sf is more liable ... to link sex with disgust." It was important to me to break that trend, to make a conscious effort to portray sex positively and to make that a criterion for inclusion in Circlet Press books.

So you will not find negative attitudes about sex here. Nor will you find rape, dismemberment, castration, or murder. What you will find are consensual, loving relationships manifested through rather outré sexuality. You will find stories in which the erotic and the fantastic enhance one another, stories in which the sex could not be removed or toned down, nor could the science fiction, without the story coming apart.

These stories are not, perhaps, high literature. That is for some future scholars to determine. But they are pushing the envelope of what is science fiction, of what can be expected; they expand the boundaries of the genre along the erotic edge. It is my hope that they will make room within the genre for more works which integrate the erotic with the fantastic. Enjoy them!

FELINE FETISHES

Erotic Tales of Science Fiction

edited by
corwin

Editor's Note

In a way this book began when I mentioned to Lauren Burka that there isn't very much good erotica (or even bad erotica, for that matter) that deals with my particular fetish—panthers. A few days later she handed me a copy of "Divinity." I had always suspected that there was a vast, untapped potential in feline erotica, and that I wasn't the only one who got off on it. My suspicions were borne out as I was presented with a set of stories that not only explore the feline aspect of eroticism, but also speak to totemic forces within us all, be they feline or otherwise.

Even before that fateful conversation, I had known I wanted to do this book. I had even picked out the artist and discussed it with him. After talking to Lauren, the project gained momentum. Manuscripts arrived scant days after their authors heard that we were doing this book. They seemed as excited as I was.

But, as is always the case, there was a snag. Neither I nor anyone else at Circlet could figure out what to call the book. We asked our friends; we asked the Net. We got a wealth of responses, and we could not use any of them. Everything that was suggested, both by us and by others, was either too cute or a pun. And although I enjoyed the jokes, all of the works in this anthology are more serious, and I felt they deserved a more serious title. In the end, we settled on *Feline Fetishes*, the working title of the project from the beginning. However, in appreciation of all the suggestions, and in acknowledgment of the fact that humor is a good thing, I would like to share some of the better titles that we did not

end up using: Nine Lives Has Desire, ErotiCat, Erotic Mewsings, Midnight Songs by the Back Fence, Cat Nips, Purrnography, Pawnography, Cat 'O Nine Tales.

I hope you find these stories as interesting and as exciting as I did.

corwin

Publisher's Note

This anthology is the first in a series of books collecting erotic science fiction and fantasy stories under common themes. (Future anthologies will explore other topics such as sex and technology, ritual SexMagick, elves and bondage, transgenderism, vampirism, and many more.) Why "feline fetishes"? A number of reasons. First, by challenging authors to write something that "connected the feline universe to the erotic one," we were assured that we wouldn't be seeing anything typical or run-of-the-mill. Second, both the publisher and the editor have a "thing" for cats. And third, there was something about the thought of feline erotica that just sounded right.

But of course there was. Our cultural references all connect the cat to the sexual, viz: common slang for the female genitalia; a sexually aggressive female is a "tigress," but if she's real cute, she's a "sex kitten"; a house of prostitution is a "cat house"; and so on. In pop culture, the feline has always carried with it a certain air of eroticism. Think of Catwoman, the only woman Batman ever loved in the old comic book and TV show. (And now Tim Burton has gone one more step, to make her an SM/fetish goddess, up there with Emma Peel and Betty Page.) Or of the scene in the Billy Crystal film *When Harry Met Sally* when the line "You made a woman meow!?" was delivered. Or of the ultimate cat-lover's film, *Cat People*. The 1980s remake of the classic film was billed as "an erotic thriller about the animal in us all."

Considering that all the references above were to women and female energy and imagery, we are not surprised that all the stories in this volume come from women. These authors have made explicit the connection between the feline universe and the erotic one, exploring that juncture through fantasy and science fiction in a way it cannot be examined in the so-called real world. Here's hoping you enjoy exploring them as much as we did.

<div style="text-align:right">

Cecilia Tan
Publisher

</div>

Divinity

Lauren P. Burka

The water spilled over my hands. Too hot. I wasn't used to it. If I ever needed a reminder of my changed estate, I had found it. I understood razors. I could cross a street without getting hit. But every day I burned myself on something. Sally had long since given up trying to get me to cook.

The sink had filled with soapy water. I dipped my fingers into the suds and grease and waited for it to cool a bit. I could see out the window. Glass towers rose above the residential buildings, their mirrored sides reflecting the sunset I could not see. I could have been standing on top of it, feeling the evening breeze go right through me as I picked one mortal out of a city to play with. I'd let them toss my dice, and if they won, I'd give them something they cared about. If they lost, I took. Not souls, for no one cared enough to value souls anymore. What sport to take what they didn't know they had? I took sex instead, or pride.

Never gamble with gods. Even if you are one. They don't like to lose.

"Michael? You were supposed to have the apartment cleaned by the time I got home."

"Hello, Sally," I said. The water in the sink had gotten cold. I drained and refilled it.

The bedroom door slammed behind Sally. I heard the sound of clothing and other belongings hitting the wall. She'd probably had another bad day at work. I'd better get the dishes done soon.

The front door rattled. Loud swearing drifted in from the hall as Meredith wrestled with an old lock and a bad copy of the key. I knew better by now than to open the door for her.

Meredith finally wrenched the door open and swept into the apartment, trailing her coat, her purse, and a gravity-defying hairdo. She would be coming home to change clothes between one low-paying job (retail) and another (waitress).

"Hey, Sally," she called out in her thick, beach-bunny accent. "Is Michael busy?"

"I don't know if he's busy," came the muffled voice from behind the bedroom door. "Michael, are you busy?"

"I'm doing dishes," I replied.

"He's doing dishes."

Meredith was stripping off clothes and hanging them in the hall closet. Unlike Sally, she didn't care what I saw. She wasn't merely resigned to the lack of privacy of living in someone else's spare room. I was male. I didn't count, most of the time.

"Well, I want to borrow his mouth, if he's got nothing better to do with it."

"Michael," called Sally, "Meredith wants you to..."

"I know, I know. She wants me to give her head. Well, why can't she ask me herself?"

"Meredith, Michael wants to know why you can't ask him yourself."

"Because he's a boy, that's why. Tell him to get over here on his knees, okay?"

"Michael..."

"I heard."

I washed the last of the grease off of my hands and dried them carefully. This little game had started a month ago when I got in a fight with Meredith. She could argue with devastating logic when she wanted to, but logic didn't seem to fit the airhead image she cultivated with such care.

"Eat me!" she had shouted.

"You want me to eat you? Get down and spread your legs."

That had shut her up for an entire twenty seconds while her jaw opened and closed silently.

"You can't."

"Why, afraid I'm better than the bitch who threw you out?" That wasn't strictly fair. Meredith had moved in with Sally after some dramatic argument with her ex-lover which resulted in a bruise on Meredith's perfectly made-up face. "Afraid you might get to like it?"

With perfect Meredith-logic, therefore, she had stripped off her clothes, dropped into one of the chairs, and hooked one leg over the arm.

She always came. Sometimes twice. She never talked to me about it. I suppose I could pass for a particularly square-jawed, short-haired dyke if she tried to imagine it, but not if I talked.

And me? I gave to her because I figured as long as one person was getting some pleasure from my presence, I was ahead of the game.

I got a towel from the hall closet. When I turned back, Meredith was seated in the chair, naked, in her favorite eat-me pose. She had her arms pillowing her head and her hair untied, the bleached-gold ringlets tumbling down over her shoulders. Her nipples were already poking upwards from breasts that weren't quite heavy enough to sag. Her legs, impeccably shaped by years of running in high heels to catch trains, were spread wide in an invitation too casually unselfconscious to be really obscene. She had shaved her armpits, but not her pubic hair.

On my knees, I kissed the inside of her left thigh very gently as I slid my arms under her legs and lifted her just enough to push the towel under her butt. This was her fantasy, but I was the one who had to clean up afterwards. I continued the kiss up toward the juncture of leg and body, finding the soft, barely furred crease where blood pulsed beneath her skin. I delayed tasting that deeper crease that would be wet already from my attention. If I were

careful, the wait would make her come harder. If she thought I were teasing her, she would spend the next week trying to make me miserable. It was a challenge.

I spread my hands over her belly and sneaked the thumbs down into her fur, tugging a bit on the lips. She drew a sharp breath, giving the first sign that she even noticed me. I closed my eyes and kissed her cunt very softly, only parting the lips with my tongue after I'd taken a deep breath. The juice of her dripped down my chin, reminding me of how it felt to eat a nectarine over the sink in the summer, getting sticky. Parts of her were rough and parts very smooth. I tasted through layers and layers, down to the hot and hidden center.

Her stomach went taut, the muscles pulled into a new alignment by my attentions at her groin. I dared not look up at her face. Wishing I had an extra hand, I probed the lower parts of her cunt with a finger, feeling past ring after ring of muscle. Penetration was politically incorrect but technically appropriate. I'd have my fingers out before she was coherent enough to protest.

Parts of me were stirring too. My cock was bent exactly the wrong way in my jeans. The discomfort kept me sober. This was for her alone. My knees hurt. I tensed and relaxed my calf muscles, sending blood to my feet without moving.

Meredith gave a long, drawn-out moan. Her hands emerged from under her hair, fists clenched, small biceps pale and marble-hard. I slowed my pace just enough that she sank back into the chair, gripping the arms with her perfect nails. The towel was getting soaked. I had two fingers inside her now, stroking the walls of her cunt.

"Michael, fuck you with a lightbulb! I wanna come now. Two lightbulbs. Aaaah..."

I leaned into her, pressing my tongue to her clit, keeping a rhythm that strained my jaw. At that moment, I couldn't remember if she'd ever said anything to me before while we were so engaged. I must be getting good. The first spasm squeezed my

fingers. Encouraged, I licked harder, sending her into a crying, dripping cascade of pleasure.

A hand pushed my forehead back.

"Stop!"

I took a deep breath, wondering when I'd gotten so dizzy. Salty liquid had dripped down my hand to my wrist. I licked my fingers one by one, with a bit more enthusiasm when I realized she was still watching me. My jaw ached.

Meredith grabbed the towel and ran it between her legs. She got up and pounded on the bedroom door. "Sally, is the shower free?"

"At the moment, yes."

"Well, unlock the door."

Ah, well. I washed my face and hands in the sink.

The bedroom door opened, letting Meredith in and Sally out.

Sally was dressed in jeans and an embroidered shirt. Her short hair was pasted back rather severely. Earrings brushed her shoulders.

"We're going out," she said.

"Out? Let me get my shoes."

"Do something about your breath."

"I can't brush my teeth. Meredith is in the bathroom."

"Then do something else about your breath."

I found a mint in the pocket of my other pair of jeans, ran a comb through my hair, and pulled on my shoes.

"Would you mind telling me where we're going?"

She had her back to me. "Reception for an artist. Loft in Cambridge."

No wonder Sally was in a bad mood. She'd had a gallery of some sort not too long ago and lost it because of financial troubles. Now she was working as a legal secretary. Still, she put in a mandatory appearance at this party or that, pretending she still played that particular game.

Somewhere along the line, she'd lost something else, and now she wouldn't go out alone in the dark without someone to stand

between herself and evils I could only imagine. I'm not female.

But then, if she didn't need a bodyguard, she probably wouldn't have taken me in. I was male, yes, and utterly helpless. I'd just discovered that there were too many fourteen-year-old pieces of chicken on the street, and since I looked old enough to shave, I couldn't get more than three dollars a blow job. Knowing that I could not die gave me a sort of recklessness. Knowing that I could very well spend the next fifty years getting more and more hungry gave me another.

She had watched me panhandle by the train station, and was nice enough not to call the police when I slept in the entrance to her apartment. She didn't seem to like police too much either. Then I took a chance and made her an offer: clean her apartment if she'd let me use the shower. After a while it became a habit. Then she stopped kicking me out after I'd done her dishes. I didn't mind sleeping on a floor. Streets are harder. Someday maybe I'd get around to establishing a fake identity, but I was having moral problems dipping into the criminal underworld while I lived with Sally. Or maybe it was just despair.

"This way."

Sally brought us down into the train. I stayed close enough to look like her boyfriend, but usually not close enough to touch her. She stood with her arms wrapped around the pole of the train, looking like a folded-paper statue. When the train stopped, she jumped out so suddenly I was almost left behind.

As we stepped over the granite curb, I heard a scream rising from the alley like someone was torturing a baby.

Sally clutched at her purse. "What the hell was that?"

"Cat," I said.

"Can't be."

"Is. They're fighting."

A small, black bolt of fur sped under my feet, almost making me trip.

"Told you."

Sally gave me a dirty look and pulled me in the front door.

Cats. The Mother kept a couple of them lying about her throne. Not my mother, you understand. The Mother. She'd acquired a taste for them back when they inhabited her temples in Egypt. These cats were big. Panthers. Sometimes they bit one of us. We laughed about it. They interjected the pungent scent of mortality into the realm. They died so soon. And now they were all I could remember.

The senses of a human are not those of a divinity. I cannot remember what the Mother looked like. Or my treacherous brother, who brought the charges against me, or the rest of the tattered refugees of a hundred pantheons who judged me. I can't remember the discomfort of hanging by one foot from a rope that was tied to the roof of the world, or what I had felt when they passed a sentence of fifty years of humanity.

I can only remember the cats.

And how one must not gamble with gods. They don't like to lose.

There was a thin cloud of smoke hanging over the party. The huge loft had been redone as a studio, decked with abstract paintings. The floor was interrupted with art, or with trays of discarded drinks, if one could tell the difference. People were talking in groups. The carpet was stained with cigarette ashes. As usual, most of the important people were men, the only women their dates. Someone offered me a drink and I turned it down, then changed my mind.

Alcohol bit the back of my throat, giving me the dizzy feeling in which I could almost remember divinity. Almost. I'd told a street person my story once. I wasn't sure if he believed me, but he told me to try acid. Maybe I would sometime. I got some expensive snack food from a tray and quieted my stomach.

My mind had been wandering again. Sally was deep in conversation with a man who wore very sculptured clothing and a very sculptured haircut. She had introduced us, but I didn't remember

his name. He was looking at me with more than casual interest. I wondered if I should offer to do him a favor, in Sally's name, and if the favor would get her something she wanted.

By then, I needed to use the bathroom. When I returned, he had drifted away, to be replaced by a tall, black-haired woman in a green silk kimono and black pants. She soon had Sally swept up in an art-world minuet. Sally's eyes were looking brighter, almost human, talking to someone about her favorite place to be. Talking to someone female. No threat. No challenge.

"The last retrospective at the ICA? I was there on opening night. Yes, I was impressed, but I know who they could have gotten if his boyfriend hadn't had a fight... Ah, do you mind stepping into the hallway? This smoke is making my eyes hurt." The tall woman smiled apologetically.

"Not at all." Sally turned after her.

She was not exactly pretty, but interesting. I wondered if anything warm and breathing would look interesting after almost having Meredith. Her smell hooked into my senses. I wondered if she was wearing some familiar cologne.

We were out in the hall. The bathroom door opened, spilling more smoke into the hall. Not tobacco this time.

"Oh my," the woman said, coughing. She motioned to a door.

"This is the new part. They haven't renovated it yet. I don't think anyone else knows it's here."

We shut the door behind us. There were no lights, but the windows were open to the spring evening. Blocks of orange light from the street broke up the black expanse of floor.

"But about the ICA," Sally began, turning back to our companion.

Her eyes opened very wide, and her hand dipped into her purse. Funny, I hadn't known that Sally carried a gun.

I turned around very slowly.

The woman was gone. In her place stood a man, much taller than she had been, black hair down to his waist, and eyes that

seemed to glow. He was wearing her clothes, though. They fit perfectly. The scent I thought I remembered was thick in my nostrils, cloying as a drug. Around then I noticed that the sound of the party had faded to silence.

"Put the gun away," I said. "It won't do any good against him."

"What are you talking about, Michael?"

He smiled at me. "Michael. Is that what you're calling yourself now?"

I shrugged. "I needed a name. They took mine."

"Michael!"

"Sally," I said, "Meet Siljuria Sheh, Incubus."

"What?" Her revolver still held steady on Sheh's left eye.

"Incubus. The gods make them for playthings, then let them go when they get bored." I felt the bitter prick of jealousy. This created thing ranked higher than I did now.

Sheh smiled at me, coldly. Did he want just to gloat? I recalled how his female persona had been so precisely calculated to disarm Sally. I was more than a casual judge of male flesh, though most of the men who had had me were none too pretty. Sheh resembled an animal more than a man. Very beautiful. Very hungry.

"How pleasant of you," he said. "I've had better manners than to mention your parentage."

"Yes, well, you've hardly the wit for an original insult. You must have found me by accident. I'm sure you couldn't have reasoned it out."

"Are you both crazy?" asked Sally.

"Not yet," I answered.

"I've never been anything but," answered Sheh. "But then, I'm a plaything of immortals, and my sanity is of no consequence. I'm sure Michael didn't take it into account the last time he had me at his mercy. Did you, Michael?"

"Ah, well, the Mother wanted you punished. I obliged."

"And you, of course, are known for your obedience." Sheh's eyes narrowed. "I know your name. I could say it now. Draw attention to you. Lots of us are looking for a minor deity of chance, recently demoted."

I thought about that. Many creatures of many different planes thought I owed them something. I could not die. This would be a liability. Too bad I didn't believe in repentance.

"Siljuria Sheh, if you would invoke my name, I don't think I could do anything to dissuade you."

"You're right," he said. "How lucky for you that I've decided to overlook your lack of appropriate humility. I'll do only what I would with any other human I fancied."

"There are rules," I said, frantically wishing I knew what time it was. After all, at worst, he had me only until dawn.

"There are rules," Sheh agreed. "You may still run."

"Don't."

I turned to see Sally's revolver pointed at me. "I think I know what he wants, and I want to see you give it to him." Her face was twisted into something ugly, made pale by the outside light.

"Do you really think watching me get mauled will make up for anything anyone did to you?" I asked. She couldn't kill me, but a bullet hole would cause me great discomfort. Not to mention the damage it would do to our relationship.

"No. I'd enjoy watching, though."

Sheh was looking at her. I sighed and wished she hadn't drawn his attention. Incubi are single-minded creatures. If Sheh wanted to see me struggle, he wasn't going to like having someone else mess with my motivations.

"Sheh, leave her alone. She doesn't understand."

He didn't wave his hand, or anything else remotely dramatic, but her gun suddenly got long and wiggly. She dropped it and jumped and started to back up to the wall. Up until that moment, it would have been possible to believe that Sheh was an ordinary human wearing strange contact lenses. But not with

guns turning into snakes. Sally just didn't know how lucky she was.

Sheh very deliberately stepped out of the way of the door. "Now, Michael. Run."

I thought about it. I could do what they both expected and try to escape. But then, I'd eaten Meredith for an appetizer and stayed a little hungry for the rest of the evening. Sheh wanted me. More to the point, he wanted me screaming, weeping, and helplessly pleasured, and so drunk with the taste of incubus that I'd thank him for hurting me. So I'd lose a little dignity. There are worse fates.

He was standing behind me now. It was one thing to decide not to run, and another thing to follow through. I was remembering how to be afraid. The door seemed to retreat from me. A hand touched my shoulder, so cool and steady that I could feel myself shake against it.

Liquid fire poured down my back, and something tore. My clothes. And my skin.

"Look at me."

Sheh was standing in the light, watching my blood drip down his hand. I was thinking that his fingernails didn't look sharp enough to have done the job.

"You're mine now," he said, and licked. He had his eyes closed as he ran his tongue up and down his fingers, with a look on his handsome face like he was having sex, only better.

When Sheh had cleaned every last drop of me from his skin, he looked up, and he changed. Flesh melted and flowed, turned dark, acquired inhuman textures. His eyes got larger, and his teeth gleamed in the yellow light. The smell of him grew thicker. Hot drool mixed with my blood dripped from his jaws. Just like Mother's pet cats.

I should have known he wouldn't keep a man's shape. I felt my skin flush with shame that Sheh would think to take me thus, as an animal. The immortals were having an extended joke at my expense.

And then he moved. He made a sound, almost too thick and loud to be a purr, vibrating the floor and my feet, rising all the way to crotch level. Silk-in-water fur rippled over steel muscles of a different design than mine. Sheh arched and stretched with evident delight.

How silly of me. If anyone in this room had contempt for me, it was me alone, not Sheh.

I laughed and knelt to the great cat who padded across the floor to me. Sheh took a teasing half-step to one side and let his cheek just brush mine. I reached out for his head, encouraged when he only blinked and gave another deep purr. My fingers barely skimmed the softness behind his ear. He leaned into my touch until I could put my arms around a neck that was, I swear, as thick as my waist.

Sheh pulled back a bit until we were eye to eye. His were yellow and slit up and down. The very tip of his tail was dancing. Whiskers tickled my nose. He tilted his muzzle and licked the side of my jaw. I closed my eyes and let my lips part so that our tongues just met. The taste, hot and sharper than alcohol, seared down through my throat and into my heart. I whimpered and held tight to his neck as his tongue snaked deeper into my mouth and two-inch teeth nipped at me in play. Several different kinds of pleasure converged in my neglected cock, which sprang to sudden and insistent attention.

And to think I'd observed with such condescension the effects of my kisses on mortals, when I was a god. Next time I'll have more sympathy.

I was good and drunk with the taste of him, too dizzy almost to sit up. Sheh bit at my tattered shirt, tearing cloth. He licked my throat, tasted my sweat, then turned his attentions to my nipples. His tongue was very rough and pulled at my flesh. I tried to hold on to him, but he gave one swipe of his paw and knocked me down, leaving four long bleeding cuts in my chest. So I could still feel pain. No matter. I'd decided that I hadn't given nearly enough

attention to this body in the year I'd had it. Anything with this capacity for sensation couldn't be so bad.

Sheh took another swipe at my legs, shredding the jeans while leaving most of my skin intact. He settled one paw on each thigh, claws barely extended, pinning my legs open. His breath ruffled the hair of my groin. I put my hands behind the back of my neck and locked my fingers together.

A touch almost too soft to feel stirred my cock. I bit my lips and moaned. He licked me again, savoring the salt of my precum. His tongue went down between my legs, curling over my balls and into the crack of my ass. I moved and felt his claws come out just a bit more, in warning. Sheh tasted the length of my cock with cat-washing-kitten deliberation, now taking it partway into his mouth so that I could feel the roughness of his hard palate against the head. My hips thrust upwards and I screamed because his claws had pierced me, and because I was coming.

And when I was complete, he gathered up my leaking fluids with his tongue. His mouth found mine again, giving me our mingled tastes. Sheh sat back, his tail twitching and ears flat, and snarled at me.

It's not always easy to tell the gender of an animal by sight. They know each other, but their sex is tucked neatly away. I'd been certain the cat was male, though. Perhaps it was something in the scent, or the attitude, or a certain heaviness of jaw. I had not doubted what he would want from me, nor mistaken his demand.

Sitting up a bit stiffly, I cast aside the remaining shreds of my clothes. I got up on my hands and knees, feeling the hard wood of the floor and Sheh's impossibly soft fur brushing against me. Sheh mounted me, staggering me with his weight. His forelegs braced me. My stomach tensed as his strange anatomy pressed against my ass.

I wept at the shock of penetration. It was too beautiful a sensation, too soon after orgasm. I wanted to faint. I did not. His

tongue stroked the back of my neck with almost apologetic soft-ness. Sheh growled deep in his throat. The pitch rose with his pleasure. I leaned into him, letting his shaft take me deeper. My insides rearranged themselves to accommodate his entry.

A sound of a booted heel scuffing floor broke my concentra-tion. I looked up to see Sally watching us, her arms folded tight. I wondered what she saw, and what she thought of it.

Sheh moved inside me. He bit at my shoulder, and his growl rose to a tortured-baby shriek. My body shook, held on the razor points of his teeth and claws, as I absorbed the spilled passion of a divinity.

I did not faint. Sometime afterwards I fell asleep curled up against the fur of his chest, with his teeth still holding me pinned and his whiskers in my ear.

▼▼▼

There was gray light in the windows. I stretched a bit, feeling the soft, dark curve of a cat's body against mine, paw thrown over my ribs and tail wrapped around my leg. Then the fur rippled and grew smooth, and the claws were fingers.

"Quickly," he said, and turned me onto my back.

Siljuria Sheh's eyes glittered, still slit-pupiled. He forced his tongue into my willing mouth and bit at my lips just a little. Long hair tickled my throat. I linked my hands across his muscled back and held on for just a moment longer.

Sun lanced through him, dissolving the body that was the whim of an evening. Within seconds there was nothing left but a burning taste in my mouth.

The floor shifted beneath me, no longer bare wood but worn carpet. I was in Sally's apartment, and there she stood by the doorway to the bedroom, watching me. I sat up, looked around, and broke into helpless laughter.

"Exactly what do you find amusing?" she asked.

"There." I pointed to where the clothes I was wearing last night lay in a neatly folded pile, store-bought new and rip-free. "He magicked my clothes back, but not my skin."

Catching my image in the window glass, I decided I didn't mind the souvenirs. Sheh had drawn an anagram in flesh: human, beast, god.

"You aren't going to throw me out?" I asked, then cursed myself for speaking up. Maybe if I hadn't, Sally wouldn't have remembered she had an option.

"No, I'm not going to throw you out. I'm sorry about the gun."

"That's okay," I said, and it was.

Meredith stepped out of the spare room door, wearing nothing but underwear and the smeared remains of last night's mascara. She halted and stared.

"What the holy fuck happened to you?"

Lauren P. Burka lives in Cambridge, Massachusetts, with her two rats. She smiths silver as well as words. She is the author of Mate: More Stories from the Erotic Edge of SF/F, *also included in this omnibus, and her short stories have appeared in* Absolute Magnitude *magazine,* By Her Subdued *(Masquerade Books, 1995), and* S/M Futures *(Circlet Press, 1995).*

A Persian Fancy

K. A. Kristiansen

Sebastian and Bathsheeba lay together on the red velvet of the divan. Bathsheeba was unclothed. Sebastian was not. He was propped up on one elbow, while with his free hand he stroked between her legs. She tossed her head and made little sounds of delight in the back of her throat. "You like that, don't you?" he whispered as he moved his hand up to touch her nipples. She said nothing, but looked up at him with adoring green eyes, reaching out to toy with one loose end of his cravat.

After a few minutes, she rose and stretched, and lay back down, this time on her stomach. Sebastian knew she never liked being touched the same way for too long.

He caressed her back, her flesh warm under his hands, and crooned to her. She made him feel so comfortable; he could say things around her he could never say to anyone else. "I love you, you sweet thing, my little dumpling, my little morsel…" He buried his face in her musky pale hair; it tickled his nose. Her hair felt so soft and luxurious; he twined his fingers in it, losing himself in the sensation, and kissed Bathsheeba behind the ear. He wrapped his arms around her and held her close, feeling her heartbeat next to his.

She squirmed in his grip and broke free, then jumped down off the divan and sat on the Persian carpet below. With a delicate pink tongue, she began to groom herself.

He leaned back and watched her, marveling at her grace at something as pedestrian as grooming. She was plump, but her

movements were fluid and sinuous even when she twisted around and licked between her own thighs. When she finished her task, she sat and looked back at him for a moment, then jumped back onto the divan and lay beside him.

He sighed. The sun was setting, casting golden light on the brocade drapes and the harpsichord across the room. The fading sunlight played across the painted nymphs that cavorted in gilt and pastel colors across the instrument's sides, while papers, spotted with scattered musical notes, crowded its top. Tall piles of half-finished sonatas and suites obscured the elegant classical flower garlands that adorned the chairs and chests around the small salon. Sebastian did not allow the servants to clear them off in this, his favorite workroom. He thought about the concerto he had been commissioned to do for the Baroness of Rhoads, for the ball she was holding to celebrate her escape from the uprising in France. *I ought to get started on it,* he thought. *But I'm so comfortable here...*

Bathsheeba rose, affronted that he was ignoring her, and climbed onto his chest to get his attention. With a dainty claw, she pulled at the embroidery of his waistcoat. "No, no, darling, none of that," he chided, and gingerly disengaged her from it. To make up for the reprimand, he petted her, but she rose in a huff and walked down to his waist, and settled herself right over his crotch, resting her head against his crossed thighs, her tail curled over his stomach.

He shuddered at the sudden warmth and felt the beginnings of an erection. "That's what I want to do," he muttered. "Have sex." He closed his eyes. The cat shifted her weight, rubbing against his engorged cock and arousing him even more.

One of his serving girls would come if he rang the bell, but he would have to rise and walk over to the bellpull, and he didn't want to disturb Bathsheeba. He moaned as she bent to lick her paw, her head rubbing right through the thin fabric of his summer breeches. She stopped, leaving him breathless and wanting more.

He tried to hold himself still, afraid that if he moved too much she'd be put off and go away, leaving him cold. *Bathsheeba could make herself more useful around here*, he thought. *I feed her and take care of her; she could do something for me besides tracking pawprints all over my freshly written music.* He peered down at her. She was serene as she looked with regal disinterest at the sunset through the leaded windows.

What would Bathsheeba look like as a woman? She would be young, Sebastian thought. Bathsheeba the cat was barely past kittenhood. *She might be a bit plump, but shapely like a Grecian goddess. I always did like a well-fed woman*, he thought. *Why they lace themselves into those infernal corsets is beyond me.* Her complexion would be fair, her pale hair straight, but voluminous, like a mane. Her eyes would be large and guileless, of a crystal emerald, her nose a delicate button, her mouth wide and sensuous. Her movements would be dainty and fluid, her voice soft and musical. She would be shy and quiet, demure and trusting. He pictured her dressed, like his Grecian goddess, in a short draped tunic, fastened at one shoulder. Perhaps she kept one round, perfectly shaped breast bare, a ruby nipple peeking out from its ivory setting. She would be Diana, moon-silver and changeable.

Sebastian sighed and closed his eyes. Bathsheeba finally jumped off of him, but he stayed half-erect. As the room grew dark, he pictured an image of the girl that Bathsheeba would be. He held the picture like a cherished memory, and his hand strayed down to his now fully extended organ.

Something began rubbing against his knee. He opened his eyes reluctantly. He could see a white form in the dying light. Intrigued, he pushed himself onto his elbows.

He was staring at a pair of large, round eyes. Human eyes, with a faint catlike shine, and below them, a delicate button nose and sensuous mouth.

"Bathsheeba?" he asked, confused, for this total stranger was completely familiar.

"Se-bas-tian," she whispered, pronouncing every syllable, as if just saying his name were a pleasure.

He touched her cheek. It was like velvet. "My Bathsheba," he whispered back. "My Diana." He ran his fingers through her moon-pale hair. It was soft, impossibly soft for a woman. Though straight, it stood out from her head like a halo.

She leaned her head into his hand, closing her eyes and humming under her breath. He caressed her face, her neck, her bare shoulder ... and, as he had envisioned, the perfect ivory breast left bare by her Grecian tunic. He watched the nipple crinkle as his hand brushed against it.

Her eyes widened and the corners of her mouth turned up in the hint of a smile. His cock strained against the fastening of his breeches.

He stood up and leaned over to pull her to her feet from where she sat. He checked the rough grasp he had felt the urge to use. He knew Bathsheba liked to be handled with care and delicacy.

"Come, my darling," he said, and offered his hand to her in his most gentlemanly fashion.

She took it and rose with singular grace, flowing without effort from one attitude to the next.

Now she stood before him, a small woman, but, as he had wished, delectably fleshed out, her bared legs well turned. He approached her and took her face into his hands, feeling the warmth of her throat. He brushed a finger below her chin, which made her sigh in contentment. He echoed her sigh and touched his lips to hers.

Her breath was sweet, like candied flower petals. He held back the kiss, allowing only the lightest of touches, but it was she who pressed into his mouth. He returned the gesture, just barely brushing his tongue against her parted lips. Then he pulled away and gazed deeply into her eyes, now dark pools in the twilight. He twined his hand in her hair and kissed her with more fervor, though still with exquisite control. She opened her mouth, and

with his tongue he felt her small, sharp teeth, the rough texture of her tongue. He ranged his lips across her face, down to her neck, and then lingered just behind her ear. She moaned and threw her arms around him, rubbing her crotch against his knee. Then she twined her fingers in his hair and pulled his face down to her enticing rosebud nipple. He closed his hungry mouth around it.

She held his head to her breast as he suckled, and he heard nothing but her breath and her heartbeat. She was very quiet then and held very still, though he could feel her quivering. He looked up at her face and saw in her eyes the eyes of the cat, reveling in being petted.

He undid the brooch at her shoulder that fastened the tunic covering her other breast, and carelessly tossed the brooch aside. The newly revealed breast was just as delicious as the one exposed, and he drank deeply there as well. He came up and kissed her again, a short, intense kiss.

She pawed at his brocade waistcoat, toying with the brass buttons. He opened the waistcoat, shrugging it off and tossing it aside. With a familiar gesture, she batted at the loose ends of his cravat. He grinned and tore it off, exposing his throat. She reached out and, lightly, traced his Adam's apple with her fingertip. The sensation was maddening, but delightful. He took the hand in his and sucked upon the outstretched finger. She took his free hand in her mouth—and bit it.

The pain was jarring, but it heightened his desire. He grimaced for only a second; then, with an exhalation of breath, he pulled her to him. Her hips ground against his, and he leaned over and nipped at her earlobe, then at the fleshy spot at the base of her neck. She squealed playfully.

Their eyes met again, and then their smiles faded, replaced by an unspoken assent.

She ran her hands across his chest, seeking out his nipples through the linen of his shirt.

He sank to his knees, pulling her down with him, and with great care pushed her onto her back. She seemed to glow against the darkness of the carpet, lying in a square of light from the rising moon. He parted her thighs, and undid the belt that held the fabric that hung from her waist. The cloth fell away, revealing the few pale downy hairs that framed her sex.

He caressed her belly with his open hand. She stretched her arms over her head, making little sounds in the back of her throat.

He traced his tongue across her collarbone and down along her sternum, moving his hands in a circle from her belly to each of her breasts, then in a straight line to the mound between her thighs. Then he took his hand away, positioning his face between her legs, to do to her what he had seen her do to herself so many times.

He flicked his tongue first across the soft flesh of her inner thighs, then over to her vulva. It was wet and tasted faintly of scented bathwater. He moved his tongue in lazy circles over her labia, then lapped at her like a kitten at a bowl of milk. He heard her breathing deepen; then, as he continued, he felt the rippling of her climax under his touch.

Sebastian smiled as he drew back to watch her arch her back and sigh. Then he unbuttoned his breeches and freed his phallus.

She saw him and began to turn onto her stomach. He grabbed her shoulder and turned her onto her back, pinning her shoulders down so she couldn't move. Her chest heaved, but she lay still, her gaze expectant.

With his knee, he pushed her legs apart, then let go of one of her shoulders, and used his free hand to guide his cock into her.

He thrust once, and suddenly she squirmed under him and let out a sharp cry. He ignored it and thrust again and again until with a sobbing groan he emptied himself into her.

She squirmed more, and got her hands on his chest and pushed him away from her. He pulled out, spent and unable to both fuck her and fight her. He drew back onto his knees.

He looked at her for a second, puzzled. Then he saw the dark spot of blood on the tunic bunched between her legs.

His Diana had been a virgin goddess.

He held his hand out to her, to embrace her.

She sat up and took his hand in hers. Then she closed her mouth around it and bit down hard. His eyes widened, but he froze, knowing better than to yank his hand away, lest he tear the flesh. As it was, when she did let go, there was a bright ring of bloody drops between his thumb and fingers. He looked up from the injury to see her smiling at him.

Then she knelt before his now-limp organ. He felt some fear, letting those sharp little teeth so close to him, but she ran her rough tongue slowly all along its length, calming him and bringing him erect once more. She straightened, caressed his sides, and pulled his shirt off.

He forgot the ache in his hand and held her, kissing her again. She straddled him, taking him into her from above, and began to rock.

▼▼▼

Apollo's golden rays warmed Sebastian as he lay, naked, facedown upon the divan. He arose slowly, surrounded by his own garments. Of Bathsheeba, there was neither hide nor hair.

He sat, crumpling his breeches and shirt on his lap. *I might have dreamed it all*, he thought sadly.

He stood and stretched, then gathered his garments into a pile for the servants to deal with. From a hook by the door, he took down a dressing gown of red-and-gold-striped silk.

He felt tired and spent. He had passed the night with someone: this was certain. There was the angry aftermath of a bite still on his hand—though the toothmarks looked more animal than human—and there were scratch marks around his body...

As he reached the doors of the room, a white, furred form caught his eye, passing his feet. Bathsheeba!

Sebastian shook his head and picked her up.

"So, darling, did we just dream it all?" he asked her.

The cat said nothing, but squirmed free and jumped to the floor inside the room.

Sebastian shrugged. It was too early in the morning to worry. He turned to go, but heard a sound behind him and turned back.

There, standing by the divan, was his Grecian goddess, one pert breast bare. The other was covered by her tunic, which she held together at the shoulder with one hand.

He watched her stoop down and pick something up—the brooch, he remembered dimly. In the light of day he could see that it was silver, shaped vaguely like a cat's head. She fastened her tunic with it, and looked to him with a triumphant smile.

Sebastian stood still.

She walked over to him and kissed him. He tasted the flower petals on her breath once again. She tossed her head, and left the room on padded paws.

He watched her receding form, blinking to clear his vision. Then he grinned and went to his harpsichord, where he began to pick out the first notes of a new concerto.

Insanity runs in K. A. Kristiansen's family; she's a third-genera-tion writer (but the first to be published). This story is dedicated to the distinguished dead: her writing ancestor, a Persian cat, and a badass composer who grooved on harpsichords long after they were fashionable. She doubts that they hang out together in the afterlife, but this story wouldn't have been possible without them.

The King's Shadow

Mary Malmros

The storm caught me by surprise. A few dark spots on the asphalt, then a rapid patter of drops, and then a sudden roar as the downpour started. Berating myself for not carrying an umbrella, I glanced around and spotted an alley with an overhanging ledge. By the time I got to it, a cascade of rainwater was streaming down steadily from the ledge, almost forming a curtain. I ducked through the water, cursing, and stood panting in the relative shelter of the ledge.

It didn't help much. My hair was already soaked; my shoulders were uncomfortably damp—I'd been meaning to get my coat waterproofed and had procrastinated too long, it seemed. I stared grimly down at my saturated dress shoes, my rain-spotted silk tie, and tried vainly to get a handle on my rising temper. Because of the storm, I'd be late for the theatre. I'd draw everyone's attention as I entered, looking like a drowned rat. I imagined the looks on the faces of my friends, laughing and teasing as I took my seat among them, and my mood worsened.

The rain hammered down dissonantly on the garbage cans. Beads of moisture trickled down the wall next to me, streaking the meaningless snarl of graffiti that covered the greasy brick. In the midst of the graffiti stood a large, tricolored spiral, a circle with three arms of red, yellow, and blue reaching inward to its center. Across it, in black, were the words AS ABOVE, SO BELOW. I frowned at it, annoyed as I am by all vandalism, and wondered why anyone would trouble to make such a thing.

It was the absence of sound that alerted me that the rain had stopped. I blinked. I'd been staring at the spiral for perhaps five minutes, while the rainstorm spent itself. Drops fell from fire escapes to land in puddles on the asphalt; one, cold and quicksilver, landed on the back of my neck. I shuddered and turned away from the wall.

And saw her. She was crouching just outside the mouth of a trash bin that was lying on its side. In her mouth was a discarded half sandwich; on her legs and sides was the filth she'd crawled through to get it. She regarded me steadily, waiting for me to move.

I made a sound of disgust and drew back. Her expression changed slightly, amusement and slight contempt glinting from her eyes. Moving a step at a time, she climbed on top of the trash bin, leaped from there to another, to a fire escape ladder. She climbed to the first landing. Then, still watching me, she set the sandwich down, stepped back from her meal, and deliberately began to groom herself.

What emerged was not beautiful. A long way from it. Her coat was gray, short-haired, drab and nondescript; her body, bony and angular. On one flank I could see a ragged patch where she'd been chewed in a fight. Understand: I like the look of my domesticated Persian, sleek and contented, who kneels at my feet and purrs when I stroke her, whose only pleasure is to please me. This ragged alley cat, with her wary, independent look, her run-wild, uncared-for appearance, offended me. A cat should sit at a master's feet. One who doesn't is good for nothing.

But I continued to watch, fascinated, as she shook her paws one at a time, to clean off the worst of the muck, then began to lick them clean. Her paws free of filth, she turned her attention to her flanks, pausing every now and then to lock gazes with me. *"A cat may look at a king,"* I found myself thinking.

The cleaning went on and on. You'd have thought she'd just dined on cream and caviar, the way she licked at her matted fur,

ignoring the sandwich at her feet. It was nothing, really. A discarded end of a cheap roll that might have been fresh a day or two ago, now soggy and grubby from the trash bin, with perhaps a bit of meat in the middle. I could imagine my Persian wrinkling her nose at the sight and drawing her paws back in distaste. But this alley cat finished her grooming, and then slowly ate every scrap of the filthy thing.

I watched her eat, then suddenly said, "Are you hungry?"

I expected her to jeer or flinch or grovel. Instead, she merely returned my stare and said, "Yes."

Yes. I bared my teeth in anger. Another thing I detested about the wild alley cats. Not "Yes, Master" or "Yes, sir"—none of the proper deference that a cat should show. When I went to visit friends, their cats would kneel, drop their gazes, approach when beckoned, and speak with proper honorifics and respect when spoken to. When my friends came to visit me, my Feather would do the same. Now this ... this dirty, shabby, chewed-up, ugly alley cat was looking me in the eye and speaking as if to an equal.

"You might not have to be hungry if you knew how to speak to a master properly!" I retorted.

I turned on my heel, furious, and started to leave the alley. Then I heard her voice from behind me, quiet:

"I got this sandwich."

I turned and stared at her, not comprehending, and she added, "I can get another one if I need to."

I laughed. "What, by rummaging through garbage cans?"

"If I need to," she repeated. Her gaze was steady.

"You wouldn't need to if you weren't an alley cat!" I snapped, then turned and walked away.

I went to the theatre, then home to take my pleasure with my Persian. She obeyed my wishes and endured the suffering that I gave her, then savored the pleasure that I gave her afterwards. I allowed her to share my bed and stroked her long, silky fur as she drifted off to sleep. But I lay awake, thinking of that alley

cat, wondering how that drab gray fur would feel under my fingers.

And I went back to the alley. Of course I went, expecting to find her there, perhaps emerging from that same trash bin. But she wasn't. She was nowhere to be seen. I stood there in that filthy alley and felt anger rising in me, anger at my alley cat for not being there when I wanted her.

Because she was already mine, in my mind.

I turned to leave, furious, and found myself faced with the graffiti, the tricolored symbol that had held me in a trance the first time I'd been there. And the rage grew stronger. My alley cat was gone, was off doing whatever pleased her, and had left nothing behind but this mocking symbol.

But I'd come prepared for this encounter. In my coat pocket was a can of garish green spray paint. I pulled it out, shook it, and covered the face of the tricolored symbol with wide swaths of disharmonious green. The symbol was destroyed, the sense of the words lost along with the unity of the design. I tossed the can in a trash bin and was about to leave when I spotted several empty liquor bottles in the bin. Without thinking, I seized the bottles and smashed them against the alley wall. I scattered the shards with my boot, thinking of my alley cat's little gray feet.

The next morning, as I approached the alley on my way to work, I held my breath. I half believed that the symbol would be magically restored. But it was destroyed, as I'd left it. My mark had remained, and so it remained all week. The conviction that I'd developed, that there was something special about the symbol, gradually faded. The pull of the alley lessened.

Of course, I did go back, eventually. The defaced mural was as I'd left it. I looked for the glass and didn't find it; found, instead, a spatter of blood, droplets and a long smear.

She was on the fire escape, looking much the same as before: ragged, dirty, gray as the pavement. There was a long scratch healing on one side, and another across her face.

I cleared my throat. "I came to find you."

"I know."

No "Master." No "sir." No collar, not even a token string. But, I saw this time, there wasn't truly any insolence in it.

"Where were you?"

"Getting some food."

I hesitated, then blurted out, "You could come to my house. I'd give you a meal."

I regretted it as soon as I said it. I imagined this stinking, ugly alley cat next to my prize Persian, and winced. I watched her, hoping that she'd refuse the offer of food, knowing that she probably wouldn't.

But she surprised me. Nodding at the defaced symbol on the wall, she said, "You did that."

"Yes."

"Why did you do that?"

I didn't know what to say. No cat had ever questioned my whims before. I wanted to strike her for her arrogance. But I calmed my temper, telling myself that she was ignorant and knew no better. "Because I wanted to," I explained.

"You haven't the right," she said soberly.

Again, I was taken aback. She was even more insolent than I'd thought. When I could speak, I said, "What? You, cat, tell me I haven't—"

"You haven't the right," she repeated. "You're not my master."

And my anger died as I watched her lower her head to lick at her forefeet. I realized that, in fact, I didn't have the right. No one gave an alley cat anything. What did an alley cat owe to anyone?

But I was determined to change the balance of owing. I wanted her in my debt. I'm still not sure why. I think I wanted to prove to myself that she'd be as ungrateful as I'd anticipated. Or maybe I wanted something from her, and knew she needed nothing from me.

"If you want to, you can come to my house," I repeated. "You can get clean there, and I'll give you a meal."

And I turned and walked away, expecting her to jeer at my back, or to run and twine obscenely around my feet and slyly trip me up, or to otherwise humiliate me. But nothing of the sort happened, and when I glanced back after half a block, I saw her pacing obediently at my heels, her gaze on my steps.

She was limping.

She followed me all the way home. I was embarrassed at having her there, mortified at the thought of possibly running into friends and having to explain this alley cat at my feet, like a dirty gray shadow. I did see LaFleur, coming out of a bookseller's, and thought of his beautiful Abyssinians, each looking like sunlight through a jar of honey. But he turned down the street and didn't see me, and I continued on my way.

And I half expected her to hiss and spit when she saw my Persian. But she stood quietly when Feather greeted me, and listened with eyes lowered as I gave instructions for her to be cleaned and fed. She surprised me even further by kneeling beside Feather and offering graceful obeisance before standing and leaving the room.

I went to the library, and sat to enjoy a book while they bathed. I knew that Feather would do whatever could be done, but I wasn't hopeful that it would be much. And it wasn't. When Feather brought her to me, her fur was the same dull gray color, and I realized that she'd actually been rather clean whenever I'd seen her in the alley. The rough spots where she'd been bitten or clawed were essentially the same.

I beckoned to her. "Come here."

She came to me on her knees, head bowed. I reached out and stroked her ears. She twisted her head, and at first I thought she was trying to avoid my touch. But when I held still, she butted her head against my hand shyly, seeking a further caress. I smiled, delighted at the unexpected response, and stroked her again.

When I reached out with my other hand to place the collar I'd selected around her neck, she didn't try to pull away, but held still and let me fasten it in place. Encouraged, I grasped her under the belly and lifted her to lie across my lap. She lay quietly as I ran my hands over her ribs and back, feeling the scars, the swollen lumps, the cuts. And, under them, the play of muscle, strong and lean. The body of a cat with a hard life.

I won't tell you what happened between my alley cat and me, what pleasure or pain I took from her. Not because I value my privacy all that much; I'm rather prone to discussing my encounters with friends, in fact. But the experience simply wouldn't measure up, not if I had to take it and spin a tale out of it. How could it possibly compare with Kalber's stories of his two matched Burmese? And yet ... and yet. It was remarkable. It was remarkable, in some way that I am helpless to define ... and therefore helpless to talk about.

In the morning, I removed the collar and set her out on the stoop. She looked up and down the street, the wary look returning. Then she turned, looked me in the eye, then knelt one final time to press her forehead against my feet. "Thank you, Master," she said clearly, then leaped off the stoop and was gone down the street.

Unexpectedly, my Persian took a liking to her. I don't know what passed between them during her bathing, but Feather asked after her one night the following week. "Master," she said, after bowing and kissing my feet, "may Shadow come to visit again sometime?"

I was startled. "Shadow?"

"Yes, Master. The little alley cat. I like her. May she come to visit again?"

I felt pleased. My experiment had worked better than I'd planned. "Yes, I suppose so," I said magnanimously. Already I was thinking about returning to the alley, to bring her back home once again. "Her name is Shadow, then?"

"No, Master, not really," Feather replied, rubbing her soft facial fur along my arches. "She doesn't have a proper name. I just thought she looked like a shadow, all gray like that, so that's what I call her."

So I went back again, looking for Shadow. She was there, sitting on the fire escape. I offered her the food I'd brought. She climbed down, knelt, and thanked me politely. I watched her eat, then said, "I was wondering where you learned those manners."

She glanced up at me. "Manners, Master?"

"Yes, manners. You live like an alley cat, but when you came to visit, you acted like you were house-bred."

She began grooming herself. "I had a master," she said softly.

I suppose I wasn't surprised. Her whole bearing spoke of prior training. "What happened?" I asked quietly.

"I had a master," she repeated. "He had a lot of cats. He'd hardly ever see a new one without wanting to buy it or pick it up. He bought me when I was just a kitten. There were four others when I got there. After a little while, it was seven, then a dozen, then more.

"But he couldn't take care of all of us. He let us have the run of the house, and let us care for ourselves. Some ran off. He had them fetched back at first, and beat them, but after a while he stopped trying. After a while, none would mind him, and he didn't try to discipline any of us."

I'd heard of this kind of problem before. I had nothing but contempt for masters who acquired cats that they couldn't care for. Still, I felt a perverse curiosity, wondering what it would be like if you were to simply pick up any cat that caught your eye, to be able to have so many. "What happened?"

She shrugged. "They said one of the runaways got into some kind of trouble. Got involved in a gang, hurt someone, I don't know. I don't think that was it. I think he was just embarrassed of us. He'd stopped buying ribbons and nice collars for us. Half the time we'd go about with no collars on at all. After a while, most

of us stopped grooming, and got all dirty and nasty-looking. And all of his friends were laughing at him, because he couldn't control his cats. He'd try to take them to parties and they'd misbehave, knock things over, disobey the masters, act like ... alley cats."

I cringed inwardly, picturing the party scene. I imagined myself in the parlor of a friend's house with a pack of shabby, screeching, collarless cats at my feet. I imagined my friends' reactions, their looks of disgust and contempt as they turned their faces away. I imagined talk that I'd hear for weeks afterwards, quickly hushed as I approached ... or perhaps not.

Shadow continued the story. "Anyway, one day he decided he had too many of us. He kept his favorites and got rid of the rest."

"Sold you."

"No. A few he sold, or gave away. But most of us, nobody wanted. Said we'd been spoiled and were good for nothing. Said he hadn't chosen us well to begin with."

She paused, staring down at her feet. I wanted to reach out and touch her, stroke her ears, but I refrained. She was an alley cat, after all, and I'd no desire to end up with a scratched hand because I startled her.

I took a deep breath. "So what happened?"

She shrugged. "He turned us out. None of us knew where to go. Most of the others went about looking for new masters. I don't think any of them had any luck. They all turned to begging, or prostitution. I don't know where any of them are now."

"And you've been without a master since then."

She nodded. "That's right."

"That's no way for a cat to live." I gave in to the impulse and reached out, tracing my fingers along the line of a scar.

She didn't jump or scratch. She stood still, watching my hand move, ruffling the fur back to reveal the knotted flesh underneath. "I know it's ugly," she said quietly. "I know I'm ugly. That's why I live here. Alley cats are supposed to be ugly. I'm ugly, and I'm ill-bred, and I'm all those things that you think I am. That's why

I'm here." And she looked at me with that direct gaze. "You masters, you always say the same thing. That alley cats are all runaways, disobedient, the ones who can't live with a master. You love your house cats, and you admire the wild cats. Us, you have no use for. You trained us off hunting, and took us to this city where there's nothing to hunt anyway, and then you threw us out." Her eyes strayed to the ruined mural. "Nothing we do is any good for anything. Here's where it ends for us. There's nowhere to go."

I left. She was right, of course. She was neither skilled nor beautiful, and growing less so with every day. I went home and set about forgetting her. When Feather asked after her again, I told her sternly never to mention Shadow's name in my presence again. I felt sad for a moment, as I realized that I'd never even told my alley cat her name, before I took myself in hand, as sternly as I'd treated Feather.

My alley cat would survive. That's what alley cats are good for.

Mary Malmros says, "I blame this story on my childhood, adolescence, and adulthood. If I'd had a nice, straightforward life, I wouldn't have to write stories about how nothing's as simple as it seems. I am indeed living in interesting times. Film at 11." Her work has appeared in Venus Infers, Leatherwomen III, *and in* The Best American Erotica 1995.

Courtship Rites

Reina Delacroix

"Duke Varek, sir?"

I acknowledged Kattor's presence with a slight nod, but did not rise. Depression, bred of frustration, lay heavily upon me.

"You should not sit here in the dark, my lord. Shall I set the globes aflame?" I nodded again. The warm humidity of late spring in equatorial Mirvun weighed my limbs down as if invisible chains clung to each extremity. Like most Kalis, I prefer the cold crisp weather of our homelands in the mountains; if I were in Kalissanne now—

But there was no use in thinking of Kalissanne; Kalissanne was no longer mine. My younger brother, Darez, now king, had seen to that when he accused me of treason. No Kalith land could harbor me after that, and my servant Kattor and I had been lucky to reach the border ahead of the three days' outlawry. Even the Mrumman provinces closest to Kalissanne were uneasy with my presence, and so I had made my outcast way to Mirvun, where Lord Jatur welcomed me for my late father's sake, if not my own.

Now I was truly in alien lands, in alien hands, and if my situation wasn't precarious enough, I could easily make it more so.

"What is the time, Kattor?"

"Ten at night, my lord."

"No, tell me in Mrumman terms. If I am to remain here, I must learn to live as my hosts do."

"They say 'two-night,' sir, as their hour of arising is eight at night."

I grumbled as I, too, arose. "How appropriate for a race that legend has descending from cats. It saves them from working under the hellish noonday sun they have here, though, so I suppose it's sensible."

"Do not laugh at legend, Duke," came a low, purring voice from the doorway. "If you are to stay with us, you will come to know the truth of our legend."

I looked up, startled by the sound of a Mrumman voice speaking my own language, its husky contralto vibrating even the harshest of consonants. Suddenly I knew how the prey of a cat must feel: trapped, helpless, and fascinated. The eyes—almond-shaped, jewel green around the slit iris—would have caught me alone, but the voice held me as secure as any cage. It held such promise it made my chest squeeze tightly around my heart.

I wasn't sure if the speaker was a man or a woman, but it didn't matter to me. With all the calculated sexuality of my brother's court, Kalis had become masters of perversion; gender would be no barrier to me, though what it might be to Mrumma I had as yet no idea.

I recognized the speaker; in the confusion of my unheralded arrival the previous evening, Jatur had introduced him/her as Ruzhe, youngest of his siblings. Youngest what? I could not remember him saying. Ruzhe, standing in the shadows, had not spoken, merely nodded; if I had heard that husky voice then, I would have remembered it and pursued it as I intended to now.

I switched to the Mrumman language, Dumnan, to acknowledge the honor of a greeting in my native Kaita. "I did not mean to make light of your beliefs. Please forgive my ignorance. Perhaps you would teach me Mrumman ways—" I stopped, not wanting to offend by giving this Mrumma the wrong title. Already I knew that Mrumma were prickly about protocol.

"Perhaps..." began the slow, pensive answer. "It must be diffi-
cult for you, leaving your family and friends, making a new home
in a land you don't understand." Ruzhe looked carefully at my
baggage, at Kattor, who was making my bed with a great show of
pretended disinterest in our presence, and finally—it seemed un-
willingly—at my pajamas of silver satin, but never directly at my
face. There were many elaborate rituals of eye contact, or lack of
contact, in Mrumma society; this looked to be a gesture of tenta-
tive, but noninvasive, interest.

The simple gentleness of his/her comment would have been
an object of derision in my old life, but here the unexpected
sympathy touched me. "I have not had much time to consider it,"
I lied blithely. "Running for one's life doesn't leave much time for
contemplation."

"But now you have come to rest here," Ruzhe replied, the soft
voice a deep throb, almost a growl. Still this one would not look
directly at me—so why did that very indirectness strike me as a
welcome, almost an invitation? "Maybe in time you will come to
love us for our own sake."

Was this Mrumman flirting? If so, I had to respond in kind.
"Maybe you will help me with that."

I saw Ruzhe flush, even through the fawn brown skin, and I
worried I had gone too far. But the response came in an even tone:
"There's no time for us to talk now, Duke Varek. Jatur sent me to
ask you to see him in his chambers by three-night. But I'll be in the
gardens until four-night, and then once I groom myself, I usually
go to the palace library until midmeal."

I kept my gaze firmly on the table. Two could play whatever
this game was. "I'll seek you out there, then."

As my visitor turned to go, I glanced up and saw, very dis-
tinctly, that each finger ended in an inset claw. And that a fine line
of chestnut fur ran down the nape of the neck into the back of the
red-and-gold tunic.

I shivered.

I had thought I was cynical, and immune to love. There were more surprises in store.

▼▼▼

"A what?"

Kattor, eternally patient with my irritable nature, explained, "Lord Jatur's sibling Ruzhe is a neuter Mrumma."

That explained some of my confusion about gender, but the obvious implication was even worse. "You don't mean ... castration?"

He shook his head. "Apparently, my lord, Mrumma are born neuter. In adolescence, nearly all experience something called *cuoia*, which changes them permanently into either male or female. I gathered from the servants that Ruzhe, who seems to be a favorite of theirs, is nearly nineteen, and may never change."

"I wondered why Dumnan had all those neuter pronouns to describe people; I thought it was part of their generally excessive formality. The word *cuoia*—doesn't that mean 'marriage'? That's how it's used in the Histories."

"It seems to be closer in meaning to 'mating urge.' It's used in conversation both for the initial experience and for the permanent bond. And it is permanent, sir; Mrumma mate for life."

I raised an eyebrow at that. "That's also in the Histories, and I thought that was just poetic exaggeration on the part of old Badez."

"After the Great War, Badez actually lived under Mrumman rule for some years, until the Kinwar. He would never have made that mistake; he was too good a historian for that," Kattor said, as he straightened primly. He had been my tutor, before my father rewarded his loyalty to the crown by making him my general servant. Some reward it turned out to be.

Bitterly, I bared my teeth in an attempt at a smile. "We're in the same boat as Badez, so I'd better not make any mistakes either. How do I address Ruzhe?"

▼▼▼

"Rhunne Ruzhe," I said, my scratchy tenor voice held as quiet and steady as possible, so as not to startle the quiet reader.

In the dim candlelight its green eyes shone red, and I felt myself pulled into them as our eyes finally met. I felt my blood racing.

"Duke Varek," came the soft acknowledgment, as the eyes slid away and I was left free to breathe. Wanting to make a good impression, I had dressed in a white notch-collar tunic and black silk trousers, belted with a silver sash. I could not disguise my tremendous height and gray skin, so I hoped to make it exotic by emphasizing it.

Ruzhe barely seemed to notice, yet I felt examined from head to toe. My instinct was to stride over and break down that coolness with a rain of hot kisses, but I still wasn't sure of the response I would get.

There was a curious dichotomy in Ruzhe; although the graceful movements implied a sensual adult, the physical immaturity coupled with an astonishing directness of manner suggested more an overgrown child. I am not a corrupter of children, though Darez now painted me as such.

Ruzhe smiled, a hint of fang at the edge of the mouth. "What would you like to know first, Duke?"

What I have to do to have you, I thought, but I was straining to be as oblique and polite as my Mrumman hosts, so I brought up what I thought would be a safer topic. "Let's start with the legends of Mrumman origin. Do Mrumma actually believe they are descended from cats?"

"The first Mrumma were changed from cats by the gods of mischief, Naa and Bolg. We retained many of the features of our feline ancestors, including fangs, retractable claws, vertical eye-slits, ridges of noticeable fur—even a vestigial tail."

"Could you show me an example of the differences between Mrumman and Kalith anatomy? Pictures, perhaps?"

"Better than that." Ruzhe laughed and stood up. I turned to pour some water from a pitcher, and when I turned back I almost dropped the cup.

Ruzhe had shed the knee-length tunic that was common Mrumman wear in the sultry heat, and stood naked a few feet in front of me, turned slightly to the left. It was unselfconscious in its total nudity. I, on the other hand, was quite taken aback.

"If you remove your clothing also, I can demonstrate the differences between us better. Being neuter, I lack male or female genitals, but if you're still curious, I will ask my older brothers or sisters to show themselves."

If this was a seduction, it was a damned odd one. I must have looked as confused as I felt, for Ruzhe was actually staring at me with a look of concern. "I'm sorry, Duke Varek, I should have asked—is nudity a taboo in your culture? If so, I ask your pardon."

I stammered, "No, it's just I expected sculptures, or something. Models."

"Oh, the doctors have some, but they don't show the details of fur ridges that mark the difference in Mrumman sexes, and none of their parts move. If you would rather—"

"No, no problem," I cut in. If it didn't bother Ruzhe, I wasn't going to let it bother me. Hiding my embarrassment by turning my back, I stripped also.

Ruzhe pointed out some major differences, such as the fangs and claws I had already noted as opposed to my flat teeth and nails. Others were more subtle. The 'tail' was two fingerwidths of stump covered with a reddish brown fur, and it joined the back just above the base vertebrae of the spine.

A single line of that fur ran up the spine to the nape of the neck, with a branch line curving away from the center of the shoulder blades over each shoulder. "Is that the fur ridge?"

Ruzhe nodded. "It develops around our tenth year. Males develop a more manelike pattern, with two or three ridges running up the back and much more tufting scattered over the top of each

shoulder. I have a female pattern of very little fur in distinct lines. If I were to have cuoia, I would almost certainly be female."

From the back, Ruzhe looked like a young boy, but looking at the Mrumma from the front was disorienting. In contrast to my penis and scrotum, there was just a single swollen lump between its thighs, as if what was pubic hair on a woman of my race had been transmuted to solid flesh. Also, below two pinkish brown nipples appeared four more dimples that had the look of nipples, if not the exact form.

"Extra breasts?" I asked, pointing to them.

"We call them false teats. During cuoia, the top pair darken and plump into breasts. The other pairs usually lighten, if not disappear altogether." Ruzhe peered at me with a puzzled look. "You are the second Kalith I have seen, the first being a fosterling boy we housed until my eighth year."

"That explains your fluent Kaita." *And why you had no hesitancy in stripping before me,* I said to myself, embarrassed by a sudden rush of unreasoning jealousy of some callow boy.

"But you look different, here," and a fingertip touched the head of my mostly limp cock.

The resulting jolt made me leap backwards, as if I had been stung by an angry wasp. Instinctively, I looked for a mark on the tip, but there was no visible evidence of the sudden pain I had felt.

No, pain wasn't the right word; it was only that it was so unexpected it seemed like pain. I felt my shaft swelling, and my heart begin to pound.

Then I looked up at Ruzhe. I had seen such an expression of mingled agony and joy on a face only once before, on a man I had known in Kalissanne who could achieve orgasm only when tied to a whipping post and beaten until the welts bled. But I hadn't even done anything, had I?

The brown skin was now flushed with red, and Ruzhe was staring wonderingly at its hand, green eyes wide and pupil slit dilated. "I, I didn't know. They didn't tell me—"

"Ruzhe, what is it? Did I do something? What happened?"

The slender body in front of me shook visibly. The eyes raised to mine, and again there was that sensation of heat streaking through my body. It completed my erection, and I took a step forward, aware of nothing but Ruzhe's eyes, Ruzhe's body, Ruzhe...

Whereupon Ruzhe fainted right into my arms.

I've had women swoon into my arms on several occasions, but this was different. Ruzhe was not play-acting, but had really fainted. I staggered, surprised at how heavy such a small, slender person could be. Ruzhe was out cold, not stirring as I swept the legs up for carrying.

My worry increased as I felt the skin burning against mine. Something was very definitely wrong; such a sudden fever was dangerous.

I recalled Ruzhe's mention of doctors in our conversation; I had to find one. I strode with my bundle into the corridor and looked for someone to direct me.

As Naa and Bolg would have it, the first person I encountered was Lord Jatur, who took one look at the limp form in my arms and the worried look on my face and motioned for me to follow him.

He asked no questions until the doctors took Ruzhe in for examination. Then he looked closely at me and said, "What have you done, Duke?"

I realized that, in my concern for Ruzhe, I had forgotten I was naked. What a sight I must be to Jatur! I explained in a few halting sentences what had happened.

There was a long silence, and then Jatur looked away, but not before I saw that his eyes, emerald like his sibling's, had hardened like their precious namesakes.

All he said, though, was "You should go to your rooms, Duke Varek. Once I have spoken with Ruzhe, I will come to you there. This may be more serious than you realize."

That sounded ominous. My nervousness increased as two palace guards followed me at a discreet distance while I returned to the library to collect my clothes. They stood patiently at the doorway to my suite once I entered.

What had I done, indeed?

▼▼▼

I did not try to leave my rooms for the rest of the night. Kattor brought midmeal on a tray; he said that the servants didn't say much to him, but that there were a lot of sidelong glances and whispering behind his back.

I did not like the sound of this. Did they think I had tried, for some unknown reason, to hurt Ruzhe? Kattor offered to try my food, in case some vengeful person had tried to poison me, but I told him I would take my chances. If Naa and Bolg were playing dice with my life, I could do nothing about it.

It was not until well after dawn that Jatur came by. He looked exhausted, and for a moment I thought the worst had happened.

"Rhunne Ruzhe is resting," Jatur said, sinking onto the bench by the window. "We spoke, and Ruzhe confirms your account of the incident in the library."

"I'm glad. Glad Ruzhe is all right, that is. I was very worried." I began to slump back in my own chair, in relief, but was brought bolt upright by his next words.

"Whether Ruzhe is 'all right' is a matter of opinion," he replied, shooting a swift glance across me, his eyes never fully lighting on me. Far from being a dismissive gesture, it looked almost dangerous, as if it would rest only when he was ready to pounce.

"I had to summon my ruling council to discuss the situation. There is a great deal to consider." He looked pained for a moment, and with great effort shifted his eyes toward the window.

"Situation?" I ventured cautiously.

"You don't understand what has happened, do you, Duke Varek? Your presence has somehow brought Ruzhe into cuoia,

long after we had given up hoping it would happen. According to Mrumman custom, you should bond with Ruzhe. But you are not a Mrumma, and our customs mean nothing to you. We must appeal to your honor; I beg your pardon for saying this, but we fear that the honor of the Kalis has diminished since your father's time."

"I'm supposed to marry Ruzhe?" I couldn't decide if I was having a dream or a nightmare.

Kattor coughed, a soft, warning interruption from the corner, to remind Jatur of his presence. The Mrumman lord gave him a swift, coolly distrustful glance. "I had not realized you were present, Kattor, or I would not have spoken so directly to your master. Forgive my blunt words."

It was really a rebuke for eavesdropping, but delivered with exquisite politeness, and could easily be misconstrued. Kattor chose to do so, and after he spoke, I grasped why. "You have not lessened my master in my eyes, Rhonne Jatur; as a servant I must know my master's business, so that he may rely on my discretion, advice, and performance of sometimes unpleasant duties."

Here, as Jatur was looking at the bookshelves, Kattor shot me a quick look: *Pay attention!* it said, as he continued. "I must ask you, in turn, to forgive my own directness, but what is directness to Mrumma may still seem mystification to a naive Kalith such as myself. What is the true Mrumman custom of bonding? I am not familiar with it."

I began to open my mouth and protest that he actually knew quite a bit about it, much more than I did, and then the subtlety of the game between the three of us unfolded.

The subject, and the necessity to confront me directly, were obviously upsetting to Jatur, who could not even meet my eyes now for the brief moment that passed as respectful acknowledgment among equals in this rigid society. With my servant, he did not need to make such a visual gesture; he could lecture an unequal.

Similarly, I could be much more arrogant, inquisitorial, even lose my temper, with Kattor; showing such aggression toward Jatur would have meant at best a continuation of my outlaw sentence in the rest of the civilized lands, if not evisceration on the spot. The social formalities of Mrumma were designed to defuse their innate aggression; the bloodlust of the wildcat lay just beneath the soft civilized fur. Despite my greater size, an enraged Jatur could easily rend me with his claws. Mrumman ferocity in battle, and in matters of pride, was a proven legend. I tried to look thoughtful and distracted, but listened covertly as Jatur began his discourse on the subject of cuoia.

The Mrumma sighed. "Some of us feel cuoia was the final act of mischief played upon us by Naa and Bolg. The human cultures speak of love and hate as two separate emotions; for us they are inseparable in cuoia, and present in far greater intensity than what you consider 'true love.' Cuoia is irrevocable; once two neuter Mrumma instinctively follow the beginning of the cuoia ritual, it is as binding and permanent as ties of blood. It cannot be severed, save by death."

Jatur's mention of love, hate, and ties of blood brought my brother Darez to mind. There, too, were ties that could not be severed except by death. Had there ever been love between us?

He was really my half-brother, but we were so far apart in age, looks, and temperament that I found it hard to believe we shared even a drop of the same blood. My real father was killed in a tournament before I was born, and King Amnok took my mother to be his queen when I was still an infant, raising me as his own son and heir. When I was seventeen, my mother found herself unexpectedly pregnant after years of barrenness; she died bearing Darez. Amnok, already old, did not marry again.

To Amnok, I was the child of his spirit and youth, but Darez was the child of his blood and dotage. And that made all the difference.

Kattor said, "I heard cuoia called 'the curse of the Mrumma' in Kalissanne. Yet it seems they did not know the half of it." He

rubbed his thinning, white-streaked hair and leaned forward as he squinted, as he had done hundreds of times as an academic tutor, a mannerism which he assumed naturally to draw out further information from a hesitant recitant. For Jatur had paused, and tapped anxious claws on a tabletop, unsure of his next words.

"Yet in some ways cuoia has been a blessing in disguise," the Mrumman ruler continued. "Our physical and emotional urges are constrained in such a way that we live much differently from the human cultures. The fur ridges are late and unreliable indications of a child's future gender, so it is less confusing to raise all our children the same. Our distinction between male and female is only a matter of biology. Also, we had no concept of infidelity, same-gender relations, rape, or incest. Dumnan had no words for these things; we had to borrow the words from Kaita," he added pointedly, disgust giving an edge to his soft growl.

Kattor looked appropriately contrite, but the words were not aimed at him. I had to suppress a wince; it was plain that the worst of the rumors from Kalissanne had crossed half a continent faster than I myself had. It amazed me now that Jatur had given me sanctuary at all, considering the net of lies and incomplete truths that Darez had trapped me within.

The truth would be no defense here, either, so I made no reply to Jatur's oblique comment on Kalith morality. I wondered what the Mrumma would have made of Darez, had they met. A greater contrast to Mrumman sexuality would have been hard to picture. Darez had no inhibitions; anyone was fair game in his campaign of seduction, manipulation, and elimination.

Yet his outward appearance, his manners, his bearing were all flawless. I had never doubted his love and loyalty until the moment he turned on me.

What would it be like to be with someone whose feelings I would never have to doubt?

"If the Duke were to accept this bond with Ruzhe, what would be expected of him?" Kattor asked.

Jatur yawned, a wide showing of his pink tongue and white fangs. Again, his eyes slid over me, and he passed his hand over his ear twice in a curious slicking motion; it was an elaborate show of unconcern, and I didn't believe it for a moment.

"The immediate need would be for Duke Varek to learn our mating rituals. During the first stages of cuoia, Mrumma mate completely by instinct. If one partner makes the wrong move, the offending partner could be seriously hurt, even killed. Our mating can be very demanding, in more than one sense."

He mentioned the possibility of my being injured or killed quite casually. I had lived with that possibility every day since I'd left Kalissanne, though; it did not frighten me now.

"More important in the long term, the duke must understand that he must live as a Mrumma would in his personal life. As a human, I fear, he will find this duty confining, but it is the only way he may function in our society. Mrumma do not accept that behavior outside of cuoia. To touch a Mrumma without warning, without permission, is punishable by death. The bonds of cuoia do not allow 'affairs.'"

Again anger tightened his voice. I had noticed that Jatur hesitated and ducked his head whenever he dealt with Mrumman emotions. Perhaps he didn't expect a mere human to understand them; or perhaps Mrumma simply didn't need to, or want to, talk about feelings at all. What had passed between Ruzhe and myself had been below the level of speech, of conscious thought, but was no less real for that.

I broke in, my voice sounding like sand in a windstorm, strained by my own anger at Jatur's assumptions, mingled with the ugly knowledge that what he had heard of Kalissanne, of myself, made these assumptions possible. "Despite what you may have heard about Kalis, Jatur, some of us have a sense of duty. I would never take such a bond lightly."

I never had. I had loved Darez, and thought I had been loved in return, without reservation. From the earliest days, though, he

was plotting for himself and against me. He was very careful inside the court of Kalissanne, presenting the right mask at all times. Not until he had destroyed our family—destroyed me—did I begin to see his true nature. He planted the seeds of doubt in those around me, waiting for the right moment to turn on me in pretended horror, accusing me of poisoning my father and attempting to poison him, and I never saw it.

When he first turned against me, I thought perhaps his grief over our father's death had made him unbalanced, and I tried to reason with him. Coldly, he slapped me, knowing I would not dare to raise my hand against him.

His black eyes danced triumphantly as the court, eager to please the young lion, passed sentence upon me. I wished then that I had tried to poison him, and succeeded. I saw too late that he had never loved me. He saw me only as an obstacle, to be removed at the proper time.

Now I was being offered the kind of love and loyalty I had thought I had with Darez. Only this time it would not be a lie.

Kattor saw the longing in my face, and cut in to forestall my impulsiveness. He asked, "Are those all the conditions of cuoia then, Rhonne Jatur?"

The Mrumman lord nodded, stretched, and yawned again, this time closing his eyes for a few seconds. This was a much more natural movement than his previous yawn, a slow and graceful stretch beginning at the midpoint of the spine and traveling both up and down through the torso, a constant ripple through the limbs.

I could picture Ruzhe, stretching across creamy linen sheets in the same way, relaxing into my arms and turning those green eyes to mine, and the longing tightened inside me. Hurriedly, I got up and moved across the room, pretending to stare at a tapestry on the wall, turning from Jatur and Kattor so they could not see either the flush on my face or the tears in my eyes.

Swallowing hard, I managed to say, "I will consider all that you have said, Rhonne. I cannot give you an immediate answer."

"Of course." Jatur looked both tired and relieved as he rose and moved to the door. "Perhaps I have been a poor spokesman, telling you only of the difficult aspects of cuoia, but I wanted to make clear the bonds you would assume. Though I should hope it would not influence your decision, there would be a practical benefit to your political situation: you would become a Mrumma, and a member of the nobility of Mirvun, with all the rights and responsibilities of both positions."

That would be a great honor; Mirvun was the mightiest of the Mrumman provinces, and all others deferred to it. I would wield great power. I could have a life of my own.

Or I could return to Kalissanne—return, and take back the life Darez had stolen.

"And you would have Ruzhe, of course." He paused. "You may consider this merely the wishful, doting thoughts of a brother who has stood in place of our father since just after Ruzhe was born, but Ruzhe is special. She is the wisest among us; I had hoped to have her as my First Councilor someday, if she had remained neuter.

"Cuoia is not as random as it may seem, Duke; it happens between Mrumma for a reason. We say, 'Murhe alom cathonnou anom': in your words, 'Two halves fit together.' I think Ruzhe was waiting for you to arrive, Duke Varek, and if I worry, it is because no one knows yet if you are worthy of my sibling. Except you."

▼▼▼

It was nearly two weeks before Ruzhe would be well enough for the ritual. Much of that time she spent in deep sleep, exhausted by the skeletal, muscular, and organic development of cuoia, changes that would take years in the puberty of a human.

I sat with her in the evenings, holding her slender fingers in my hand, marveling at the daily changes in her face and body. Her features defined themselves more strongly, cheekbones pushing to the fore and tightening the cheek and jaw, limbs becoming more

solid and massive as her torso lightened. Yet she was still recognizable as the maddening woman-child I had given my heart to so blindly.

I began to understand the extent of my blindness only during my talks with Karng, the human man they found to tutor me in the mating rituals.

Instinct guided male Mrumma almost completely, so they could not explain themselves; I needed a human guide. Interbreeding with other races was not completely unheard of in Mirvun, but only two couples were in the city of Molinne at this time, and only one had the other race as the male partner.

Karng was an Aemael, a race whose culture affected a kinship with birds. Unlike Mrumma, who were physically related to cats, the Aemael resemblance to their totem animal was superficial imitation.

Karng's hair was artfully cut to resemble wings, and he had a funny habit of cocking his head slightly sideways when I spoke to him, as a bird might consider a worm for breakfast. I judged him to be around my own age of thirty-seven.

He seemed more outlandish than the Mrumma, a large doll come to life with his peach-colored skin, bright blue eyes, and small, plump body. I found I looked equally bizarre to him; he nearly mistook me for a statue, with my stone gray skin and giant's stature.

Yet we were still, essentially, both human. He was the only man available for whom this behavior was learned, rather than instinctual. He told me that he had been taught the same way by another Aemael nearly twenty years before.

"The first and last lesson Ayon drilled into my head was that any deviation from the Mrumman mating ritual may be deadly. It doesn't matter whether you've been together one year or twenty; a false move could very easily cost you your life. If you're lucky, you'll escape with a few broken bones and scars you'll bear all your life."

I tried to picture tiny Ruzhe harming me, and for a moment it seemed foolish, but doubting the possibility was the real folly. I had held her hand, stroked her face; those razor-sharp claws and teeth could shred my thin flesh.

I pictured leaning over to kiss her with love and tenderness, only to be rewarded by a sudden slash across the face, my eyes filling not with tears, but with blood...

His thin mouth tight and serious, Karng continued. "Most dangerous is fear between your mate and yourself. The moment Mrumma sense fear in you, you might as well kill yourself rather than approach them again for mating. Oh, they love you more than life itself, and it will nearly kill them in turn if they do hurt you during mating, but it can happen. Because they can't help it. Their reactions are quick and deadly. By the time they know what they've done, it's too late."

I must have been white with imagination, for he stopped, laughed, and clapped me on the back. "Now that I've scared you, good! It'll make you more careful."

"You said all that just to scare me?" I yelled at him, rising angrily from my chair to tower over him. The vision of my blood staining Ruzhe's claws touched too keenly my memories of betrayal. It was all I could do to hold myself still, the way my heart hurt.

"It had better scare you, Duke," he shouted back, standing up to me though I was twice his height. "My friend Ayon was a careful man, and he was killed last year. You'll live with death every day, and yet you'll get used to it; we all do. And you'll push it too far, and make the same mistake."

"I live with death now," I bellowed, losing my temper as I had not dared to do since before I left Kalissanne. "I've lived under a sentence of death for years before I knew I did. I've lost my father, my country, my brother—" I couldn't finish that sentence, the knowledge was too raw.

Breathing deeply, I tried to rein in my anger, but it boiled over. "And now I've gotten a rare treasure in Ruzhe, someone who

doesn't care that I'm a dishonored duke of Kalissanne, or an exiled traitor, or a supposed patricide, or—" I caught myself just in time. If Karng didn't know the worst rumors, I didn't want to enlighten him any further. "She's the only reason I have to live; she doesn't know me at all, and yet she loves me. If she does kill me, I'll probably deserve it, and welcome it."

Karng moved warily away from me, his bright eyes fixed on my clenched hands and drawn face. "Naa and Bolg help you, Duke Varek," he said in a gentle tone.

I looked at my hands, trembling with rage, and tried to ease the tension. My heart felt squeezed and tender, and my head pounded with rushing blood. "I need Ruzhe to find me worthy, Karng. If she rejects me, it will mean my death, one way or another. I'd rather she cut my throat quickly than leave me to die slowly. I ... I cannot bear another loss, Karng. I have lost too much already."

Reassured by my tone that I would not set upon him, Karng lightly took me by the elbow and made me sit again. Once our eyes were level, he shook his head slowly. "I meant no harm, Duke. But I have also lost a friend. If that loss is to mean anything, I had hoped you'd take my help in this."

His eyes had turned dark blue, soft with sorrow, and I nodded in understanding. "Forgive me, Karng. You spoke of a friend. That has not been common in my life of late."

"So I gathered," he replied, with a slight grin. "Let's work on keeping you alive then, shall we?"

▼▼▼

Karng took me to a perfumery, where he made me identify different Mrumman musks until my head reeled. He had insisted on buying one particular type called abba pardriou, which I learned later meant "red leopard."

"You're not to wear it," he stressed, "but carry it with you in case you need it for comparison. The ceremony requires you to be blindfolded and to identify Ruzhe by scent alone, among several

women. Your nose isn't sensitive enough yet to tell family scents apart, and I imagine they'll allow for that during the test, but you mustn't guess wrong. They'll slaughter you without a thought, for profaning the ritual. Sniff it several times a day so you'll start noticing it on Ruzhe."

Some days later I leaned over Ruzhe, as she lay dozing, to brush her glossy fur with my lips and was suddenly, shockingly aware that he had picked Ruzhe's exact scent.

One moment there was nothing, and then I smelled something too sweet for smoke, too bitter to be toljingja, pool-flower, which Kalis call water lily. I breathed deeply, feeling how close I was to her skin, and found I was beginning to be aroused.

Experimentally, I leaned farther over and parted my lips slightly, touching my tongue to the base of her ear, where one of her musk glands was located. The odor was much stronger then, an almost sharp, oily scent. My cock was so hard I had to pull back, resisting the urge to take her as she lay sleeping. As the scent lessened, I relaxed.

Jatur, with his usual sense of timing, had walked in during this, took one look at my flushed face and the bulge in my trousers, and knew exactly what had happened. His sympathetic smile showed a hint of fang as he pointed first to my nose and then to his own. "Perhaps you are more like us than we realized, Duke. With that response, one might almost think you were Mrumma."

I remembered Jatur's cold distaste of my race during our first talk of Ruzhe, so I said cautiously, "Shall I take that as a compliment to me, Rhonne Jatur?"

"Scent is usually one of the last perceptions other races have of us. Your obvious ability does you credit in our eyes." Not a very direct answer, but I was beginning to get a sense of what Jatur left unsaid: he was beginning to believe in me, in my feeling for Ruzhe. "Karng is a good teacher, then?" he asked, ruffling Ruzhe's fur with the casualness of a brother. I could never have touched her so.

"Karng is a good man," I said slowly and pointedly, pausing before I sought Jatur's eyes.

"So he is," he said blandly, slicking his hand over his ear, avoiding my look. He was waiting for something more, and I thought I knew what to say next.

"I would say a good Mrumma, except he was born an Aemael."

I knew I had said the right thing when I saw Jatur's ears flicker. It nearly caused another smile, but he covered it with a turning yawn. "It is possible for humans to be Mrumma also."

"Perhaps even Kalis?"

I had him. He allowed me to catch his gaze, and his eyes were laughing. "Even Kalis," he replied, "can be Mrumma."

▼▼▼

The night before the ceremony, I sat at Ruzhe's bedside and told her everything about Darez: our love, his betrayal, and my anguish. She had not asked about my life in Kalissanne, although the whole province knew the worst of the stories before I even arrived in Mirvun.

My confession was a bitter, but necessary, gift; I wanted her to know that I would keep no secrets from her. I hadn't known what to say at first, but my pain poured out in torrents of words as she listened patiently, and at first without judgment.

"When it seemed that my mother would bear no more children, as the legal heir I began to be approached by both lords and ladies of the court, offering me sexual favors. Later I found that the most enterprising of them, Lady Halle, had bribed the servants to inform her when my bedsheets showed I was beginning to dream about sex."

Ruzhe remarked wryly, "So nice of her to go to so much trouble for you, Varek."

"They all hoped to ensnare me quickly, with the heat of desire, before I lost my innocence and learned enough to maintain my independence," I explained, as she rolled her eyes upward and

shook her head in disbelief at the intricate insanity of temporary human mating.

"I can't imagine you would ever have been that innocent, Varek. Were you such a prize, then?"

I nodded violently. "I was always aware that they were looking at the heir to Kalissanne, not at Varek the man. I returned their favors more precisely than they knew: one night was worth a small onyx bracelet or signet ring. I rewarded more-accomplished lovers with carriages or elaborate furniture. But I never gave them myself; I knew they weren't really interested in that."

Her mouth drooped in a sad curve. "What a lonely life you led as a human. Even your revenge seems so bleak and pointless. Was there no one who understood you, who could return your depth of feeling?"

"Only when Darez was born, emerging small and pale from my mother's cooling womb. I took him in my arms and promised to raise him in her stead, and I gave to him the love I could give to no one else. I thought he returned it as eagerly and fully as I gave it."

She sighed. "Yet he turned on you. Why?"

I shrugged my bony shoulders. "Many people have the raising of a king's son in Kalissanne, cuotta. Who knows what the more unscrupulous nobles whispered in his ear? Or what they taught him in their beds?"

"But, from what you say, he must have been planning your downfall for years. How could he have fooled you for so long?"

I felt the familiar pain in my heart, recalling Darez, and yet it lessened as I looked at her. She had loved me by instinct, without knowing anything about me. I could only hope her love was strong enough to survive her inevitable disgust, since she was Mrumma, at what I would say next.

"I loved him at first chastely, as my half-brother. Then, when he was twelve, things changed." Her ears pricked up as she perceived a new, uncertain note in my voice, and her face seemed to flatten in anticipation.

"One night there was a resounding thunderstorm that shook the mountaintops. He ran to me for comfort. I held him, and I was horrified to find I was aroused by his body pressing against mine. I began to lift him from my lap, meaning to send him away. But he turned his face to mine, innocent and trusting, and kissed me full on the mouth, then slid his tongue down my neck and chest until he suckled on my aching cock. I thought I had been seduced by experts, but even on that first night Darez led me."

"So he twisted your love for him into something unnatural," said Ruzhe, in a voice as frighteningly deep as I had ever heard from her. Her sculptured face was impassive, but her eyes glittered like dark crystal. "Then you could no longer see him realistically."

I swallowed hard; I could not excuse my weakness, but I had to try to explain. "I told you how lonely I was, and it seemed like a gift from the gods, that we could give each other so much ... in eight years, we did everything two men could do together."

She took my hand firmly in hers and, turning it, rubbed the back forcefully down the side of her neck several times. I couldn't imagine why that comment made her want to mark me with her scent, but the gesture comforted me.

"I knew it was wrong to want him so, and at first I thought he also would feel that way. But my episodic fits of remorse only seemed to make it more exciting for him. Once my barriers were down, I could not get enough of him, and he was always ready for me, never had my doubts. I thought he loved me past all thought of shame."

I watched Ruzhe stiffen as I spoke. Her smile, normally so gentle, broadened into wantonness, and finally a curl of cruelty pulled at the very ends, turning it into a carven grimace of hate.

My gut turned nervously, as I saw how fierce and hot her anger was. She had not yet turned her fury against me, and I hoped her loyalty would stand the strain.

I bowed my head slightly and said, "Ruzhe, I loved Darez. Whatever his motives for seducing me were, I was too weak to

resist. I had never felt such heat and need with my other partners. I told him once that he made me feel like an animal, with my need for him. He just grinned and laughed."

"Laughed like the hyena he is, no doubt!" she hissed as her claws curved out in furious reflex. "It was not enough for him to make you think you were perverted," she growled in condemnation. "He had to make you suffer like that, had to torture you in order to control you."

She shook her head, to clear it, and snarled, "Varek, animals aren't evil." Impatient to make me understand her point, she leaned forward in her bed and took my huge, splay-fingered hands between her tiny ones. Her extra claw tendons made her grip nearly as strong as mine.

Unsure of her meaning, I indicated for her to go on.

"I was wrong to call Darez a hyena; even the hyena has the excuse of scavenging. Only mankind can be evil," she continued. "Only mankind can do wrong."

"Jatur said something similar, about how Mrumma didn't have any idea of rape, or incest, or ... homosexual relations until they came into contact with human races. Are you saying that the human races are evil, while Mrumma can only be good?"

She forced herself to look directly into my face, to make plain her earnestness. "I didn't say humans, Varek; I said mankind: that includes Mrumma. We may not have had a word for rape, but we have many words for lies, violence, hatred, treachery, and murder. And we have men such as Darez, though I think our society deals with them much differently than yours does.

"I don't mean that our race is better or worse than yours. Humans and Mrumma have more things in common than we do in difference, including a capacity for evil. But we are different in our view of our animal natures. You pretend yours doesn't exist, or treat it with disgust. We don't have that luxury; cuoia makes us come to terms with it. It's part of being Mrumma."

"But I know what Darez and I did was wrong, Ruzhe, especially in the eyes of a Mrumma. My hope is that you don't despise me; that part of my life is over. If you wish, I will swear by the Great Lion that those feelings are gone forever."

I had thought she would be touched by my vow, that my renunciation would make her happy. Instead, shocked and furious, she screamed, "No! No!"

Her ears pulled back, and the curve of her suddenly extended claws pricked my palms. I couldn't help myself; I dropped her hands and jumped back in the face of her unexpected ferocity.

"Don't you see," she hissed, "what Darez did to you was wrong! Horribly wrong!"

I was bewildered. Her words made no sense to me. "What Darez did to me? But, Ruzhe, I can't deny that I wanted him. I was just as guilty."

She bared her teeth, frustrated with me, threw back the covers, and began to pace back and forth, splendid in her nakedness, the stump of her tail whipping back and forth as she stalked the room.

She growled, half to herself, as if I had not even spoken. "It was the greatest wrong he could do to you, Varek; I thought you knew that. If you don't know it, how can you want me? Gods! I was so certain you understood me, understood what it is to be a Mrumma. Was I mistaken?"

It was the first time I had seen her full body in two weeks, and it was all I could do to hold myself back from her. Her breasts were small but firm, with upturned, blood red nipples that were echoed by the line of false teats that burned against her tan skin.

Her hips had thickened slightly, but still retained a slender, boyish cast. Glossy chestnut fur lined her shoulders and back, and covered her mound thickly. Her violent emotions made her musk glands erupt, and her scent overpowered me.

I wanted to groom the fur ridge on her spine from nape to tail with my tongue, calming her until she arched her back. Then I would set my teeth gently in the back of her neck, and thrust

myself slowly into her from behind as she settled her haunches under me. My cock stiffened instantly.

I would swear she could not have seen or heard anything, and yet her eyes turned to me the moment I became erect. "You do know it, your body knows it. Scent can't lie."

She came over to me and raised her paw to my chest. With one swipe of her claws, she ripped my clothing completely down the center, neatly avoiding tearing my skin. She tore it from me until I stood as naked as she was.

I was burning, and with sudden clarity I knew she was too. I had never felt someone else's need so clearly; I breathed her, I bled her, I sweated her. I wanted her, and I had her, somehow, even with no physical contact. I did not think I could control myself; my penis bounced in little jerks as my heart seemed to swell and burst.

Then I met the pure, unblinking, relentless Mrumman stare, and I knew the unspoken reason why Mrumma seldom meet each other's eyes. Her pupils were almost round in their blazing green irises, and she held me closer with her eyes than any man or woman ever had. I felt a release that was more complete than an ejaculation, a terrible joy that made my whole body dissolve.

At that moment, it was enough to know that we truly wanted each other. The ceremony was just that: a ritual to demonstrate what we already knew.

Filled with wonder, I raised my hand to stroke the curve of her jaw. Her fur was sleek with droplets of musk.

"What did I say, Ruzhe? Why were you so angry?"

Her smile was sweet and vulnerable. "I thought you were renouncing what you felt for me, cuon'do, and I could not bear it."

"I was renouncing what I felt with Darez, not with you."

Then I saw what she meant, and how close I had come to losing her.

Shaken by my glimpse of my narrow escape from disaster, my knees turned to water, and I sat heavily on the window seat. "You thought it was the same thing."

"It is."

"But ... Jatur all but spat at me in disgust, when he talked about human 'proclivities.'"

She curled up at my feet and crossed her front paws on my knee, looking up at me with compassion. "Jatur did not know you then, only the rumors of you. Mrumma who know you know the truth of your feelings. Granted, they'll never understand how you could have been fooled into picking such a person; how his scent must stink!" She wrinkled and shook her muzzle in vigorous pantomime, and I found myself laughing.

"But they would never condemn you as they would your half-brother. Darez tried to take your animal nature from you. That is the worst crime Mrumma can imagine; it would destroy us."

"It nearly destroyed me, but you found me in time."

I combed her hair with my fingers and she nestled her chin over her folded hands. We sat in quiet companionship as the sun rose and her eyes narrowed to thin slits, then drooped in tiredness. I saw her glow in the daylight as she dozed, her mane molten copper in the sun. It was my first clear look at her with Mrumman eyes, and I wondered that I could have said I loved her without really seeing her as she was. My heart had known from the start, but only now did my mind love her, fully and completely.

I wanted us both to be rested and ready that evening, so I lifted her carefully and put her to bed. She opened a sleepy eye and yawned, showing her fangs as I rose.

Curling up, she murmured drowsily, "Varek?"

"Rest, Ruzhe. I'll see you tonight."

Her wide smile was a delicious promise. The only response I could possibly make to that look was to roar like a tiger, and startled faces peered out of doorways as I bounded down the hall.

▼▼▼

I waited in a small antechamber to the ceremonial hall, trembling with anticipation as I dressed for the bonding ceremony. I just

wanted the ritual to be over so I could carry Ruzhe off to the mating chambers. Kattor was unusually nervous, and with him that took the form of last-minute lectures.

"My lord, remember what Karng taught you about moving slowly enough so as not to be threatening, but forcefully enough so that you look confident."

"I will, Kattor. We practiced it this morning before I went to bed."

He fussed with the clothes on the bed he had already straightened and brushed a dozen times: supple pewter-colored leather boots, and a floor-length cape of jamaline skins, glossy blue-black fur from the smallest and most vicious of the great cats. The cape was Jatur's gift for the ceremony, and was worth nearly as much as a small nobleman's palace. The fur rippled and shone; I thought of Ruzhe's brown suppleness enfolded within it, with me, and my heart beat faster.

"Where is the vial of scent? Do you have it, my lord?"

"I don't need it, Kattor," I said patiently, trying to fold my loincloth without folding my genitals with it. "I can tell Ruzhe apart from other Mrumma easily enough."

"Even within her own family?" came Karng's high warble from the door. He looked worried, as his uneasy hands fidgeted with a dark blue pouch tucked into his belt.

"I thought you said they wouldn't—"

"I know what I said," he snapped. "And if it was up to Jatur, you'd be comparing abba pardriou with black tiger and jamaline, a test you could pass while pinching your nose closed. But it's out of Jatur's hands now, though he fought for you claw and fang; his ruling council has issued a formal challenge to the mating."

My body went cold. "Does that mean they won't allow the ceremony and mating ritual, then?"

All I could think was that they were going to separate me somehow from Ruzhe, permanently, and I fought vainly against waves of panic.

"Oh, they'll allow it, all right." Karng said sourly. "They can't stop that part now, even if they wanted to."

I realized that I had been clenching my fists only as they began to relax. "That's all right then. I'll just take the vial." I walked over to the wardrobe, glad to have a physical movement to loosen my tight muscles.

"Master?"

I knew that sound in Kattor's voice. The last time I had heard it, I was being outlawed from my native land.

"There's more to it, isn't there?" I said heavily.

My advisors—my friends—exchanged nervous glances.

"Go on."

Karng spoke with his usual bluntness. "I didn't tell you any of this before, because it hasn't been done in hundreds of years. A formal challenge means the ceremony must take place under the most stringent conditions. The trial of scent may involve any of seven of Jatur's sisters, and you can't have any help with it."

I tried to assume a lightheartedness that felt grotesque. "Then I'll just have to be very certain before I choose, won't I?"

The Aemael bit his lip and looked at his feet, then up at me. "I'm afraid it's even worse than that, Duke Varek."

"What could be worse than instant death, Karng?" I asked with polite sarcasm.

"Well, for one thing, there will have to be witnesses to your mating."

I gaped at him. "Witnesses? I thought cuoia was always a private matter. Mrumma are certainly shy enough about it."

Karng shrugged. "It's a special rule for human-Mrumman matings. They have to verify that the mating actually occurs, because once it does, you become a Mrumma. From then on, they expect Mrumman behavior from you, and judge you by Mrumman standards. But they'll also defend you as a Mrumma, against all human laws and judgments. Your life as a Mrumma begins the moment you complete mating."

Kattor added, in his level tones, "Normally they waive this rule, my lord, because it's embarrassing to all parties. But a formal challenge would change that."

I sighed. "Embarrassing is far too mild a term. Does Ruzhe know about this?"

"I just left her, Duke." Despite his worry and anger, Karng had to grin at the memory. "She exercised her entire vocal range for a good five minutes, and shredded a few dozen pillows just for practice. You don't need to worry about Ruzhe, though. Once you start the mating ritual, she won't know anyone is there except you. Instinct can sometimes be a blessing."

"Who's going to be in this audience? And what will satisfy them that our mating is complete? Do I have to produce sperm on demand?"

The Aemael looked evasively at the window, his face a muddy orange in the sunset. "Well, you'll be observed by the Council, and other ... interested parties. The way word spreads, half of Mirvun will probably be there. And in a literal sense, they'll only be satisfied with blood."

My jaw dropped. Had he said what I thought he said? "Blood?"

"I brought what you're going to need." He pulled the bag from his waist and dumped the contents into my hand.

Though they were designed for smaller hands, the gloves were made of a stretchy mesh. At each fingertip, a short, silver claw curved through. I tested for sharpness on a curtain, and shuddered when the thick material parted like butter.

The real nightmare, though, was the other item. The basic material was some kind of intestine, shaped into a long sheath. Cunningly worked into it were dozens of tiny prickly hooks, made of horn, facing to the outside. I rubbed my hand toward the open end, and it felt simply bumpy. But when I brought my fingers back down, some of the hooks caught and tore my skin, and a drop of blood welled up in the second joint of my middle finger.

My heart sank. I could not hurt Ruzhe that way. This had to be some kind of awful practical joke.

But Karng shook his head mutely to my silent appeal, and Kattor turned ashen white and ran out into the hallway, retching. I wished I could do the same, as I stared at my teacher in horror.

"You may want a few minutes of practice with the gloves before the ceremony; practice on me, if it would make you feel better. I'll give you what pointers I know. They're meant only for protection; wear them anyhow, because if you do need them during mating, you'll be in deep trouble."

"What about this?" I shook the sheath in front of his face. "What is this, this abomination? Why didn't you tell me? In Naa's name, I'm tempted to practice with this on you instead of the gloves!"

He blanched, but his voice was tightly calm as he replied, "It's called an eollon, Duke, made from the bladder and horn of a sheep. It simulates the outside of the Mrumman penis. Before you pass judgment further, consider: to a Mrumma this is completely normal. Human men have to wear it with Mrumma only when they want to induce fertility."

Ruzhe had told me that Mrumma were physically related to cats, but I had been too naive to make one logical connection.

Male cats had barbed penises, to embed themselves firmly in their partners. It made an ugly sense that, if Mrumma were truly the result of a cosmic joke by the gods, the human would parallel the feline in this intimate a detail.

Karng almost burst into tears, his tiny face pinkened with anguish. "Duke, I never dreamed the Council would make you would go through any of this your first time, and if I've failed you, I deserve whatever punishment you see fit. I didn't tell you about the eollon because I knew it would scare you. By Naa and Bolg, it frightened me when I first saw it, and I'd been with my cuon'da five years! But you have to wear it this time. It's the only thing that will satisfy the challenge."

Awkwardly, I squeezed his shoulder. "You did what you thought was best, Karng. If I have to jump through their hoops to prove I'm worthy of Ruzhe, then I will. But when I get my hands on the stubborn, stiff-necked Council Mrumma who are putting us through this, I'll make sure to wear these thrice-dammed gloves!"

"Do not blame the Council, my lord. I know who made the challenge," whispered a weak voice behind me.

I whirled to face Kattor, leaning heavily in the doorway. He looked ghastly, as if he suddenly had aged years. He pointed a dry, shaking finger outside. "I wanted to clear my head, so I walked out to the main hallway. He was just entering; I don't think he saw me. I shouldn't have run back..."

He started to faint. Karng reacted more quickly, and staggered under my servant's weight as I stood there, feeling paralyzed by the implication of Kattor's words.

Karng helped Kattor to the bed, and I snatched up the cape so he could lie down comfortably. "I'll get a doctor," I said, throwing the heavy fur around my shoulders.

He shook his head. "I'll go. Finish dressing. It's almost time."

I thought I had been angry at Darez before, but now I was filled with fury. I had played his game in Kalissanne, and he had won. Yet he could not let me be, but must continue the game in Mirvun. He had brought trouble to Kattor, who loathed and feared him. He had used the Council somehow to force Jatur to formalize the ceremony. And he had put both Ruzhe and myself on public display, intensifying the ever-present danger of Mrum-man mating.

Without hesitation I tied the drawstrings of the bag around my neck. He had played the game a little too long, and a little too far. Now it was my turn to move.

I laced up the boots to the top of my calves. As I was tying the laces above my left calf, Karng returned with one of the doctors. The plump Aemael came over to me as the physician looked at my

ailing servant. We watched silently for a moment, relieved when Kattor was able to sit up to drink some wine.

"Looks like his color is coming back," I said, my voice uneven with strain.

"What little color he has, you mean."

"Even so." I couldn't laugh, but the tension eased a little. "You know, Karng, that old man tried to give his life to get me out of Kalissanne safely, and I wouldn't let him do it then."

He smiled grimly, as his sharp eyes noticed my neckpiece. "And it won't happen now either. I'll wait with him, until you return."

"Thank you for your help, Karng." I started into the hallway.

"Don't let it go to waste," he called after me. "Good hunting, Varek."

▼▼▼

I strode alone into the cavernous ceremonial hall, hearing many gasps as I entered. No doubt those in the audience who had not yet seen me were commenting on my height. Many of the faces were unfamiliar to me as well, and few looked overly friendly. Ruzhe, Jatur, and some others in their family might consider me all-but-Mrumma. To most of the Mrumma of Mirvun, I was still an outsider, and must prove myself here.

The hall, carved into the mountainside with the initial start of a natural crevice, stretched upward into shadows. I breathed deeply. After weeks cramped in rooms scaled more to Mrumman size, here was a space more suited to my dimensions. I felt suddenly confident, and deliberately stopped to survey the room.

It was shaped like a narrow bowl, with the arena I would mate in as the base and the galleries of observers steeply curving up the sides. I had come in one of the two bowl entrances; Ruzhe, along with her sisters, would be brought in the opposite one after I was blindfolded. The entrances to the galleries were at right angles to the ones for the arena, and I saw that late-comers were still pushing along, eager to view this most unusual spectacle.

The circular floor was mostly unpolished hardwood, inlaid with a four-armed spiral of red marble whose arms ended in stylized paws. I estimated its diameter to be twelve or thirteen of my strides, which would be around fifty feet in Mrumman terms.

The walls around me stood as tall as I was, covered in a dark soft wood. I could see the scoring from countless claws, some marks nearly reaching my shoulder height.

Jatur waited by himself in the center of the spiral. He was wearing the mulzha, the great cape that marked him as rhonne in Mirvun. The lion's mane and skin flowed around him, puffed up and out by a shoulder yoke made of thick padding and woven reeds. A rhonne could obtain a mulzha only by killing a lion with fang and claw, nothing else.

As I stalked up to Jatur, he nodded stiffly to me, but said nothing. His eyes were fixed on a spot above and directly behind me, wide and unblinking in their stare. No Mrumma would stare so insolently unless provoked beyond endurance; Jatur was as angry as I was. I turned slowly and followed his gaze upward.

In the first row, above the entrance I had used, my brother smiled sweetly and blew me a kiss.

Deliberately, I straightened to my full height, clasped my hands behind my back, and added my blank stare to Jatur's.

His height made him conspicuous among the much shorter Mrumma, but I would have known his whipcord body even in a crowd of Kalis. He wore unrelieved black, as if he intended soon to attend a funeral...

Mine?

Perhaps, and perhaps not.

My dear brother was sitting with some of the Council members, obviously those he had somehow influenced to interfere in my mating. Though Darez might be unaware of the meaning implicit in Jatur's gaze, the Mrumma knew better, and shifted uncomfortably under the pressure.

Then every bell in every tower of Molinne rang in unison, the signal that a mating ritual was starting. The last arrivals scurried for their seats.

My hatred for Darez and my love for Ruzhe ran as one through my blood. My eyes never left Darez as I reached into the bag and brought out the gloves. His triumphant smirk faded a little as I pulled them on, the right one firmly, the left one more delicately so that I didn't pierce myself. The mesh stretched to its limits, but it fit. I flexed my fingers, feeling my new claws.

Jatur, startled by my movements, glanced over at me. He bared his fangs in a malicious smile when he saw what I wore. "Karng thought to give you Ayon's bag," he said joyously. Until then I had assumed Karng had given me his own bag, but instinctively I knew Jatur was right.

"As rhonne, I keep bags whose owners have died or forfeited them. The Council wouldn't allow me to give one of them to you. Karng would have had to break into my chambers to get it. I could have his hands cut off for stealing." The words sounded harsh, but he was almost laughing. "But he's saved you, and so I will be merciful. I will try to drown him in gold, instead."

I realized my impulsive gesture of defiance had one unexpected drawback. "Rhonne Jatur—how do I put on the eollon while wearing these gloves?"

This was too much even for normally sober Jatur. His body was shaking with suppressed laughter. "A Mrumma would know to don the eollon first. But since you are not yet a Mrumma, Duke Varek, you may have my help." He threw back his head and howled with bright Mrumman mirth. He was still howling when the bells ceased, and the whole room fell silent.

"Who dares to claim he is now a Mrumma?" boomed a loud voice from somewhere behind me.

Jatur sobered and motioned for me to stand still. I did, lifting my chin proudly as he spoke.

"Duke Varek of Kalissanne shall prove his claim through the ancient rituals of cuoia," he answered, bringing a blindfold from under the shoulders of his mulzha and walking behind me.

I saw Darez frown as the rhonne gave my former title, but having forced this, he could not interrupt the ritual now. Then the soft, thick cotton covered my eyes.

First my hearing sharpened. I could hear the skittering of several pairs of clawed feet moving into place on the other side of the arena.

Then smells came into place, as the fainter scents of hundreds of Mrumma in the galleries swirled around me. Jatur's pungent musk moved back, and another pair of claws clicked toward me, a heavy, milky scent I did not recognize.

The voice was young and gentle, the speaker unknown to me. "I will lead you to each woman. You may sniff as long as you wish, and compare as often as you need to. However, you must not touch any of them until you wish you indicate your decision. If the Mrumma is not your intended cuon'da, she will slit your throat with her claws immediately. Do you understand?"

My mouth was dry, and I merely nodded.

I was led forward to the first woman. Karng had said that the test might be done using Jatur's sisters, so I expected the scents would all be the family scent of red leopard, with the subtle individual differences harder to discern. So my nose was almost stung by black panther, and I shook my head angrily.

"Don't insult me," I said in a loud but level voice. "This is not even a challenge. Take this one away now."

There was a sudden flurry of scratching as she ran to the other entrance, and I heard a few yelps of sympathetic laughter in front of me as I was led onward.

The second woman was leopard, but it was black leopard. "Anyone who cannot tell leopards apart doesn't deserve to be a Mrumma. Send this one away too."

Another flurry of claws, and warmer laughter from more throats.

So far, this had been easy.

The third woman was abba pardriou, and I was certain she was one of Jatur's sisters, but one I had not met before. The hint of orange was all it took. I didn't bother to send her out, but simply asked to move on to the fourth one.

She was more difficult. Ruzhe had two sisters close to her own age, though both had been in cuoia for some years, and I had had trouble before telling them apart. I made no indication one way or the other.

The fifth one smelled exactly the same as the fourth one, and now I began to panic. They had to be two different people—the test was required to be fair in that respect. But my nose couldn't tell the difference. What if I couldn't?

My heart was pounding as my silent guide led me to the sixth woman. I had heard of a nose being overloaded with scent to the point where it stopped discriminating. What if that happened now? Which one was Ruzhe?

We stopped in front of the sixth woman, and I reached out and touched her the instant I sniffed her. My head, my heart, my body all knew at once that Ruzhe was before me. Her scent, lily and smoke with a faint bite of iron, seemed to fill my head to the exclusion of all else.

Up and to my left, someone began applauding, and others followed, paying tribute to my unquestioned recognition of my cuon'da. Faintly, I heard the others walking to the exits.

I pulled the blindfold off myself, not waiting for Jatur to do so. Ruzhe's smile was blinding as she touched my hand lightly with a claw in acknowledgment, then drew back to the other entrance, where a guard was locking the iron gate behind the departing women. She stood naked, impatient to begin the ritual that would bind us together forever.

Jatur took my cape and untied the loincloth, then took the eollon from the bag at my neck. Retracting his claws, he pulled the sheath easily over my cock, which had gone from nervously soft to eagerly hard the moment I caught Ruzhe's scent.

"Good hunting," he said before he moved to the entrance I had come in. I heard the gate clang shut.

Now Ruzhe and I were locked in together. I knew we had an audience, of course. I even remembered that Darez was here, waiting eagerly for me to make a mistake. But those thoughts faded, as I looked at Ruzhe.

She began to wash teasingly, her left hand rubbing over her temple and ear to the back of her neck, and I copied her movement with my right hand, turning my head away from her as I did so. My ear caught the sound of her leap, and I backed up several feet.

She halted, a few feet away from my original position near the center of the spiral, and then resumed washing. She looked at me slyly.

I ran forward quickly, an exploratory run to see how quickly she could move. She darted to the left some three strides, and washed some more, watching me more intently now.

I stood, stretching, and yawned widely while watching her through nearly closed eyes. My height made this easy, and she must have thought I had actually closed my eyes, because she pounced.

Even though I was ready, she moved so fast that I almost didn't jump out of the way in time. Her teeth snapped in a playful bite inches from my hip. I gave her a hurt look and stalked off to the other side of the arena.

Again she washed, a flirting gesture raised in intensity when she began to groom her arms in earnest. I moved slowly toward her, head held a little sideways, sniffing and waiting. If she broke, I would have to begin again.

She lifted her head and gave a pure yowl of delight as I came warily close and drew my tongue gently along the side of her

neck. Her scent made me dizzy, and I forgot myself and rushed to claim her.

She cuffed me on the side of the head with a cocked paw, keeping her claws sheathed. I had approached too quickly.

Contrite, I sidled away, licking the back of my paw and sneaking glances at her. She was watching me also, green eyes round and unblinking as she slicked her reddish hair back with her right paw.

We began over again, circling and glancing, washing and playing. This time I waited longer before I approached, until she had twisted her neck to groom almost up to her shoulder. Only then did I spring in earnest.

Her reaction was slow enough so that I was able to set my teeth in the back of her neck before she turned. She fought wildly for a minute, and I grabbed one wrist with each hand for balance. My hands were still much bigger than her wrists, and so the claws were safely away from her skin as she struggled.

Then she went limp, and I knew she was mine.

She fell on all fours, pulling me down with her. I could feel her tail lashing back and forth, tickling my stomach, as I shifted to mount her.

Even through the eollon I could feel her cunt. Oval-shaped, it held me tightly in the sides and very loosely on top and bottom. It pulled at me as I entered it, grabbing and tugging at my cock.

It had been so long since I had had sex, and she felt so hot, that I knew I would not last, but I was still conscious that I would need several penetrations to draw blood. I concentrated on thrusting very hard, and was rewarded with a series of incredible yowls from Ruzhe.

Worried, I stopped thrusting for a moment, murmuring, "Ruzhe?"

She looked back over her shoulder at me, and her eyes were dazed. She gave an interrogative "Mrow?"

"Am I hurting you? Do I continue?"

She did not answer in words, but pushed her hips back voraciously and let out another piercing yowl. I took that as assent, and rammed my cock into her again. Then I came in a hot explosion, screaming my throat raw as I felt myself bursting into her. We howled together for a moment, and then there was dead silence in the hall.

As I pulled out, still hard, I could see where the base of the eollon was smeared with blood. Jatur stripped it from me and held it aloft as thunderous cheering erupted from the entire audience. Except for one. I very much doubted that Darez was cheering.

I knelt next to Ruzhe, and we groomed for a minute. Her sweat tasted sweet. She nuzzled my hand, murmuring, "Cuon'do."

I helped her to her feet, both of us a little wobbly. The sight of her lean body made my cock stiffen slightly. Now that the ceremony was over, I hoped we would be left alone for a while. I wanted to take her again, and again, and again, making love both as animals and as humans. I still had so much to learn about being a Mrumma.

Her nostrils caught it first, and I saw her stiffen, all her hairs rising. Then I smelled it, whatever it was, and it stank like a garbage pit of carcasses.

Darez was approaching us. His skin was paler than I remembered, and his hair had matted with sweat in the heat. But the eyes were the same coal black, calculating constantly, intent on his endless game of torment.

"I couldn't miss your wedding," he said, smiling as if we were still friends, still lovers, as if he could still fool me. "I wanted you to know that I bear you no ill will, brother."

There was nothing I could say to that, and he continued. "May I be the first to kiss the bride?"

He reached out his hand toward her.

Eight long streaks of red appeared on his face and continued down over his body. Only when Ruzhe's other paw tore his throat open did I realize that one set of claws had been mine.

Yet he registered only annoyance, not pain, as he began to reach out toward Ruzhe again, this time in rage at what he assumed were surface gouges. The cuts were so sharp that it was not until his body crumpled to the floor with his first step that he realized his error. As he lay dying, I leaned over to whisper something in his ear; his initially disbelieving glare turned to anger, and then faded as the blood left him.

Jatur smirked in satisfaction as he walked over, deliberately scratched imaginary dirt with a back paw over the pile of offal in front of us, and left without a word to either of us. The other Mrumman nobles followed his lead in eloquent pantomime, scratching and leaving silently.

Ruzhe licked her paw clean of his blood, stepped over him without a second glance, and made her ritual gesture a sketch of fastidious distaste.

I was finally free of him.

She asked me as we left the hall, "What did you say to him?"

"'You wanted blood, Darez. Now that you have it, how do you like it?'"

Her grin was as swift and certain as her claws had just been. "So show me what a Mrumma does next," she purred.

Her green eyes twinkled as I began to chase her playfully down the corridor.

Reina Delacroix is the pen name of a shy, quiet librarian. She lives in northern Virginia with her cats, George and Shen T'ien, and her precious Pet Michael, who inspired this story about finding one's true passion, people, and homeland. Her work appears in several other Circlet Press volumes, including SexMagick: Women Conjuring Erotic Fantasy *and* S/M Pasts.

FORGED BONDS
Erotic Tales of High Fantasy

edited by
Cecilia Tan

Introduction

This book is the second in a series of anthologies that explore the combination of erotica and science fiction/fantasy. Most of the books in the series were planned from the start to have a certain topic, such as feline fetishes or magic and sex.

But this is a volume that took on a life of its own from the moment it was conceived. It was conceived by chance, when two manuscripts came in over the transom and seemed to fit together so perfectly I knew they had to be in a book together.

What is it these stories have in common? All of them, obviously, are in the genre of high fantasy. All of them are portions of longer works, either novels or novellas. And all of them take a close look at the master-slave dynamic known so well to practitioners of bondage and domination and/or SM.

Elves held captive and mistreated are nothing new in the genre of high fantasy, but these fantasy authors delve into the positive and erotic aspects of submission, of the need to be loved, the deep-seated submissive need to please, and, on the other hand, the responsibility of dominance, of being one's caretaker and keeper, and the tenderness that must be doled out with the same hand that punishes. These mature and complex emotions go beyond the mere "captured" fantasy that inspires them, to an interaction between master and slave, a unique bond that becomes a lifetime commitment.

And so, welcome to these worlds, where desire sets the stage for one person to own another's soul, where passion allows for the most complete surrender.

<div align="right">
Cecilia Tan
Boston, MA
</div>

Slaver's Luck

Tanith Tyrr

I.

The streets stank, and the cobblestones were cold under his thin-worn boots, but the young Elf hardly noticed, intent on the woman he followed. He was gaunt and spare, even for an Elvatuar, and his cloak was torn. And yet, for all his poor attire, he wore a heavy torque of gold at his throat. Its soft, rich gleam was hidden beneath a patched and ragged tunic.

His delicate features, upswept ears, and pale, wine-colored hair marked him as an alien to the Human city. He walked as if he too were merely a pleasure seeker in the wharf taverns, casual, even insolent. The woman did not notice him. Once, she stopped in one of the dim, smoky halls to trade some of her coin for a stoppered crystal flask. She walked on, sipping clear violet wine.

Aeryk shivered, drawing the cloak tightly around his slim frame. His profession was not one generally approved on the wharves of Reshor, and he was not eager to meet its guardsmen again. He still bore bruises from the time he was last caught. The captain, a tough-looking 'Morph breed woman called Khesti, had beaten him and laughed all the while. After the beating, she had tossed him into the dirty waters of the bay. Her claws had left deep, scarlet weals in his pale skin.

The slender Elf shuddered again, not only from the cold, and concentrated on remaining unobtrusive. He continued to watch the woman. She was dressed in rich scarlet and brown silks, with the short leather tunics of a fighting woman tight over the swell of her breasts. What he could see of her body seemed fit with taut

muscle. *She might not be such a good target,* he thought. *Still, the weight of that purse she's carrying...* Aeryk had been hungry for a long time, and one good haul from a rich merchant, or a rich merchant's wife, would take care of him for quite a while.

Nervous with anticipation, he fingered the heavy gold torque he still wore, stolen a week ago from the collection of a man who had probably not yet noticed its disappearance. *Maybe I should just try to fence this,* he thought. *Even at Nattic's prices, it should bring me enough to eat, until I can find a more likely victim.* He sighed, recalling the old man's extortionate offers.

"Ye won't be able to sell such as that anywhere else, Prick-Ears," he'd mocked. "Five silver is the best I can do for ye." Aeryk had known that the torque was worth easily ten times that in metal value alone, and the artistry of its make was unmistakable. So he had left the shop coinless, the torque still around his throat.

That had been two days ago. Since then, he had eaten only what he had managed to scrounge from the wharves, or beg. *If I pull this one off,* Aeryk vowed to himself, *I'm going to eat for a week.*

The fog crept in to twine intimately around his thinly clad legs, and he shivered and cursed quietly. *A new set of clothes would also not be amiss,* he thought. Resolute, he picked up his half-numbed feet to follow the woman, kicking away the fog that had settled around them. Offended, the thin gray tendrils dissolved into the surrounding air.

The woman stopped in front of one of the wharfside taverns and read the legend on its sign. Satisfied, she took a last swig from the flask at her belt and pushed her way in through the double doors.

Aeryk glanced at the sign, which boasted that the Silken Bridle had the best selection on the wharves. *What an odd name for an inn,* he thought. *Still, it should do.* He followed her into the light and noise of the tavern.

The place was warm and well lit by a blazing fire in the corner. Shivering and grateful, the young Elf moved nearer to the stone hearth.

The woman moved with a fluid grace through the room, her precise, controlled walk hinting at the skills of a dancer or a warrior. Other patrons scuttled aside to let her pass, and she claimed a table at the far end of the room. The press of bodies made it difficult for Aeryk to follow her, so he contented himself with soaking up the welcome warmth of the crackling flames and looking about the tavern.

It struck him that the tavern was occupied by 'Morphs of various breeds as well as Humans. He was not surprised to see that none of the 'Morphs, full- or part-breed, were serving tables. Since the 'Morph wars had ended seven years ago, few or none of the genetically altered animal-human crosses served in menial positions anywhere, if they could possibly help it.

Freed from slavery by their savage and hard-fought victory over the powerful Guild mages who had created them, few of them were eager to take up work that reminded them of their former lives. The only 'Morph slaves now were those legally captured and judicially enslaved. The single exception to this rule were the First Breed, who were still considered to be legal property. Humans made up most of the slave stock now, with occasional Elvatuar or other nonhumans sold or kept to serve in a tavern as exotics. But the majority of the Humans in this bar were fairly well dressed, in obvious contrast to his worn and tattered clothing.

I'm going to be conspicuous, he thought. *Unless...* He looked around with forced casualness. A fair number of the tavern's workers were male, as was made quite obvious by the brief cloths they wore. All of them had distinctive necklaces, almost like his torque, but of a solid metal that closely encircled the neck. If he turned the half-circle of the torque around and removed his shirt, he might be able to pass for a worker. It made some sense, he

supposed, for the table servers to wear little clothing, as it did get quite warm in the enclosed tavern. He slipped into the privy area.

He presented himself to her at the table, deferentially, as he had seen several other men do. "Shall I bring you wine, or something else?" She appraised him with a keen eye. He blushed, realizing how much the disguise revealed his body.

She let her grin grow. "Something else, I think. What's your name?" Her eyes traveled down his lithe form, appreciating the view.

He thought for a moment, struggling to come up with an appropriate reply. "Aeramar. And who do I have the honor of serving?"

"Jenna Blackwolf, of the Lykos Slavers' Guild." Her stare was piercing. "You didn't come through the Guild, did you? I know that I would have noticed you."

O my ancestors, he thought. *She assumes I'm a slave. That must mean all the men here are slaves.* He swallowed once, frightened. It was too late to back out of this job now. "Ah, no, I was a recent capture. I, uh, haven't even been branded yet."

Jenna regarded him with interest. "Nor pierced." He spared a quick glance at the serving slaves, and saw that each had a single, thin hoop dangling from one ear. His hand went to his own ear before he could stop it. "You must indeed be new."

She looked at him with an appraising, predatory stare. He had to fight to keep from feeling like a hunted, helpless animal under her gaze, and wondered if she had 'Morph blood. Probably wolf genes, if her clan name and her body were any indication.

There was a distinct suggestion of something savage about her face, with its high, slanting cheekbones and deep-set green eyes. Unlike most 'Morph quarter- and half-breeds, there was no hint of an extended muzzle, or fur on the sides of her face. She was beautiful rather than pretty, with an odd charisma that was apparent in the way she held herself. When she spoke, even softly, it was obvious that she was accustomed to being obeyed. *She's high in the*

Guild, Aeryk guessed. *O Mothers, what have I gotten myself into?*

"Come with me," she said, and snapped her fingers, as if he were indeed no more than an animal. She rose from the table, jerking a decisive thumb at him. "I've rented a room upstairs." He stood at her command, elated. In private, he would find a better opportunity to get what he came for, although she looked as if she might prove formidable. Extremely formidable. Still, he would have the advantage of surprise.

The room was lush and decadent, with velvet hangings and mirrors of beaten metal. With soft fur silver-tipped and pale, the long skins of ice snakes lined the large bed. She turned on him at the door, abruptly, frightening him. "I gift well, when I am pleased. I also carry a slave quirt, for when I am not. I suggest you try hard to please me."

His heart was beating hard. *I may actually have to go through with this.* The thought was oddly arousing to him, although more than a little frightening.

Jenna was hardly unattractive to the young Elf. He had never seen a woman who exuded so much raw power and confidence, combined with an exotic beauty. He wondered what her hands would feel like on his body.

The woman shut the heavy door behind them. The finality of the door's grate and slam made him squirm, feeling trapped. She yawned, tossing her belt with its pouches onto the soft bed. "I'm going to bathe before I have you, pretty Elf." She pointed sharply to the floor, and her voice became a whip's crack. "Kneel there on the furs until I return." She turned and walked into the bathing alcove, not stopping to see if he had obeyed.

He waited until he heard the sound of running water, then counted twenty breaths. Swiftly, he scooped up her pouches and jeweled dagger, and whipped off the golden torque with which he had, he now knew, masqueraded as a collared slave. Pausing only a moment more to untie his shirt from his waist and put it on, he hurried out of the room.

II.

"What in Dhanu's name do you mean I don't get my gold back?" Jenna bellowed, her hand twitching on the hilt of her sword. "I tell you, one of your slaves stole my good charmed dagger and most of my coin as well!"

The older, balding man flinched. "I assure you, he was not one of ours, or he couldn't have gotten out of the place. We're very careful about keeping nonhumans, since the Wars ended. We thought he came in with you." He flinched again as she moved toward him, her hand still on her blade. "You can't just kill me!" he quavered. "I'll call the guards!"

Her eyes were cold and steely. "You do that." She spoke with contempt. "I'm going to visit a wizard." She walked out.

III.

The thing moved about unhappily in its cage. When its captor had done speaking to the other, hideous, blobby creature, it hoped it would be fed. It had been too long. The susurrations of the other's voice were melodious and not unpleasant, almost reminiscent of the mating songs of what would have passed for insects on its own world. Twining its tendrils sadly, it listened, and thought of home.

"You're sure this will work, wizard?" Jenna was wary. "This is costing me dear. I swear I'll come back and hang your guts on a tree if it doesn't."

Vasht laughed, half sunk into a chair so soft that it was obscene. It was not a pleasant or attractive laugh, and it made the ugly rolls of fat on his belly shake. "No need for threats, little cub. It will work."

Jenna snarled under her breath. "Don't call me that, wizard. Don't ever call me that." Again, the man laughed.

"As you wish." He attempted a courtly bow, mocking. "Farewell, then, my lady Wolf." She glared at him, and turned to go.

On her way out she noticed the cage and the writhing, alien mass within. Jenna barely suppressed a shudder. "Damn wizard's pets," she muttered to herself as she left the citadel.

IV.

The door exploded inward, and Jenna hurled herself into the small room. Startled, Aeryk cried out as she thrust sharp steel against his throat, pulling his head back. Her fist clenched in his long, silver-pale hair, and he cried out in pain. "Little Elf," she snarled. "I think I'm going to enjoy this."

The razor-edged dagger traced a thin line down his throat. With a deft stroke, she slit his tunic down the front. His chest was lightly furred, outlining small, rose-colored nipples. She laid the cold steel against them, to watch them harden and rise. He cried out as she toyed with him. "A pretty one, aren't you. Did the Guild send you?"

He tongue darted out to moisten dry lips. "No. I'm not with the Thieves' Guild."

Jenna chuckled. "Then you're a wharf rat." She used the common term for the gangs of youths and orphans who slept beneath the wharves and lived by what they could scrounge or steal. Sometimes, they hired out for petty, criminal work beneath the dignity of the professional Thieves' Guild. "Seeing the way you're dressed, I thought that was the case. The Guild generally does better by its members."

She grinned, caressing his bare chest with the flat of the blade. "This time you picked the wrong place to nibble, little rat. Do you know how much I paid last night to use you?"

He shook his head, frightened. "Two gold. That's the standard price at the Bridle for a room and a slave." She held the dagger in front of his face. "Not to mention what you stole from me, and what I spent to get it back. You cost me a great deal, pretty Elf, and I'm going to take my satisfaction out of your hide."

As she spoke, she tossed the dagger upwards with an expert flick of her wrist, leaving it stuck quivering in the ceiling. She pinned his arms with one hand, and whipped a length of leather around them with the other. With a brutal push, she pinned him face down on the small bed. In an instant, leather encircled his ankles, fastening them. Dazed, he tried to get up. She held him down easily.

Aeryk felt leather brush his bare back. He struggled, trying to see. "Do you remember what I told you in the room?" The young Elf shook his head wildly. "I gift men well when I am pleased. And I carry a whip when I go to the taverns, for when I am not pleased." Again, he felt the rough hide stroking his back, and he shivered, knowing it for what it was. "I am most assuredly not pleased."

The Elf howled for mercy after the second stroke. She stopped, and regarded the smooth arch of his back, now marred by the rising welts. She could see blood beginning to break the surface in the deepest parts of the marks, turning them dark. He looked up at her. "Please, my lady, please no more! I'll never bother you again, I swear it!"

She reached down and fondled his head. "I'm sure you won't." Jenna thrust the remnants of his cut tunic into his mouth and tied it around his head. "We can't have the other patrons of the inn disturbed, now," she remarked, and resumed the beating. Helpless, his slim body jerked and trembled under the leather.

Before she was done, she used her hands on him as well as the whip. She left him bruised. Dark welts crisscrossed his back in a frightening artistic pattern, and reddened patches showed on his chest and face where Jenna had cuffed him. Aeryk whimpered through the gag, his cheeks stained with tears, when she stepped back to admire her handiwork. "Very nice. Very nice indeed. You mark well."

Through his pain and humiliation, he felt a curious sensation. He had pleased her, and he was glad to have done so. Not just because it might incline her to hurt him less, but because he had

pleased this woman. Though he knew not why, he felt suddenly grateful that she had chosen to compliment him.

Jenna flipped him over without effort. He winced at the harshness of the coarse weave against his back. She leaned closer to him. "Pretty Elf," she whispered, trailing one finger down his chest. Again, the flush of gratitude, his eyes wide and vulnerable. "I think you're ready." Sudden fear gripped him. Did she know, somehow, that he had had a moment of weakness, that he had wanted to please her?

Jenna extracted a gleaming hoop of metal from her pouch, her fingers deft and sure. "Something I bought from a wizard," she explained. "I had it attuned to my dagger, the one you stole." She grinned down at him wolfishly. "That's how I found you. I have another use for it now."

She opened it, revealing two complimentary, sharp points, as if it had been cut diagonally with a knife. "Slaves at the Silken Bridle serve with one ear pierced, to show their submission and willingness to serve."

She smiled at him humorlessly. "There are two differences with this earring, however. First, it does not come off. It has a binding spell set on it, to lock permanently once it is fully closed. Second, it has a magical binding on it to be attuned to my dagger, which I will be more careful of in the future. If I wish, I can always find you."

He felt the unyielding metal touch his delicate, pointed ear. "I decided that you would be marked like a slave, before you served me as one."

Wild denial rose in him, and he wanted to cry out. Her hand gripped him by the hair. Firmly, she pulled his earlobe taut, and pushed the hoop through. It flashed with a cold fire and seared itself through his flesh. He jerked at the sudden, sharp pain, but could do no more than whimper through the gag.

Jenna smiled with satisfaction, adjusting the earring a bit. "Lovely. You wear the earring well." He felt a slave's helpless

gratitude, complimented, but tried to thrust it away, angry.

She heard him try to mumble something through the gag. "Do you want this taken off, pretty Elf?" she asked. Impatiently, he nodded, waiting. Jenna regarded him. "Do you beg for it to be taken off?" she asked. He thought for a while, and then nodded. She removed it, and tossed the now sadly abused, wadded tunic to the floor.

"You can't just rape me. I'm not a slave!" Aeryk tried to sit up, but she stopped him, her hand heavy on his chest.

Her short-cropped hair fell in dark fronds around her face, framing a wicked grin. "Very well. I won't rape you, until you beg me to." Holding him down, she began to touch him. Her hand was in his hair, and his arms were arched and bound over his head. His ankles were lashed together; the thin cord cut into his flesh even through his cloth pants. He squirmed, helpless.

With relish, she ran a hand down his chest and belly, and licked her lips. "I'm going to make you beg me to." Delicately, she moistened a finger in her mouth and drew it across one of his nipples. Without wanting to, he shuddered and jerked.

"No, please...," he begged, terrified by the uncontrollable and unfamiliar sensations he was experiencing. Bound and helpless and touched, he was beginning to grow more and more excited, as much as he tried to fight it. She touched him again, this time roughly. She pinched first one nipple, then the other. He twisted his body against his bonds to try to escape her.

She laughed at him and tightened her hand in his hair, her arm thrust through his bound wrists for leverage. "Don't struggle, little Elf. You might hurt yourself," she warned. He froze and arched his back, trying to ease the pain of her merciless grip. She jerked his head back and cuffed him. "Don't ever pull away from me. I own your body. I do with it as I please."

"No!" Aeryk cried. "I'm not a slave!" She regarded him coolly and removed the doubled length of leather from her belt.

"Shut up." She caressed his chest with the strap, rubbing the rough-cured hide against his nipples. Against his will, they stiffened. "I think you need another lesson."

Aeryk cringed. "No, please, no," he begged. "Don't hurt me." He could feel the heat of the welts on his back. By now, the pain had faded to an almost pleasant warmth, but he feared another meeting with the whip.

Her hand was in his hair, holding him down. Her face was near his own, her green eyes flashing with a powerful, animal vitality. The woman's air of command was natural and unconscious, and he responded to it, more than a little aroused, despite his fear.

"Will you obey me, then?" Jenna asked, touching him meaningfully with the leather. Gulping, he nodded. He felt very small and insignificant next to a woman who could control him so. "Will you try to please me?" He hesitated, then flinched, expecting to be struck. She moved onto the bed, stroking his chest. "You want to please me, don't you." It was not a question.

Wide-eyed, he looked at her. She knew; she had read his desire and his involuntary submission from his body. Slowly, terrified of what he was doing, Aeryk nodded. "Say, 'Yes, my lady, I want to please you.'"

He froze. It seemed to him a significant thing that he should admit to her with his own mouth that he wanted to please her. He still wasn't sure what she wanted, but he was fairly certain that she wasn't going to kill him.

"I own you," she said, gently. "Say it." Her hand touched his face, and he could feel its warm strength. Aeryk closed his eyes, abandoning himself to it.

"Yes, my lady, I want to please you," he whispered. A heady rush overwhelmed him, making him feel dizzy.

"I own you," she said. "Say it." Her hand closed around his throat, claiming him, but did not tighten.

This time he did not hesitate. "You own me." He looked up at her shyly. "My lady." Jenna smiled, obviously pleased, and he felt

grateful. "Please don't hurt me," he begged. He felt utterly vulnerable, having submitted himself to her. She could do what she wanted to him.

"I'm not going to hurt you, pretty Elf," she told him. "At least, not much." He shivered as she slipped a hand between his thighs. His flesh tingled at the contact, even through the thin cloth, and he felt himself beginning to harden.

She caressed him. "I'm going to enjoy you," she said. To his shame, his hips moved, pressing his cock into her hand. He groaned.

"But you own me, you said so. So I must be a slave!" he said, desperate. He squirmed, horribly excited.

She regarded him with a serious look. "Are you a slave, then?"

"Yes!" He cried, surprised himself. "Your slave!" He could hardly believe what he was saying.

Jenna grinned, showing her teeth. They were very white and sharp. "But I still can't, you know," she informed him. "I promised, remember?"

He moaned. "You said that you wouldn't, until I begged for it." She lowered her head to his chest and began to flick her tongue on his swollen, erect nipples. He held back a scream.

When she had finished tasting him, she commanded, "Beg for it, then. If you want it."

Aeryk closed his eyes. "Please," he whispered. "Please..." He thrust his hips up, offering himself, without shame.

"Please, what?" she demanded. She took his cock roughly in her hand and squeezed it. He moaned.

"Please, my lady, rape me. Take me. I beg it." His cock throbbed in her hand.

She put a hand under his chin and forced him to look into her eyes, deeply. "Beg me again," she commanded.

He writhed. "Please rape me. Take me. I'll try to please you, I beg to please you. Please, my lady." He was suddenly desperate, his need overwhelming. What if she decided not to give him

relief? "Please, I beg of you, please, have me!" His cock was a jutting tower of need, painfully swollen, an insistent throb between his legs.

Knowing he would no longer struggle, she removed her other hand from his hair and began to touch his body. He moaned and arched his body up to meet her caresses. He was excited to be bound helpless and touched by a woman who literally owned him. She wanted him enough to own him. *No one has ever wanted me like this,* he wondered, lost in a blaze of sensation.

She untied his pants and jerked them down. He did not resist. His cock was long and slim with a slight curve, strained erect. Grasping his hips with her hands, holding him down, she flicked her tongue over the head of his cock, tasting the eager moisture. A few more drops beaded his belly. "Ready for me, I see," she remarked. He gasped and tried to thrust his hips toward her, but her hands held him still. "Such a lovely toy you are to play with. So responsive."

She crouched over him and put her mouth on his nipples, biting and licking. He cried out. She stopped and looked down at him.

"Are you ... are you going to rape me?" The question was half fearful and half hopeful. She grinned down at him. "No, I can't," she told him, idly pinching one of his nipples.

He whimpered. "Why not?"

She chuckled. She continued to stroke him, running her fingers over his nipples and the moist tip of his cock. He trembled and strained upward in his bonds. "Very well, pretty slave. I will rape you." He whimpered his gratitude and arched his body, offering his hips to her. "But first you must please me. You haven't yet earned the right to pleasure. Do you understand?" He nodded, obedient.

She showed him the quirt. Cut from rough-cured hide, it had a wide strap in the middle and thinner, twisted cords extending at both ends. The cords were knotted at the ends and along their length. The slim Elf shuddered, remembering how those vicious

cords had cut into his back. How the strap, doubled, had slapped against his reddened ass.

Jenna teased him, drawing the leather across his chest. "I'm not going to hurt you too much, this time. I just want to play with you a little." She cracked the leather strap between her hands, a predatory grin on her face.

He jumped a little at the sound. "Don't hurt me," he pleaded, not really meaning it. He trusted her. She wanted his submission and his body, not to maim or kill him. Even in her anger, she had only beaten him. And was it not exactly what he deserved? He had stolen from her, displeased her, and now he was to be punished. If another beating would make her pleased with him, then he wanted it. A part of him cried rebellion, but it was too late. He wasn't listening.

The young Elf could not ignore his body, his nakedness, and the harsh leather scraping his wrists. He cried out, startled, as she brought the strap down hard on his nipple. It seemed to throb and burn. Again, the loud crack, and the pain. He fought to keep from moaning. He wanted to please her.

She noted his clenched fists, the tight line of his lips. "No need for silence, my pretty slave. I like to hear you." She pinched and lifted the abused nipple, making him gasp. "Tell me your name," she demanded, seizing a handful of flesh on his chest.

"Aeryk," he answered without delay. Positioning the strap, she delivered a blow to the other nipple trapped between her cupped fingers. He jerked, but was careful not to pull away.

"That's not what you told me in the tavern," she said. "Did you lie to me, little Elf?" She stroked him between the thighs with the strap, not quite brushing his cock. He shuddered, moving his hips.

"No, my lady. Aeramar was the name I bore as a child, before I was made Outcast." He looked away. "I don't use it any more. They gave me a Human name when I joined the pack."

She struck him a few more times, with exact strokes, striking him on the nipple each time. Once, she caught him with the

knotted cord, and he cried out, whimpering. He did not ask for mercy. Jenna watched him casually, enjoying the sight of his naked and bound body tensed against her blows. "Why were you outcast?" she asked him. "Thieving?"

His eyes flashed, defiant. "I am half-breed. That was my only crime. My people cast me out when I was only a child."

Jenna frowned. "You have 'Morph blood?" she questioned. "You don't show it."

"No." His voice was very quiet. "My father was Human. He forced my mother."

She nodded. "You lived with the wharf rats?" The youth gangs of Reshor often took in abandoned children and orphans, protecting them until they grew old enough to fight and steel for the gang.

Aeryk was suddenly ashamed. "I had no choice! This—what I did to you—is the only life I know. If I had a choice..." The young Elf fell silent. He knew what she must think of him, a dirty little thief, a wharf rat. He wished that he could have been something else. Something more worthy of this woman's respect, and of her desire.

"There are always choices," she snapped, and heaved him over onto his belly. She laid into his already welted back with the strap. He wailed, tears beginning to run down his face. Aeryk was no longer frantic with desire, and the beating just hurt.

"No! You don't understand!" he protested, his eyes stinging. The pain of the beating was nothing, compared to the humiliation he felt.

She stopped. "Don't ever tell me I don't understand, Elf boy," she told him in a flat voice. "Did you guess that I had 'Morph blood? A quarter, or an eighth, you thought." He nodded. "I'm a full-breed 'Morph."

He looked up at her, twisting his neck until it hurt. "But that's imposs—" He caught himself. "Unless you were altered not to show it. But that would mean that you're..." He trailed off, unwilling to say it.

"First Breed," she spat. "That's right. My father, may Dhanu eat him, sired me on the body of a bitch-wolf, and shaped me to his desire."

By the Slaver's Code, First Breed were still the property of the mages that made them. Altered in the womb by powerful magicks, they also tended to be stronger, faster, and smarter than any of the other 'Morphs. It was widely suspected that the 'Morph general Lhiani's capitulation on the issue of the First Breed slaves was primarily because of the prevailing fear among 'Morphs and Humans alike of the powerful, unpredictable results of the mixing of animal and mage blood. Although the 'Morph Wars had freed their descendants, the first of the mageborn were still in bondage to their sorcerous masters.

"You're someone's property, then?" he asked, then cringed. He had not meant to sound insolent.

She growled. "The first time that filthy bastard tried to use me, I opened his throat with my hands." She looked down at them, reflecting. "He didn't give me claws, but he made me strong. Among other things."

She gripped one of his bound shoulders, letting him feel a little of her strength. *No wonder she handled me so easily,* he thought. But he was no longer frightened. "I guess I had more choices than you ever did," he said. "I'm sorry." She nodded. "Why do you honor me by telling me this?"

She looked surprised. "Is it honor, then? I suppose you could see it that way." She ran a hand down his back, barely touching him, and he winced. "Well warmed, are you? But not quite so eager." He was a lovely sight, naked and bound on his belly. His back bore the deep marks of her leather, and his firm, well-rounded ass cheeks were blushing red. Here and there on his thighs were bruises where she had gripped him.

She sighed with pleasure, contemplating her captive. His body had a slim, delicate cast to it that was well matched by his fair Elvish features, and it invited an owner's rough hands. His hair,

long and pale, cascaded in a silver mane down his back. Drops of sweat beaded his skin. She thought that when she owned him, she would comb his hair and hang it with jeweled chains.

He saw the look in her eyes. "I am eager, my lady," he said to her, quiet in his submission. His cock was not yet hard, not compelling him, but he offered himself without reservation. He could see that she wanted him, as unworthy as he was, and he surrendered himself to her strength. He was her tribute, and her prize; and he was proud to be so.

She laughed a silent laugh, triumphant. To Aeryk, she seemed magnificent. "Beg me," she commanded. "Beg me to take you."

"Please, my lady, take me. I beg you." With a swift motion, Jenna unfastened the catches on her robe and cast it aside. Her body was smooth with hardened muscle, though her shape was very much female. He was not surprised to see that she had a light down of fur on her flanks in long, tigerlike streaks. She turned him onto his back and crouched over him possessively. Her tongue inscribed concentric circles around his nipples, lapping and tasting. Surrendering himself to her pleasure, he moaned happily and offered her his stiffening cock, his hips thrust up to meet her. His nipples and groin seemed on fire.

She bit him, and he groaned in pain and pleasure. Her teeth left a ring of tiny, bright drops on his chest. "Beg me to fuck you," Jenna demanded. She seized a handful of his pale hair, jerking his head back.

He felt an overwhelming rush of submission. He was fit only to be the slave of this woman crouching over him. "Please fuck me. Fuck me!" he begged, lifting his hips.

She mounted him. He cried out once, softly, as she pressed her hips down. "Fuck me!" he groaned, beyond restraint. "Take me, please..." He threw his head from side to side on the pillow, biting his lip. His hips thrashed in an uncontrollable rhythm. She rode him like an unbroken colt, her knees pressing hard against his sides. In a few moments, he arched and trembled, crying out his pleasure.

"Done already?" she inquired, barely breathing hard. She did not seem displeased.

He shook his head, gasping. "No. I ... I can do more." He moved his hips under her, straining.

She grinned, looking down at him with relish. "I'd heard that about your breed. That'll raise your price by a few gold, if I ever decide to sell you," she told him, and began to move on him. Once more, he cried out, squirming, after only a few minutes. "Again?" she queried, surprised. He kept moving, still excited.

"Yes, my lady. Again." He snaked against her, thrusting into her. He was very hard.

Jenna looked at him in disbelief. "You should be a pleasure slave, little Elf. I didn't know you had it in you." She touched his cheek, still mounted. He moaned and moved with helpless abandon, thrusting hard.

She was beginning to get excited. She drove her hips down on him, enjoying the sensation of his hard cock filling her. No longer the frightened captive, Aeryk was responding like a slave bred for passion. When his cries reached new heights, she was ready for him, and let his release trigger her own orgasm.

She looked down at him, satisfied. His arms were bruised where she had gripped him, lost in her pleasure. He was still hard inside her. "More?" she asked, lifting an eyebrow.

"Please, my lady. Please, more." She dismounted, leaving him writhing. "Please!" he begged, his hips bucking. "I need, please..." He whispered into the pillow, unwilling to anger her.

Working swiftly, she untied his wrists, shoving them down. "Touch yourself for me," she commanded. He gulped. His burning need and his desire to please her overcame his shyness, and he began to stroke himself. "You can do better than that." She spoke sternly. "Move your hips. Moan. Do it sensuously."

Shamed, the young Elf obeyed. He thrust his hips up, pretending that his cupped hands were part of her. "Touch me, please..." He surprised himself by begging. She pinched his nipples to hear

him gasp and increase his efforts. He was breathing hard, in quick pants. "Please...," he moaned, not knowing what he begged for, except to please her. She grabbed his wrists, stopping him. "I like to hear you beg," she told him. "Beg me to let you come."

He whimpered, beyond shame. His cock throbbed violently. "Please, let me come. I beg to come!"

She released his wrists, and put a hand in his hair. He pressed his cheek fervently to it, feeling her grip him. "Come, then," she commanded, and he squeezed and stroked his shaft until he thought it would explode with pent-up pleasure.

"I'm yours!" he gasped, as his cock began to spasm, jetting short streams of sticky white. His body jerked uncontrollably under her hands. "Yours," he whispered, full of wonder. He looked up at her, trembling. "Yours."

His chest was covered in his own fluids, and she rubbed it into the smooth skin of his belly, running her hands through its warm slipperiness. "Beautiful." She appraised him. "I could get six hundred for you, easy."

Aeryk looked up at her pressing his cheek against her hand. "Don't sell me," he begged. "Keep me. Please keep me. I'll serve you well, I promise. Please!"

Jenna stroked him possessively, frowning at the thought that someone else might buy and own him. The intensity of her feelings surprised her. *After all, he's just another slave,* she told herself firmly. "I wasn't planning to sell you, little Elf. I was just appraising what you might be worth. An old habit." She looked at him curiously. "Do you know what you're saying?"

He nodded. "I know."

"I was going to rape you and let you go, since you pleased me. After collecting what you stole from me, of course. I think I've been well recompensed for my trouble." The mercenary woman smiled. He did not smile back.

"Keep me," he said, catching one of her hands and holding it. Startled, she did not pull away. He bowed his head, and his long,

pale hair fell forward in a shower of silver around her wrists. Gently, he pressed his lips to her hand. "Please, my lady." He seemed somehow more dignified than he had a right to be, begging.

Jenna regarded him, astonished. "You don't know what you're asking. You want to be a slave?"

Aeryk cringed from the scorn in her voice. "I don't really understand what it means to be a slave, but I know I want to be yours. If that means I am to be a slave, I accept that."

He lifted his head. His eyes were the violet of the wine she had bought that night, incandescent. His gaze was clear, and did not waver. "I have been lonely before, and hungry. I have been beaten before. I have never been owned. I have never had someone to belong to." He met her eyes with his own, no longer pleading, but asking. "I want to." He felt more calm, more at peace with himself, than he had in a long time.

Jenna looked at him for a long time with something akin to awe. "There are always choices," she said finally, and claimed him in the firm grip of her arms. Contented, resting against her, Aeryk thought he understood at last.

Tanith Tyrr is a professional dominatrix and freelance writer who lives and plays in Berkeley, California. She is proud to be an active member of the local leather/SM community. Her upcoming novel Thieves' Gambit *is set in the same universe as "Slaver's Luck."*

Elceleth

Pencildragon & Paperdragon

I.

Sweat dripped from her naked, glistening body as she lay helpless and exhausted from her struggles against her bonds. A chain and steel collar secured her to the foot of a heavy, high-backed, ornately carven chair that was almost a throne. A leather sheath cinched her arms together behind her back and attached to the collar. Another sheath encased her legs from the knees to the ankles. Her hands and feet were confined in leather pouches and strapped together, her body bent by these bonds, so lying on her side was the least uncomfortable position she could find. Most humiliating of all was the gag in her mouth, made of polished leather fashioned in the shape of a male member. Strapped firm around her head, it prevented her from making any sound. As she lay on a thick suede skin soaked with her own sweat, she felt the rolling movements of the wooden wagon in which she lay and pondered how she came to this fate.

▼▼▼

Just one short month ago, Elceleth had been in all her glory. It was late spring in the Toliniel Woods, and the fragrance of green growing things surrounded her as she swooped and turned in the late afternoon sun. She was a joy to behold, sliding gracefully from one movement to another as she danced in her grassy practice area. She practiced behind her treehouse to music only she could hear. Elceleth was the finest dancer the Toliniel had ever known. Although her execution of the traditional dances was flawless, she

was renowned and loved for her freeform dances, which were as unorthodox as her appearance. Like all her people, she was small and trim, fair of face and skin, but with a true dancer's body, limber and small-breasted. Where she departed in appearance from the ordinary was in her ears, more pointed than most of her folk, and she wore her blue-white hair cropped short, both to show off her ears and to flaunt the fact that her dancing did not need flowing hair to embellish it.

She came to the end of her movement, and was greeted by applause. She turned in surprise and saw Elder Zantah, Head Councilor of the Toliniel, standing to one side of her rehearsal area.

"Before you lecture me about not liking people watching you practice, Elceleth, I've come to tell you that we, the Council, would like to engage your services to entertain at a feast we are giving in a month's time."

"Interesting, Zantah—are you planning something special? Normally, I would expect you to send a messenger, rather than visit me in person." Elceleth regarded him as she wet a cloth in the water pitcher and wiped perspiration from her face.

"We are having a special guest from outside the Toliniel." His stiff posture betrayed that he was ill at ease.

"What kind of guest; where from?" asked the dancer.

"It is a Human male, from Iborland," he answered, with some reluctance.

"A Human from Iborland? I have heard they treat their women as slaves and property or worse! Why ever would you want to entertain such people?" She came over to face him.

"Never you mind, Elceleth; that is strictly Council business." Zantah was unwilling to make eye contact. "All we ask is that you perform to your usual high standards, for which, of course, you will receive your usual fee."

Bowing slightly, Elceleth said, "Of course, Elder, you may count on it. But I don't understand why you would even want to talk to Iborland."

Elder Zantah merely smiled, took her hand and kissed it, and left. Elceleth went back to dancing to prepare for the feast to come.

▼▼▼

The feast was held in the Hall of Groves, the largest building in the Toliniel, whose walls and floors incorporated the trunks and supporting boughs of the trees into its architecture. After the meal was done, Elceleth rose from her seat and glided onto the floor. In the middle of the circle of low tables, she took her starting pose. The musicians struck the opening bars, and she began.

She loved to dance and it showed. It was when she danced that she felt most free and alive. Her dance had a sword-sharp crispness that evening that she had not expected, perhaps because the guest was truly mystifying. The Elders had told her nothing of him, but she snuck glances at him as she performed for the assembled people. He was a head taller than anyone in the hall, yet he was also broad, with neat, short golden hair of the style the warrior class wore. His face was beautiful and tanned, with ice blue eyes that burned with an intensity only the rarest of Humans possessed. He wore a white linen shirt that exposed his muscular chest, and leggings of black leather.

Perhaps how well she danced reflected the way he both fascinated her and frightened her with the concentration with which he watched. Her dance rose to a fevered pitch as the music reached the climax, then finished.

Thunderous applause broke out, and she acknowledged the entire room with a graceful spinning curtsey. Elder Zantah came to her. "Well done, Elceleth! I have never seen better! Our guest is impressed and desires to meet you. Won't you come this way?"

"Certainly, Elder." Elceleth followed Zantah to the head table. As she was brought toward the human, she noticed with a start a female Human kneeling on a pillow at the blond mountain's side. She had long black hair and deep brown eyes that emoted something Elceleth could not fathom. She wore less than Elceleth

herself would wear for an erotic dance—only a scant black leather top and a long loincloth that left her hips and legs bare. The only other thing she wore was a black leather collar, wide enough to keep her neck stiff. Looking at her, Elceleth had a sudden thought: *Here is one who is less, yet more, than what she seems.* Elder Zantah introduced them to her as Master Corlon, Lord and Ruler of Iborland, and his lady, Mistress Qantar. Elceleth decided, looking at Mistress Qantar, that all the rumors she'd heard of Iborland were true.

Master Corlon studied her as a cattleman might examine a brood mare, and Elceleth shivered from that look. She left as soon as she could politely do so, knowing that Zantah would send her payment around the next morning.

<center>▼▼▼</center>

While she slept that night, she had uneasy dreams of Corlon's stare and how he placed his collar around her neck, attached a lead chain to it, and drew her close to whisper, "Mine!" with possessive intensity. She awoke with a start to find that her dream had become a living nightmare. As she tried to scream, Corlon jammed a wad of cloth into her mouth and bound it there with another strip. He hoisted her over his shoulder and carried her down the tree's ladder into the night. Her punches and kicks had no effect on his massive form as he bore her to a waiting wagon, where he stripped her, laid her down upon a thick suede hide, and bound her as she now lay. She gathered her strength once more, and struggled against the bonds until she fell into an exhausted sleep.

II.

Elceleth awakened as a shaft of morning light fell upon her eyes when the flap of the wagon was opened. Mistress Qantar slithered in, a bowl and a wineskin in her hands, and eyed her like a predator would eye a morsel unable to flee. Elceleth squirmed her body

away as far as her bonds would allow. Corlon climbed in behind Qantar as the wagon lurched forward. Corlon sat in the chair to which she was chained and spoke in near-perfect Elvish.

"Well, little one, you will be pleased to know that the Toliniel need never fear from any nasty hobgoblins again. Iborland will be trading your people a substantial amount of iron, enough to arm and armor every Elf in the region. In return, we will receive enough wood for five warships, and of course, you. Quite frankly, I had half a mind to deal with the hobgoblin hordes, and just might have, except that your Elders saw the wisdom of our ways, and added you to the trade. What do you say to this?"

Her eyes said what she could not speak through the gag: betrayal and fear. How could her Elders sell her to a Human? What did he want of her? She realized her nakedness and tried to roll onto her belly.

"Oh no, my dear, we can't have that," he said, putting an amused smile on his face. "Qantar, discipline her." The black-maned pet picked up a leather-covered paddle, rolled Elceleth onto her side, and proceeded to swat her all over her exposed torso and buttocks. Corlon continued to speak in a relaxed, confident tone.

"You must be trained to act as an Iborian. You belong to me and will always do as I say. You will always kneel in my presence unless ordered to do otherwise. You will always cross your wrists in front of you if I approach you if you are not bound already. You will not speak unless I order you to speak. When I give an order, you will follow that order as quickly as possible, as long as I do not order you to do otherwise. All this you will do, and more, under fear of punishment. Do you understand?"

Elceleth was pink all over her exposed body, and her every movement was agony. But she nodded through the haze of pain, of joints stiff from restraint and flesh tender from paddling, so that the Human would cease her disciplining.

"Excellent," he purred. He gave an order to Qantar in the Human tongue, and Qantar's eyes glowed with delight. She

crawled to the edge of the wagon like a cat who had found a mouse particularly tasty, and exited without a word.

Corlon then pulled out a soft feather and played it across Elceleth's body. Her senses were now aflame with its softness, her battered skin's sensitivity heightened. He brought her to orgasm without even touching her. He then removed the gag from her mouth.

"You see the natural order of things? We Iborians bring greater pleasure to our women than anyone else in the world. All we ask in return is complete and absolute obedience, unconditional surrender." He freed her from her bonds, unchained the lead from the chair, and pulled her close with it. "But for you, because you are not Iborian, I give you the ultimate honor. A choice, perhaps the last one of your life. Having experienced a small taste of the Iborian way, you may now choose. Stay with me and be mine, or refuse and go back to your village. Stay, and the ultimate pleasure is yours, and the Elves never fear from the hordes again. Refuse, and return naked and collared. Why I'm sure a good smith would take only an hour or two to break the lock. Stay, accept pleasure, and save your people. Leave, and Iborland deals with the hordes, and all you know will be dust. Choose, little one."

Elceleth looked at him, stunned. She could see he was serious. Though her mind was whirling, one thing stood out clearly—she didn't want her people to fall to the hordes. Though she would hate the Elders forever for what they had done to her, she could not place herself before her people. "I will," she stammered, "I will stay w-w-with you. But I want to know one thing: why?"

"I wanted you, that is sufficient. If others want you, they must slay me to win you. You have chosen, but I do not see total surrender in your eyes. That will change with time. Eat your fill and await my return." With that, he chained her to the chair and leapt out of the moving wagon, leaving his newest pet to ponder her decision.

▼▼▼

When Corlon returned much later to the still-moving wagon, Elceleth had eaten the food Qantar had brought, and had wrapped the floor skin around her torso. Corlon flung the skin from her, turned her over his knee, and spanked her five times. She yelped like a frightened cur with each blow.

"This is for disobeying me!" he snarled as he struck her. "You did not cross your wrists when I entered, and I did not say you could cover yourself!"

"But I was cold, Cor—!" Her protests were cut short by another spank. She had not been spanked in 150 years, since her childhood. *A whipping would be easier to stand!* she thought.

"You will address me as Master Corlon or Master! Do you understand?"

"Yes, M-Master Corlon." She wept.

He moderated his tone and said, "Good. Now listen carefully. If I underestimate your ability to tolerate the cold, you will perform your duties less ably than I expect. It is my decision whether to tolerate lesser performance or to clothe you. Total obedience means not to assume anything. If I leave you naked, you will stay naked until I order you dressed. Do you understand?"

"Yes, Master," she whimpered. She despaired to herself. *I can't believe this is happening to me! Do the Elders understand the fate to which they have thrown me? Is Iborian iron so important that they would accept my abduction without complaint? If it was so important, could they not have asked me, or at least told me about it? Or,* she wondered suddenly, *was my unwilling abduction a part of the bargain?*

As these thoughts revolved in her mind, his voice cut through them, saying, "We will be stopping for the night soon. When I call for you, you will come out of the wagon, eat while warming yourself by the fire, then lie on your belly upon the leather skin that will be laid out, and wait. Do you understand?"

"Yes, Master." Her shoulders slumped as she watched Corlon unlock her lead from her collar. *No!* The *lead from* the *collar. I*

mustn't think of the collar as mine. But now what? I am more than a day's journey from home, naked and collared. If I ran away, he would find me and beat me, like a hound. She didn't want that humiliation. So she waited.

▼▼▼

When she heard Corlon calling, she came out. The wagons had stopped in an endless wild field for the night, but though the bright stars and moons lit up the night, she could not see the comforting outline of the woods. She felt alone, more than naked, and humiliated that she must follow his orders. She walked with apprehensive steps to the fire, as a cur might who wasn't sure if she had done wrong. A dozen pairs of eyes did not fall upon her as she expected, but continued to focus on conversations as if her approach was beneath their notice. She wasn't sure whether being ignored or being the center of attention was worse. By the time she reached the supper fire, she knew for certain. To have them react as if it were as ordinary as tying her boot laces was far worse than having them leer and taunt her as she performed their tricks.

She ate in silence, listening to their Human tongue, which had a harsher accent than the dialect she had learned while studying their dances. When she was through, she laid herself upon the skin that must be meant for her. It was surrounded by four torches mounted on metal stands that had been driven into the earth.

She wondered what would happen next. At least the torches kept her back and legs warm. Not much later, she heard several Humans get up from their places and approach her. She felt certain they were going to beat her senseless for some as-yet-unknown disobedience, or perhaps rape her from behind in the manner of the children of the forest. But instead she felt a hand stroke her hair and back, and Corlon spoke to her in Elvish.

"You see how easy it is to follow directions? Now we will reward you for your obedience." <Bind her to the posts,> he finished in the Human tongue. She did not struggle as they spread

her arms up and out, but then they spread her legs so wide she was glad she had a dancer's limberness. She thought, *What now? The feather, I hope.*

<Now prepare her for the shaving.>

"What?" she yelled with a start, wrenched her head up, and received a spank for speaking.

"Removing the body hair increases sensitivity," Corlon explained.

"No!" She yanked against the leather bonds with all her might. She knew her actions would probably bring punishment, but in her horror and indignation she did not care. Surprisingly, no pain came, only Corlon's calm, clear voice.

<Struggle if you wish, little one, but I'd advise against it. The blade is very sharp, and all that thrashing around could get you nicked.> There was laughter in the background from Corlon's entourage.

His words struck her like a stone wall, and her panic transformed into paralysis. Gentle hands removed her collar and spread lather on her trembling back as he continued to speak.

<Qantar, for every nick you give our little Elf, I will administer one stroke of the light lash. But to let you know that I still favor you, if the Elf's struggling causes the nick, you will receive the stroke from the light whip, and then you may in turn whip her once, as well. Does this seem fair to you?>

<Yes, my Lord-Master,> replied Qantar in her velvet-smooth tone.

Qantar continued to lather the Elf, and leaned down to whisper in a voice so low Elceleth was certain only she could hear it. "Do not try to be still. Just relax and think calm thoughts, and perhaps we can both avoid the lash." Elceleth tried to do as she said, and thought about a waterfall she knew. That helped.

<Yes, Qantar. You have a question?> Elceleth wondered how she let Corlon know she wanted to speak. She wished she could see it.

<Yes, my Lord-Master. May I warm the blade first so the touch does not startle her? I do not wish to mar her beauty.>

<Though I appreciate your concern, I do not believe that will be necessary. Little one, the blade may be cold. Try not to twitch when you feel it.>

"Yes, Master."

Elceleth did jump a little as the blade touched her flesh, but Qantar anticipated it and drew no blood. The Human sighed and then began her duty in earnest. Her touch was deft, and not once did she falter while shaving her charge's back, neck, hands, and arms. The buttocks were another matter, for the Elf found the touch embarrassing and ticklish. She jerked with every stroke of the blade and Qantar's progress slowed to a crawl. Each jerk made Elceleth more aware of her helplessness. Her legs went mercifully quickly, and her body was rinsed with warmed water.

<My Lord, my task is half completed. Her bindings must be readjusted for me to complete my task.>

<Excellent, Qantar. Men, prepare her.>

Elceleth was unbound, flipped onto her back, and rebound even more tightly. Now she could see Qantar, and wished that she couldn't.

Qantar was nude, and her face shone in the torchlight with a sheen of sweat. Elceleth noticed that she too was hairless, save her long tresses and her eyebrows. None of this disturbed the Elf as much as the sight of Qantar's wrists roped together. How could she possibly control the blade like that?

<Qantar, do her face first.>

<Yes, my Lord-Master.>

Qantar lathered Elceleth's face, including, to her horror, her long, pointed ears. Then the smallest razor she had ever seen was taken to her face, as Qantar removed the fine hairlets, save her thin slanted eyebrows. Elceleth closed her eyes and was at her waterfall again. Then the razor moved to her right ear. Elceleth moaned in mixed pleasure and outrage. How dare this Human pet touch her

eartips and move her to pleasure in the most intimate of areas, where only one's most favored lovers were welcome!

<Ah, my Lord, see how she stirs!> exclaimed one of the servants.

<My most sincere thanks for pointing out the obvious, Donto,> said Corlon. <It would seem that our little Elf has a pleasure point unknown to us! This does bear future investigation.>

They know! Elceleth thought in horror, as she lay spread to the four winds. *How will I ever survive such an invasion? This is tenfold worse than anything I could imagine!* But still the pleasure waves struck her like breakers against a rocky shore. As any unaging one knows, eventually the water always wins. She came to the sudden realization that this ceremony was to let him become familiar with every inch of her skin. But knowing that did not help. By the time Qantar finished her ears, Elceleth was aroused.

<My Lord, shall I stroke her ears while your lady-mistress continues her task?> teased the somewhat portly underling. Hearing him, Elceleth knew she could learn to hate that Human easily.

With the speed of thought, a dagger that had been in Corlon's hip sheath pinned Donto's boot to the ground. Corlon roared in anger. <Did I not say this bears future investigation? You will refrain from touching her!>

The shocked retainer stammered his apology.

<You live only because your insolence is slightly less than your usefulness, for now,> Corlon growled. Turning to his favorite pet, he said in a gentler voice, <Continue, Qantar.>

<Yes, my Lord-Master.>

And so, the ritual continued. Qantar lovingly traced Elceleth's arms, feet, and legs, leaving the torso for last. In shaving the torso, Qantar started from the neck and moved slowly down toward where Elceleth's legs met her body. Aroused from the touching of her ears, Elceleth was brought to greater tension and excitement by the time the touch of the blade started on her Elven-fine pubic hair. She could see Qantar was being supremely careful, as drops

of perspiration fell from the Human's face onto her legs and belly. Elceleth also saw that the Human was fighting the stirrings of her own passion. Though embarrassed, Elceleth found that in her aroused state the attention and care being administered upon her by one who found her sexually attractive was even more exciting. When Qantar finished, Elceleth bit her tongue to keep from begging for the release of her passions. Now devoid of most of her body hair, she felt like a child before the buxom Qantar.

Corlon spoke to her through her haze of introspection and need.

<It would seem, little one, that you want for pleasure again. Say something that pleases me and I will give you release.>

She thought, *He wants me to surrender, to say I give in, to willingly accept all the abuses and humiliation that he will heap upon me. I need, but not at that cost. What can I say that will please him without giving in?* Then she smiled and purred, <Master Corlon, it would seem to me that Mistress Qantar's task is not complete until my wrists and ankles are shaven where the straps touch my skin.>

Corlon howled with delight. <I knew I had chosen well when I picked you! What wit and fire you have! Qantar, ease her need.>

Qantar smiled with an arched eyebrow, an expression that told Elceleth that she had earned both respect and approval from the Human. Then came another realization, that another of the reasons for this ritual was to forge a bond of trust between herself and Qantar, for what Master wants his pets fighting?

Qantar knelt between her legs, and began to stroke Elceleth's clitoris with her tongue. So aroused was she that in only a moment Elceleth was writhing and howling in the throes of an orgasm the like of which she had never before experienced. The sensuality of her naked groin; the tension, excitement, and helplessness of her spread and bound body; the supreme skill of Qantar's tongue; the knowledge that her captor had orchestrated this whole event—all these things came together to prove a thing she had never experienced before: intensity. This was a thing no Elf lover had pos-

sessed, and what moved her this night. Elceleth went limp. As she lay there panting, Qantar replaced her collar and untied each bond, and shaved each area as she went. Corlon spoke approvingly at the last stroke.

<Well done, Qantar. As a reward, I will allow you to choose any member of my entourage to pleasure this night, except of course for Donto, in case you had in mind to lower your standards.>

<My Lord-Master. I am honored by your most generous gift. If it pleases you, I would choose my Lord-Master, for there is none other that I would rather be with than you.>

Corlon merely smiled. <You may go to my sleeping wagon, my Lady-Mistress. I will join you presently.> He knelt beside Elceleth, fastened the chain to her collar, and drew her up by it. He led her back to her travel wagon, locked her to the heavy chair inside it again, and left.

▼▼▼

He returned later, arms full, and found Elceleth kneeling with her wrists crossed in front of her. He smiled, laid out the thick fur he carried where the suede had been, and fettered her ankles together with a single shackle. As he adjusted the shackle, she found it ironic to be bound with the same metal that would save her people. Corlon picked her up gently and laid her on the soft bedding. The feel of the pelt was more luxurious than she had thought possible. Could it be because of her lack of body hair, or the remembered contrast to the touch of Qantar's blade? She wasn't sure, nor did she at present care.

"You have done well today, little one." Corlon tossed a second fur to her. "At least for your first day. You may cover yourself with this fur as you sleep tonight. When you wake, we will be traveling. You will feed upon food that will be left for you in the morning, and will cover yourself with the fur if you find it too cold."

"Thank you, Master Corlon," she said as she snuggled into the fur. It felt good to be able to cover herself without fear of punishment. She, upon sudden inspiration, distinguished between nudity and nakedness. Nudity was being at ease with one's nakedness, like Qantar was. Would she ever feel nude? She sat up suddenly and dared to speak unbidden. "May I ask a question?"

"Besides the one you have just asked? Yes. But whether I choose to answer you, I will not guarantee."

"Why do you address me as 'little one' instead of by my name?" She felt certain that to state her name would offend him, and she would not risk destroying the favor she had endured so much to earn—no, to be granted.

"The answer is threefold. One, you are little. Two, at the Elvish feast, with all the foreign names I heard, I may not remember yours. Three, if I have remembered, I may choose not to call you by it. I may give you a name of my own choosing. I believe Qantar's real name was Bashinon or something like that."

"Now I understand, Master. Please forgive my ignorance."

"Of course I do, little one. And to demonstrate how pleased I am with your progress, I will allow you to ask one question each night as I put you to bed, until I say otherwise. Now sleep, little one, whom I may or may not choose to name Elceleth. We have a long trip ahead of us." He stroked her hair before closing the flap of the wagon behind him.

She, an Elf with no name, lay wrapped in her master's furs. As she curled up in them, she contemplated again their feel, and sleepily perceived that her shaving had been a many-leveled lesson. Besides the increase in sensitivity and all the things she had already realized, it was also to make her feel small and helpless, to impress upon her that he could and would do this and anything else he wanted to her, and, last, that he did not bluff. How could she ever hope to outwit such cleverness?

She sighed as she nestled herself in the soft pelts. From Corlon's mixture of cruelty and kindness, she felt very much like a

favored pet, waiting for the morning, when she would learn a new trick to please her master. Her last thought before she drifted into sleep was *If I can so quickly go from the freedom of the wind to being a master's pet, was I destined to become one from the beginning?*

Pencildragon and Paperdragon are a married pair who met backstage in a Renaissance Fair dressing room. Pencildragon was a squire for the horse show, and Paperdragon was a musician's apprentice. While they courted, he was lured into doing the safer of the two occupations, and now they make beautiful music together. They live in eastern Massachusetts with their two pets, a cat and a snake, and a horde of stuffed animals.

By Their Works Shall Ye Judge...

Deborah J. Wunder

Darold, Crown Prince of Mountcalm, was pleased. The town fair would start in a few hours, and he'd be presiding over the festivities. He was young, rich, handsome, and single, and any number of wenches would be willing to entertain him for the week. He'd ridden into town with his tutor, Malcolm, intent on acquiring livestock and news. He looked forward to his duties, but was also looking to enjoy the gaming, and had brought a heavy purse for that purpose. He turned toward Malcolm, talking over the sound of their horses' hooves against the cobblestones.

"Mal, please arrange for our quarters. I'll meet you here in two hours."

"Yes, Your Highness." Malcolm was always formal in public, although he was one of the few who didn't have to be. "Please don't forget that we have much business here."

"Of course not, Mal. I merely long for some amusement first."

"Very well, sir. Two hours." He rode off in the direction of the inn, adding, almost under his breath, "And do try to keep out of trouble, sir."

Darold grinned, then rode off in the opposite direction. He sat his horse well, being long-legged and lithe, as he rode through the streets—dirt roads, really—edged with low buildings. Darold

knew that the ladies thought of him as slightly exotic—tall, with full lips and chocolate-colored eyes and hair against pale skin—and was well aware of the plethora of feminine glances, but kept to himself, noting all, purchasing little. At the fair's edge, he saw the slave block. Since it was still early on the first day, there was only one slave chained to it, a rather small man, with long, matted hair. He looked familiar, but Darold couldn't quite place him.

"What was his crime?" Darold asked a passing villager.

"He's an Elf. Supposed to be good luck to own one. Make you rich, so they say." The man hurried away, anxious to be about his business. Suddenly, the Elf raised his head and looked squarely at him. Darold caught a glimpse of pain-dulled eyes before an attendant cuffed the Elf hard and his head hung in resignation again. *Gods above,* Darold cursed silently, *there's no need for that. Oh, my God. It couldn't be. Dear Lord, it's Alen! I wonder if he knows me?* He'd been wandering in the forest after an argument with his father, driven to find the peace he could find only in solitude and greenery. He'd never expected to find an Elf, let alone a battered one. Memories flashed through Darold's mind: the touch of the Elf's flesh, the fear, the way he'd reacted to Darold's music. He hummed a fragment of the tune he'd composed while the Elf had slept, wishing he dared get close enough for Alen to hear. It must have been fate that had brought him to view the slave block. "Where do we bid?" he asked a nearby man.

"Right here, Your Highness."

"Thank you." He tossed the man a coin. If he could bid for Alen and win... He hefted the purse at his waist, hoping he had enough gold. Others were now being tethered to the block. He edged his mount closer to the front and studied the assembling crowd, sizing up people who might try countering his bid. He'd just decided that he had little serious competition when hoofbeats, followed by Malcolm's voice, broke into his thoughts.

"Darold, I've been looking everywhere. What are you doing here, anyway?"

"Mal, you remember my fight with Father?"

"Yes. You disappeared for several days."

"That's the Elf I told you I'd met." He pointed. "His name is Alen. I'm going to buy him."

"Darold"—Malcolm sounded his most parental—"we don't have time for this. You have business to attend to."

"I have you to help with that, Mal." The auctioneer approached the block and announced the beginning of the bidding. Darold turned his attention to the auction, ascertained that the first sale wasn't the Elf, then turned back to Malcolm. "Look, Mal, I can't let this happen."

"It's not your business, Darold."

"I saved his life." Darold edged his horse forward slightly, to get a better view.

"He ran away."

"I don't believe so. The clothing I gave him, and my staff, were lying on the stream bank. I think whoever hurt him had recaptured him. I can't abandon him now."

"No matter. You have business elsewhere. Enough of this nonsense."

"Mal, I can't—no, I won't let it happen. You take care of the business." The next sale began—a female house servant. He remembered how good it felt to hold Alen; how empty he felt upon waking to find him gone.

"I don't like what you're doing, or understand it, but I will obey, as always."

"Thank you, Mal. Please arrange quarters for him. With us."

"As you will, my lord."

"And I think he'll need a healer."

"Agreed, Your Highness."

"I'm not sure how long this will take, so if it's over when you return, I'll meet you at the inn."

"Very good, sir." He rode off, shaking his head. Darold turned back to the auction, sizing up the bidding patterns of the men he

considered serious. After planning his bidding strategy, he let his thoughts drift, recalling his last visit to the forest, his trying to draw peace from his surroundings.

The Elf had been so weak that he couldn't keep down the tea Darold had offered. Darold had held Alen in his arms to comfort him, and had felt—he still couldn't figure out words to describe the sensation. *Goddess, he must be in even worse shape now!* Darold shuddered. *Why,* he wondered, *had he been in the forest?* He knew that Elves usually kept to themselves, away from human lands. He looked at the block again, trying to imagine who had caught Alen, and what had been done to him. Because of Alen's small size, his shoulders had been wrenched into a visibly uncomfortable position when he'd been chained to the block. Darold could see scars on the Elf's back, since the slaves had been stripped to show their physical attributes. He remembered how beautiful Alen's blue-gray eyes were, and the glimmer of hope they had held. *Gods, he was so frightened, it took forever to calm him.* Darold had learned the Elf's name then. He'd gotten his lute out, and played for the Elf, which had seemed to help; then he'd drawn his cloak around them both, and had gone to sleep—only to wake up alone.

He looked at the block, noting that most of the slaves were tethered with ropes, although Alen's wrists and ankles were bound with heavy metal shackles attached to short chains. Remembering the rope burns on Alen's wrists, he wondered how the Elf stood the pain and why it was taking so long to get to selling him. *Saving the best for last, no doubt.*

Restrained as they were, the slaves had little control over their bodily functions. They pissed or shat where they stood, and sometimes had to wait hours before anyone cleaned them up. As the prince watched, the man next to Alen urinated, his stream running down the Elf's leg. Alen howled, and was rapidly subdued—rough hands yanked his head back; others forced a leather thong between his teeth. Darold thought of intervening, but stopped himself, realizing that such action would tip his hand.

Hold on a bit longer, Elfling, he thought. *Soon you'll be safe.*

He had searched for Alen for hours before returning home. The Elf had filled some emptiness inside him that he hadn't known was there. All he had wanted to do was stay with Alen, and protect him, although he had no idea why.

When he returned home, he had played the theme he composed about Alen, although he kept the story behind it to himself. Tears streamed down his mother's face as she listened, and Darold could tell the music stirred her. Her cheek rested in her hand, and her eyes misted over, so she appeared to be far away. *Does it do that to all who have Elvish blood?* he wondered. He'd played the piece many times since then, and each time he was filled with an incredible longing—one he was afraid he'd never be able to fulfill. He wondered, not for the first time, exactly how much of his mother's heritage flowed through his veins. The stories had been so jumbled, and his mother so secretive, that Darold had no idea just how far back the Elvish blood in his family ran. *And since Mother never speaks of it, it's not likely I'll find out.*

Even his father had responded to the music, amidst talk of war over the abduction of an Elfling prince, and had praised the piece. The Elves were sure that humans held their princeling, and the two realms teetered on the brink of war for the first time in several centuries. Darold had held his peace, feeling that he could contribute nothing constructive, knowing that such a war would be devastating.

He turned his attention back to the bidding, just as the final sale began. "What am I bid for this male Elf?" Alen was unchained from the block and led to the edge of the auction area. The auctioneer ran over the Elf's points, from the pleasing shape of the slender body, to the size of his genitals, noting the odd color of his eyes. He grasped Alen's hair and pulled his head back, so those in the front could see his face. Darold remembered the feel of Alen's cheek against his shirt in the forest. He was brought back to reality by a rough voice.

"Two hundred pounds." It was the villager who had said that owning an Elf could make a person rich.

"Four hundred pounds." Darold could spare that without making too great a dent in his gaming money.

"Six hundred pounds!" A villager spoke up from the rear of the crowd.

"Eight hundred," Darold called. He looked at the Elf again, hoping that Alen would see him, recognize him; wishing he had some way to let the Elf know he'd be safe soon.

"Thousand pounds." It was the first villager again.

"Thousand, two hundred." Darold steeled himself for a struggle. He shifted in the saddle, leaning forward to get a better view. *Gods, he's so beautiful. I want to bathe him, hold him.* He forced himself to pay attention, afraid that he'd be outbid.

"Thousand, five hundred." The crowd murmured, caught up in the bidding war that had developed between Darold and the villager.

"Two thousand pounds." Darold's clear tenor rang out. He would miss most of the gaming, but he felt sure that the villager couldn't match that offer.

The auctioneer's voice settled things. "Two thousand pounds, once, twice, sold! Pay at the front." Darold dismounted and moved through the crowd quickly, oblivious to their murmurs. He counted out the money, and was handed a lead and a set of keys by an attendant.

"He's a runner, so keep him chained. We're told he's a good toss, though. Knows what to do real well." He grinned at Darold. "Not that I suspect you're wanting for company, sir," he added, handing a document of sale to Darold.

Run—he can barely walk. He touched the Elf's arm. Alen raised his head slightly. Darold pointed out the direction they would go. Alen nodded, eyes blank. *He doesn't know me.* Disappointment coursed through him. Darold added Alen's lead to the horse's, and started back to the main plaza, moving slowly, so the

Elf could keep up. As they passed a food stall, Alen's eyes lit up. Noticing this, Darold stopped and purchased a vegetable pie. They sat on a nearby bench, and he handed the pie to Alen.

"I guess it'll be easier to eat if I remove these." He undid the wrist cuffs, and was assaulted by the odor of putrid flesh. "My God!" Alen ate so slowly that Darold wondered if he could keep the food down. Darold pointed to the ankle cuffs. "Will you run?" Alen shook his head, so Darold unlocked the cuffs, finding, as he expected, more infected flesh. "Oh Lord," he groaned. "And I've been making you walk. Can you forgive me?" He felt very stupid. "We're getting a healer." He hoped his voice would reassure the Elf, since he had no idea how much Alen understood. He looked around for help. He had to get the Elf onto his horse.

"The healer is waiting." Malcolm's warm baritone startled him. The tutor rode closer to the Elf, who cringed. "Easy, lad." Malcolm's Elvish was hesitant, and bore a heavy human accent, but Alen could understand him. "We're getting you help." He dismounted, lifted the shaking Elf, and placed him on Darold's horse. They walked to the healer's cottage, where Malcolm carried Alen inside.

▼▼▼

Alen woke in a warm, soft bed. For a moment, he thought he was home, then remembered the humans. He turned awkwardly. The taller man moved to his side. Fear washed over him.

"Easy, friend. You're safe. Are you hungry?" Alen nodded.

"Elvish!" Alen was shocked, although he'd heard that some humans could speak it. The tall man looked over his shoulder.

"Darold." The prince appeared at Malcolm's call, with a bowl of broth.

"Da-rold?" The Elf's voice was little more than a hoarse whisper.

"Yes, Alen. It's me." He smiled. Alen smiled back. "This is Malcolm."

"Mal-colm." He allowed the taller man to slip a strong hand under his back. Strong arms braced the Elf, as Darold fed him, a mouthful at a time. When Alen indicated he was full, Malcolm eased him down onto the pillows, while Darold smoothed the covers. Alen touched Malcolm's arm.

"Yes, Elfling?"

"You speak..." He had to know how Malcolm knew his tongue.

"Easy, Alen." Malcolm smiled. "I learned Elvish many years ago, in service to Darold's mother. It amused her to teach me." He chuckled at the memory. "We have to go out now. You rest." The Elf closed his eyes. Once his breathing indicated that he had fallen asleep, they left, making sure that the door was locked.

When Alen's eyes opened, he was alone. "Must get home." The urge to run was strong. He tried to rise, but fell back, dizzy from the effort.

He vaguely remembered Darold holding him in the woods. He sighed, recalling how strong Darold's arms were, how gently they'd circled him. *If only I had never left him.* He sighed. But he'd awakened with a fever and had looked for water to cool down in. And they'd come for him, then, and bound him between two trees. They'd gagged and beaten him, then left for their fire. Alen shifted, restless, hurting; in his mind, he was still hanging between the trees.

Shivering, Alen woke again, puzzled by the comfortable surroundings. Then he remembered that, somehow, Darold had saved him again. *Please, dear Ones, let them be gentle. I cannot take much more.* He wondered what payment they would exact for saving him. *If one must use me, please let it be Darold,* he prayed, remembering Darold's gentle touch. He closed his eyes and concentrated on the bed's softness. Soon he slept again.

▼▼▼

In the morning, the men had cut him down. Gloved hands fastened his wrists with cuffs of heated metal. His flesh sizzled at the

contact. He heard screams; realized they were his own. Rags were again stuffed in his mouth, choking him. Stakes were driven through the wrist chains, spreading his arms apart. Several low rocks were placed under him, raising him so his ass was exposed. His cock and balls lay exposed against the rocks, and his ankles were pulled far apart and fastened with more heated cuffs and chains through which stakes were driven.

Each man then took a turn at the Elf, tearing his anus, forcing himself into the small opening. Alen felt pain, sickness, then total humiliation as one of the men approached him from the front. His head was jerked up sharply, and the rags were pulled from his mouth, only to be replaced by an engorged penis. "Suck it," he was ordered. When he didn't comply, the man at his back started squeezing the Elf's penis, increasing the pressure steadily. Alen writhed in pain, but still showed no sign of comprehension. The man started to move back and forth in Alen's mouth. He then withdrew, and slapped the Elf's face. "Suck it off, damn you." He forced himself back into Alen's mouth, and laughed as the Elf gagged. "That's right. Take it all, you little nance." Soon he was climaxing, forcing Alen to swallow his fluids. After each had taken a turn at both the Elf's mouth and his ass, they wandered back to their fire, leaving Alen bleeding and exposed to the elements.

Unable to fight, he'd barely survived. By week's end, his throat was so bad that he could no longer scream. All that escaped were tiny mewling cries. He'd walled himself off, behind the pain and terror, as they broke his body. He understood they would sell him and was terrified.

▼▼▼

For two days, Alen was capable of little more than sleeping and eating, and he needed aid with the latter. He grew to recognize both voices, and the sounds of their routine. *I could be happy here,* he mused. *If only...* No matter when the panic or hunger arose, Darold was there to hold him, to feed him, to make things better.

He could even recognize the tune Darold hummed as one from that time in the woods.

The only worry he had was what they would want from him in payment. He had tried to ask, but the question had been brushed aside by both men. He sank back into his pillows, closing his eyes, imagining how Darold would feel in his arms; how the man's body would look next to his own. *Will he hurt? Be gentle?* Darold's merest touch set him ablaze. He longed to taste Darold's flesh, to stroke the long, dark hair. The prince's warm, brown eyes seemed to hold an invitation. "'Not now,'" the prince had said. Alen was tired and weak, but the bed was comfortable and the room was warm. He drifted between waking and sleep for most of the afternoon, dreaming of feelings he was afraid to explore.

▼▼▼

When Darold returned, the first thing he did was check to see if Alen had eaten, and was pleased to see that some of the food he had left for him was gone. He then moved to the bed.

"Alen. Wake up." His voice was gentle; his touch, soft. Alen turned and captured Darold in his arms. "No, Alen. Wake up." Darold shook the Elf gently. "I'd like to talk with you."

Alen opened his eyes, but didn't release Darold. "Stay like this," he prayed. "Hold me." He wished he knew more of the human tongue. He was growing to trust the prince. Darold disengaged, and mimed for Alen to turn on his stomach. The Elf did so, quaking, sure that now he'd have to pay for their kindness, willing to satisfy Darold's needs, but fearful of reopening his wounds.

"Easy, Alen. I just need to change your dressings. I'll try not to hurt you, but..." He felt Darold remove the bandages over his ass and apply something cool and soothing to the sore flesh. The probing fingers hurt, and he yelped. "Sorry." Darold's voice was soft; smooth as honeyed mead. Darold held him, trying to reassure him by tone of voice, then finished applying the healer's salve.

He applied fresh dressings to the raw areas, then knelt over the trembling Elf. "Here. This should help." He began massaging Alen's back, gentle with the newly healing flesh, working salve into it, feeling tension drain away. Eventually the Elf sighed, and Darold realized that he was very close to sleep. He covered Alen, then climbed into the bed and wrapped his arms around the small form, careful not to brush against his wounds. Alen turned at Darold's touch, and sighed, burying himself against the prince's warm body. *So nice,* Darold thought. *We should always sleep like this.* He felt himself drifting, and let go, wanting only to comfort Alen.

▼▼▼

Malcolm's footsteps woke Darold. "Lovely. Just lovely."

"Yes, Mal." He was vaguely embarrassed, but made no move to let go of Alen.

"Our business here is finished, Your Highness. Shall I arrange transport home?"

"I think we'll stay another day. He can't travel just yet."

"How is his English coming?"

"A word here and there. I think he understands more than he can speak."

"Most likely. He is intelligent, although so frightened."

"Can you blame him, Mal?"

"I guess not. But you should be careful." Malcolm directed his gaze to Alen, still snuggled in Darold's arms.

"Careful?"

"I fully expect you two will be lovers by the time I return."

"So?"

"Remember your position, Darold."

"What harm could such a dalliance cause?" Although he was annoyed at Malcolm, he kept his voice low, not wishing to disturb the sleeping Elf.

"You don't know Elves very well, Your Highness."

"No, but I must admit he is attractive." To himself he added, *And that's not the half of it.* He then dropped his bombshell. "And I suspect he's of royal blood."

"What?"

"I think he's the missing princeling."

"Still, caution is necessary."

"Caution?" Darold moved slightly, feeling Alen adjust to the new position.

"Of a certainty. Elves do not form relationships lightly. To Alen, such involvement would be much more than a dalliance."

"Mal," Darold was growing impatient.

"Listen to me. Elves are loyal until death. You have a responsibility to marry. If he is the missing prince, so does he. Besides, toying with someone's affections is never wise." Alen turned, caressing Darold's shoulder in his sleep. "See, he wants you already."

"Mal, why don't you have a bath drawn for Alen?"

"What about his bandages?"

"I can change them."

"Very well. I'll order one drawn on my way out."

▼▼▼

"Come in." It was the innkeeper's girl, with the water for Alen's bath. Darold helped her take the tub down from its hooks on the wall and placed it in the center of the room.

"Alen." The Elf mumbled and turned. "Alen, wake up, the water's here for your bath." Alen allowed Darold to remove the bandages and help him cross the room. He noticed the girl, and looked at Darold.

"Who...?"

"The innkeeper's girl. She brought the water." He touched the lip of one of the jugs.

"Do you need help, my lord?"

"Please. Pour some of the water in, while I steady him." Alen stood with his back to the girl, as she filled the tub about halfway with the heated water. Although she kept her eyes down, as befit her station, she couldn't help stealing a glance at the naked Elf as she placed the empty jug on the floor.

"Why, he's built much like men are." She almost raised her eyes, but caught herself in time. "Just what I'd need—a beating for not knowing my place. Ah, well, he's lovely at that."

"Ahhh." Darold could almost feel Alen's pleasure as the Elf eased himself into the water, leaning against Darold for support.

"Easy. Take your time." When Alen had settled himself against the back of the tub, Darold motioned to the girl. She stepped forward with soap and a cloth to wash the Elf. Darold took the soap and cloth. He noticed she was blushing, decided that she was embarrassed, and motioned for her to sit on one of the beds. She obeyed, using the opportunity to covertly study the Elf.

He began to wash Alen, taking care not to apply more pressure than necessary. "So beautiful. So delicate." His hands traced the curve of Alen's ears, then played down the Elf's neck. Excitement coursed through him. "Alen, am I rubbing too hard?" He stopped, mimed what he meant, and was rewarded by a negative shake of the Elf's head. He wished they were alone together, so he could explore Alen's body openly. The Elf fascinated him, from the points of his ears, peaking through the damp, tousled hair, to his slender hips, his well-shaped genitals, his toes. He imagined Alen's hair flashing gold in the sun, and had to force himself to breathe again. After the Elf had been thoroughly soaped and rinsed, Darold helped him step from the tub. The girl poured the dirty water into the jugs, then wiped the insides of the tub. She removed the jug from the room, then returned with fresh warmed water, refilled the tub, then left. Darold took one of the potions the healer had given him, and poured it into the water. He then helped Alen back into the tub, and began massaging the Elf's skin. *His skin is so*

soft. So beautiful. He suddenly wanted to kiss Alen from throat to groin, to feel the his lips against the Elf's flesh. *If I start, what will happen?* He shook his head to clear it. *Fool,* he told himself. *You'll scare him half to death. Still*—he sighed—*it would be wonderful.*

"Darold?" Alen's voice broke into his reverie.

"Gods. You must be chilled to the bone." He helped Alen out of the tub, and dried him with the thickest, softest cloths he'd been able to obtain. "I'm so sorry." He held Alen close for a moment, appreciating the warmth of the Elf's flesh, then helped him take the few steps to the bed. "Sleep now, love." He helped Alen slip under the covers and find a comfortable position. "Shall I play?" He reached for his lute. Alen nodded, and let the music soothe him. The last things he was conscious of were the softness of the pillows, the warmth of the room, and the sweet music Darold was playing.

In Alen's dream, Darold was holding him, caressing skin, kissing. He wanted Darold, wanted to love him, to be with him forever. *Well,* he amended, *as long as he lives.* He knew the prince would look beautiful naked, and sighed softly. Dark, long hair to get lost in, Darold's large, easy grin flashing for him, all the things Alen wanted to share, but didn't know how—it was all in his dream, and he wanted it never to end.

Darold studied the sleeping Elf, trying to sort out his own jumbled emotions. The Elf's beauty left him breathless. *I want him.* The strength of his desire shocked him. He wanted nothing more from life than to stay next to Alen, to protect him, although he wasn't sure why. Sighing, he climbed into bed, pulled the covers over them both, and buried himself beside Alen, folding the Elf into his arms, listening to the regular rhythm of his breathing, letting his hands play over the Elf's back in long, gentle caresses, feeling the soft hair that covered Alen's chest. *Never felt so good before.* He realized that what he felt for the Elf could be called love—the love that poets wrote about—the love normally reserved for members of the opposite sex. Still, his heart felt full

just holding the Elf. He wondered what sex between them would be like, and if they could be together without his aggravating Alen's already severe injuries. He was afraid suddenly: Alen had undergone so much. *Will he understand the difference between rape and love? Could he ever love me back? Will he even know what "love" means?* He turned, restless. Alen's hand was against his chest in a moment. "Love?" Darold's voice was quiet.

"Mmm." Alen moved closer, responding more to Darold's tone of voice than his words. Darold held him close to his chest, inhaling the scent of his hair and skin.

Damn, this feels so—he searched for the word—*natural.* Malcolm's words echoed in his mind: *"Elves are loyal until death." Could Alen feel that way? Could he make a commitment like that? Even to one he loved? Could I?*

When Alen's eyes opened, Darold was watching. Sensing that something in Darold had changed, the Elf tried to smile, but his wariness was evident. "Easy, love. I'll never hurt you." Alen nodded, waiting. Darold had no idea what to do next. *How in the name of the gods can I tell him what I feel?* He'd never made love to a man, let alone a male Elf, and had no idea where to begin. *At least, if he were female, I could guess at what to do.* He captured one of Alen's hands in his, raised it to his mouth and kissed the back of it. Alen returned the gesture, then opened his arms. They held and stroked each other for some time, each lost in his own thoughts, each wondering how to communicate his feelings to the other. The Elf pointed to Darold's mouth, and asked something in Elvish.

"Mouth," Darold replied, realizing what Alen wanted. The Elf repeated the word several times, fixing it in his memory. As they explored each other's bodies, Alen pointed to various features, repeating the human names until he knew them. Eventually his hands wandered below Darold's waist, and touched his genitals. Darold gasped with delight. "Cock and balls." Darold showed him which was which.

"Darold, I..." Alen tried to communicate what his urges were. Darold sighed, checking his own urges, and turned the small face toward his.

"Not yet, Elfling. When you're healed." Alen caught the meaning from Darold's tone, and disappointment filled blue-gray eyes. "Don't worry, my love," Darold continued. "There's plenty of time for us." He caressed the Elf's hair, and held him close. Entwined, they drifted to sleep.

▼▼▼

Although the servants had been surprised, there were no objections when Darold installed Alen in his rooms, and his orders to keep silence about his guest were observed. The Elf had been bathed by Darold, and given his finest nightclothes, causing much speculation among the staff. He now lay in an even softer bed than the one he'd known at the inn.

Darold had gone to dinner in the Great Hall, although he'd have much preferred staying with Alen. Discussion centered around the news that an Elvish delegation was approximately two days away from the castle, carrying a declaration of war. He debated revealing that Alen was his guest, but was afraid that the Elf would be used as a hostage. Excusing himself early, he returned to his chambers.

Finding Alen asleep, he sat at his table, and tried to think. He knew his fate lay with Alen, and was beginning to wonder how close to his own generation the Elvish blood ran; how much he'd inherited from them. His thoughts were interrupted by a soft knock.

"Darold, child." It was his mother. He gestured to Malcolm, who opened the door.

"My Lady Mother," he dropped to his knee.

"Rise, my sweet. May I sit with you?"

"Of course, Mother, but I'm not alone." He glanced at the bed.

"I was aware of that, child. May I see him?" Darold studied her as she moved across the room. *Stately,* he thought, *so serene.* He realized that he'd never seen her lose her temper, and wondered if that was part of the Elvish heritage.

She stood by the bed, studying Alen's features. Darold started, noticing how similar they looked. He wanted to question her about it, but could think of no tactful way to do so. "So, this is your destiny, my sweet? He is quite pretty. He sleeps well?"

"His name is Alen, Mother. He sleeps poorly. The journey here was difficult."

"I assume you have not mentioned him to your father." She moved to the writing table and sat, skirt rustling as she rearranged her shift.

"No, Mother." He motioned to Malcolm, who moved a chair across the table so Darold could sit facing her. He sat on the edge of the chair, and waited.

"Good. He can be quite closed to reason, especially about things Elvish."

"Mother, I'm going with Alen." Darold glanced at the bed. *Good,* he thought. *Still asleep.*

"And where will you go, Elf and prince?"

"Wherever he takes me. To his land first, I think."

She sighed, shaking her head. "Will his parents welcome their son's human lover, a man, when they learn what men did to him?"

"I have no idea. I can manage, though." He relaxed a bit, and stretched long legs under the table.

"Can you, Darold?"

"Yes, Mother. After all, you have Elvish ancestors, so I must have some of their blood, too." She recoiled as if he had slapped her.

"You think they will welcome a halfling?" He nodded. "You are very much mistaken, my boy." Her laugh was bitter. "They have no love for such as you. Still, I wish you luck." She started out of the room, then turned, as Darold called her back.

"Mother, do you think that, if Alen and I are formally bonded, the war could be averted?"

She thought for a bit. "Stranger things have happened, child. But I think it more likely that your father and Alen's will turn you both out. After all, such a union would provide neither kingdom with an heir. It would be difficult, at best." She sat down at his table again.

"But it would give both kingdoms a stake in keeping the peace."

"Your father and I thought that once. Apparently, we were wrong." She laughed bitterly. "You are so much like me, child."

"Mother?"

"Darold, why do you run to the forest so often?"

"Peace, quiet." He shrugged. "Room to compose music. Sanity, I suppose."

"The call of your blood, perhaps?"

"Mother?"

"Darold, the Elvish blood in you is mine. I am a full-blooded Elf. If you and Alen choose to be bonded, there is nothing that can be done to prevent it. He is full-blooded and you are half-blooded. But it will not be easy, no matter where you settle."

"I don't want 'easy.' I want Alen." The determination in his voice surprised even him.

"Then trust your instinct to lead you on the right road." She took his hand, pressed it to her cheek, then pressed a small purse into it. "For your journey; may it be blessed." She left him then, knowing where her son's destiny lay, praying his road would not be as hard as hers had been.

When she was gone, Darold looked at the bed. Alen rested peacefully, eyes half-closed. This, he knew, meant he'd been watching but hadn't wanted to intrude. Darold dismissed Malcolm, then looked at Alen. Alen held the covers apart, an invitation Darold did not ignore. He stripped and slipped under the covers, hoping his nervousness didn't show.

Alen caressed Darold's back, slowly, his touch gentle. Darold shivered. "Tonight, my prince?" Alen asked, pulling away from Darold.

"Yes, my Elf. Tonight." He held Alen close, hoping the Elf would not notice his tears. Alen did notice, but said nothing; just continued caressing Darold's flesh. He knew that Darold returned his feelings, but he wasn't sure how to start. His lips brushed Darold's face, licking away the salty wetness. He ran his hand down Darold's torso, exploring the soft skin, wanting Darold to explore him. He wondered if the human would respond to him. Cautiously, Darold did so, letting his fingers play over Alen's chest, enjoying the delighted gasps when he touched the two small, hardening nipples.

"Alen. Show me how to ... to love you." Darold whispered. He was afraid, not knowing whether Alen would be gentle or rough. Alen's hands traveled the length of Darold's body, roughly kneading his flesh.

"Yes." He had long anticipated this. "Yes, Darold." He gasped as Darold's hand touched his genitals.

Darold's emotions were in a complete tumult, as he stroked and probed the Elf. *Sweet*, he thought, kissing Alen, letting his tongue taste the Elf's mouth. He gave himself over to the sensations coursing through him. *Please, let me not hurt him*, he prayed silently, hoping that Alen would be able to take his love.

Alen shifted his position so that he was looking directly at the prince's cock. Shivering a little, he took it into his mouth, and sucked, feeling Darold's hips arch.

My Gods! Never felt so... Darold tried to search for the right word, but was distracted by Alen's tongue and hands. Each touch sent hot fire pooling somewhere not quite in his belly. He obeyed his body, and the Elf's hands, and soon was climaxing. He could feel Alen swallowing, then soft, Elfin hands eased him down on the bed. "Our bed," he sighed to himself, spent.

Alen turned the prince onto his stomach. Hands moved along his body, positioning him for ... whatever. Darold didn't care. He trusted Alen, and wanted everything the Elf could give him. He kneeled, open, expectant, and Alen didn't disappoint him. The Elf slipped between Darold's knees, gently spread his ass, and rested his thickened cock along the crack. He moistened his finger with his tongue, then placed it at the opening. He worked the small hole with his finger, until he felt Darold open and moisten. Darold buried his face in the pillows, not knowing how he'd handle Alen's entry, but wanting it more than he had ever wanted anything.

Although Alen was gentle, his entry hurt, and Darold groaned into the pillows, shuddering with pleasure/pain. Alen wrapped his arms around Darold's waist, and lay still, waiting for the man's body to get used to having him inside. When he did start moving, it was with long slow strokes, allowing Darold to feel his hardness.

So good. All Darold's attention was on Alen's cock. He grunted in pleasure as Alen moved against him. "Alen!"

"Darold?" Alen stopped, held the prince close, stroked his chest. "What do you wish?"

"You ... Oh, Gods!"

"How?" His voice was teasing. He withdrew as far as possible, until just the tip of his shaft caressed Darold's opening.

"In me." The prince's voice was almost a growl. "I want you in me."

"Do you, my love?" Alen asked, voice light as air. Darold nodded, not trusting his voice.

"Tell me."

"I want you to make love to me, and"—he stumbled for the words—"I want to make love to you, Elfling."

"Want you, too." The Elf thrust into Darold, hard. He reached for Darold's nipples, and found them erect. "Yes," he sighed, letting his hands play over the fleshy knobs. "You like this?" He

pulled at Darold's flesh while thrusting forward roughly, and felt the human respond. He continued thrusting into Darold, feeling the man press against him to take his cock better. His hands traveled down Darold's torso until they found his semierect shaft. He could feel his balls slapping against Darold, and the pressure excited him even more. A drop of blood welled, unnoticed, as, in his concentration on Darold, he bit his own lip. As they approached climax, he thrust harder and faster into Darold, who was bucking against him wildly.

"Don't ever stop!" he begged Alen. He shuddered as the Elf caressed his exposed penis.

"No?" The Elf forced himself to slow down.

"I—" he gasped as Alen drove into him again. He could feel every inch of the Elf's engorged cock—could feel it at the center of his stomach. "I need you, Alen." Words tumbled forth as if a dam had burst. "Need you in me. Need you to love me. Need you forever!" Alen drew out slowly; to Darold it seemed torture.

"Need you too." Darold's flesh burned under his touch. "You understand." He thrust into the waiting prince, so hard that Darold thought he would split wide open. Cries of pleasure turned to a scream of pain on one deep, hard thrust.

"Darold?" He withdrew, turned the prince and gathered him into his arms. "Darold?" The prince's tear-streaked face told him what he needed. "Not mean ... to hurt." Alen covered his face and neck with kisses. "Try again?" Darold nodded, slowly.

Alen remounted Darold, and fingered the prince's anus until Darold indicated he was ready. He then pushed in, a bit at a time. Soon, they had grown accustomed to each other's movements, and they managed to match their rhythms. Alen's hands exerted a soft steady pressure on Darold's already stiff cock, and soon Darold was ready. He could barely get the words out. "Take me!"

"Yes..." Alen's voice was little more than a rasp of breath. He knew he was going to explode, and that Darold would take it all. He prayed it would be good for the prince. Darold felt

Alen's orgasm, white-hot cum pouring into him, as the Elf repeatedly pushed deeper and deeper, unable to control his climax, driven as if by madness. Soon he lay spent against the taller man.

Darold eased himself down, and Alen slid away from him, then melted into his arms. "Alen, love?"

"Yes, my prince?"

"Show me."

"Hmm?" He felt so lazy, so full.

"Show me how to love you like that." Darold's voice was full of wonder and tenderness. He stroked Alen's back, then wrapped his arms around the Elf.

"So tired," he mumbled, "Need to rest."

"Of course, my love. We have all the time we need. Besides, I have an idea." Caressing the Elf, he tried to explain his plan. "Can you ride, love?" Alen nodded, wondering what Darold had in mind. "We should leave early," he explained. "I want to find your people." Alen shook in Darold's arms. "Easy, my love. I just want them to know that you are well." The Elf nodded. "Then, I will go with you." A question formed in Alen's eyes. "Yes, my heart, forever." Amidst gentle caresses and laughter, they fell asleep, and when they woke, Darold knew his decision was the right one—the only one.

▼▼▼

They left the castle at dawn—three figures on horseback. Darold had not taken much; he hoped they would find the delegation of riders soon. He had no idea what their reception would be, but he knew for certain that he belonged with Alen.

Deborah J. Wunder was born in Richmond Hill, New York, where women grew up to be secretaries, not writers. She hopes that one day writing will pay enough of the bills that she can stop doing office work. Her stories have appeared in various anthologies, including Christmas Ghosts, *edited by Mike Resnick and Martin H. Greenberg;* Alien Pregnant by Elvis, *edited by Esther Friesner and Martin H. Greenberg; and* Aladdin: Master of the Lamp, *edited by Mike Resnick and Martin H. Greenberg.*

MATE

by
Lauren P. Burka

Acknowledgments

Special thanks to the New England Leather Fen; Dancer, for illustrating on a heinous deadline; and P&F, who hugged me when the hard drive crashed, taking with it the first draft of "Snowflake."

Introduction

This collection of fiction is a work in two traditions: pornography and science fiction. Since the writing of *Coming to Power* and *Macho Sluts*, anthologies of challenging and different erotic fiction have traditionally begun with a political rant. Science fiction stories, on the other hand, usually present political issues as satire, the subtlety of which has saved many an author from censorship and prosecution.

Now more so than in the recent past, publishing pornography is a political act. As I write this, both the legislatures of the United States and of Massachusetts are considering laws that would, if passed, expose the authors, publishers, and distributors of pornography to a crippling risk of lawsuit. Thus my first print publication, which should be an occasion for joy, has also caused me some anxiety and a little bitterness.

I could write for pages about the evils of censorship. I would, however, be preaching to the converted. If you are reading my stories looking for something to condemn, I can say nothing to appease you, and therefore I won't waste my time. Instead, I would like to address what I think are the three big lies about sex in science fiction.

1. *Sex always has been in the past, and will be in the future, exactly as it is now.* In our discomfort with topics of sexuality, we forget that a single sexual act may encompass pleasure, communication, emotional gratification, religion, reproduction, performing or creative art, or idle diversion. The ancient Hebrews encountered

tribes who worshipped their gods by having homosexual sex with temple prostitutes. Thus a prohibition against homosexuality was codified in the Old Testament. In many cities in ancient Greece, however, most young men entered into relationships with older men, who would act as role models and patrons. Members of the Cathar heresies in the medieval south of France taught, in opposition to the Catholic Church, that sex was permitted as long as it didn't result in children. The sex lives of most modern humans have been altered by the inventions of birth control and the advent of the AIDS virus.

Given a rich human history of fucking, it is often disappointing to read science fiction stories that present the same sex I could watch by turning on cable television. If an author can postulate space shuttles taking off from Logan Airport, why must he or she write about relationships that are clearly relics of late capitalist America?

2. *Violent fantasies are a sign of emotional problems.* Fantasy is as valid a sexual sense as touch and taste are. Many of us, before we really understood that we were sexual creatures, first got that warm feeling when reading tales of brave heroes who were captured, tied up, and tortured. Writing about sex may ensure that an author's book never sees the shelves. Violence, on the other hand, is almost always a safe topic. Many authors are quite adept at coding the most delicately arousing scenes without the mention of genitalia or the slightest scent of sexual fluid, merely in writing the smack of leather on flesh, the ringing of sword blades in battle, and the shedding of tears.

Even after we have discovered the adult corners of the bookstore, we are unlikely to abandon our fantasies. For it is even more important to fantasize about the things we can't do. One person will dream about being captured, afflicted with the most degrading tortures, yet refusing to divulge the secret plans. Another will wish to spill the blood of the one who betrayed her. And still another will fancy being a slave, or owning one. Even if none of

them would want to live out these fantasies, why should they give up the comfort of dreams? Tears, rage, and violence are valid human experiences. Why shouldn't one's most powerful fantasies be about living through sadness, and finding joy in pain?

3. *Women don't read or write pornography.* It is a myth that women don't enjoy reading about sex, writing smutty stories, or illustrating the bodies of naked and aroused human beings. Women believe the myth because they have internalized genera-tions of patriarchal hatred of their bodies, minds, and sexual beings. It is both sad and dangerous that some women will coop-erate to suppress the erotic imaginations of others.

I am a woman; I write pornography. I see no contradiction. My characters have genitals just as they have faces and hands. As they eat, sleep, work, and play, so they also make love. Without further delay, I welcome you into their worlds.

<div align="right">

Lauren P. Burka
Boston, Massachusetts
April 1992

</div>

Mate

Being a tale of love, pain, sex, relationships,
and boring government jobs

On Wednesday Terry lost at chess.

He sat back in his chair and stared at the game board as it faded away. The program recorded his losing score. Terry didn't lose often. His console prompted him with several unread mail messages, which he ignored. Removing the headset, Terry blinked as his eyes adjusted and stared about the office.

The C3A building, where Terry worked, was a modern, terraced office building a bit smaller than a football field. The lowest and most central area held a fountain, grass, maple trees, and a small bit of carefully reconstructed parkland. The walls were lined with the balconied offices of those important enough to merit privacy. High above, the polarized ceiling admitted the glare of the yellow, polluted, northern Virginia summer sky.

As Terry sat in his low-walled cubicle in the center of that glass cavern, he could never have known who was staring down from a curtained window, smiling in triumph, knowing something that Terry did not. The winner need not even be in the building, though the metachess server ran off a C3A machine. Access was easy to arrange from a remote site. Terry's conqueror could have been at Caltech, for all he knew.

Terry was disturbed. Who on the Net was that good? Was it Daphne?

Packing up his things for the day, Terry locked out the console and headed for the underground, deep in thought. Once out of the Classified area, Terry passed few people. On weekday nights, the stores were nearly empty. Bored doormen lounged about the hotel entrances. A small pack of young punks clad in tight, old leather and bright new chains had spilled out of the Sense Arcade, daring the security guards to chase them away. One of them, vampire pale and androgynous, turned and gestured a sexual come-on so blatant that Terry missed his step and walked into a potted plant. Stung by their laughter, and certain they could smell his confusion, Terry hurried down the mass transit entrance.

Metro had finally gotten climate control fixed in the subway. The station was cool and pleasant and smelled only slightly of sulfur. The aseptic walls and crisp advertisements were familiar and reassuring.

Terry's train whisked out of the station and over the Potomac River. He looked back at the spidery mass of Crystal City, its hotels and DoD offices, restaurants built on expense account dining, and the hulking air-conditioned fortress of the Communication Authority. Terry wondered again about the metachess wizard who had beaten him. If it wasn't Daphne, could it have been the same person who cracked the Gateway?

Daphne was already home, but scarcely lifted her head from her console when Terry came in.

"How was your day?" he asked.

"Shitty."

Terry sighed and went to microwave dinner.

He knew why Daphne was so busy. Hers was the first class to graduate since the phone system disasters of '12. The Government had been riding the new generation of computer geniuses hard, offering them unlimited loans if only they'd build the talent and discipline to keep the Net in one piece. After Daphne passed this last set of exams, she'd be bound to a civil service job for the next three years. How good a job depended on her GPA. Daphne

was brilliant, first in her class, and likely to graduate with all honors.

Sometimes Terry wished she still had the time to love him.

At length, Daphne logged out. She tipped her chair back against the wall and tapped her fingers against her knee. Her face was pale and her blonde hair greenish in the fluorescent light.

"I aced Queue Theory," she said. "One more exam to go."

"That's good. I lost a game of metachess."

She chewed the end of a stylus idly.

"I don't know who to, either. They left no ID."

Terry was watching Daphne. It could still be her. She had been known to lie.

"You ate?" he asked.

"Yeah. Ordered a pizza."

Terry finished dinner and dumped the plate down the recycle bin.

"They're bringing in the big guns on the Gateway security problem," he offered. When she was silent, he continued hopefully. "They hired lots of outside consultants and are turning the whole Authority upside down. All staff have been asked to submit to scan. My turn is tomorrow morning."

She nodded as if to be polite.

And then, since words were useless, Terry went and knelt and pressed his head against her knee. She was quite still for a long time. He stole a glance upward at her face, and wasn't sure what bothered him more, his sexual hunger or her indifference.

At last Daphne pushed him away and walked to the closet. Standing, she was taller than he, even in bare feet. Terry scarcely drew a breath as she dropped a handful of stuff on the couch.

"Come here and take your shirt off."

Terry obeyed. Daphne clasped his wrists in a pair of handcuffs, then, pulling Terry down to his knees, padlocked them to the eyebolt set in the bottom of the couch. Daphne dropped down to sit in front of him, her denim-clad legs spread wide, and pressed

something unyielding against his lips. It was the rubber handle of her whip.

"Eat this," she ordered.

Terry opened his mouth. Instantly Daphne shoved the whip handle against the back of his throat. He tilted his head and swallowed, feeling the tears drip down his face. He was never really sure what she got out of it, aside from the obvious dominance kick. Maybe that was enough. His own jeans were becoming unbearably tight.

Daphne fucked his mouth a few more times, then pulled the whip out, wiping the handle on Terry's shirt. Then she stood up.

Terry rested his head against the edge of the couch. No matter how much he begged to be beaten with her three-tailed whip, the moment of terror before it struck was almost too much to bear. After she began, the rising adrenaline rush would wipe out his fear. Now he chewed his lips to keep from asking for mercy. One word and she'd release him, lose interest, and return to her console. And that wasn't what he really wanted.

▼▼▼

The first stroke of the whip bit into his back with the lazy deliberation of a cat at a scratching post. Terry cringed and closed his teeth on the couch. He could smell the oiled length of the whip as it cut the air, then his flesh. Blow followed blow, regular as clockwork. Daphne wasn't strong, but her whip was nasty artillery. The fire in Terry's skin consumed doubt and confusion like some live and hungry thing. Terry was getting hard, faster than the stoned feeling was emptying the thoughts out of his brain.

Then Daphne stopped. Something bounced on the cushion before his face. It was the key to the cuffs. Behind Terry, a door shut, the door to her bedroom, with her on one side and him on the other.

Terry knelt there, panting, not quite believing. He snagged the keys with his teeth, brought them down to his fingers, and started

working at the locks. When he had freed his hands, he didn't stop to take his jeans off, but pressed his erection against the edge of the couch. He came so hard that his foot cramped and he had to step on it before the pain went away. It wasn't the kind of pain he wanted.

Dropping his clothes in the corner of his tiny room, Terry went to the bathroom to check his back. He was bleeding in a couple of places, with an impressive set of welts. Terry showered briefly and then tried, with partial success, to spread disinfectant over his back.

Terry's room was actually a closet with a bed. It had no windows. Most summer days he slept on the couch to catch the breath of Daphne's air conditioner as it leaked under her door. Once he used to sleep in bed with her.

Terry lay down on his stomach and stared out the window. The pollution made the sunsets beautiful, deep and red. It almost made up for air too hot and harsh to breathe.

Did he really think himself lucky for having Daphne? She did let him stay in her place, a boon in the midst of a severe housing shortage. And Terry couldn't exactly afford to be picky. Femme dominants were in short supply, and men like him too numerous to count.

Daphne used to love him. After that, she had hurt him as a favor. Lately, she did it out of simple cruelty. He considered, as he did every night, dumping her for someone vanilla, someone less brilliant and preoccupied and more personable, who talked to him once in a while.

It was just Terry's misfortune to turn on to intelligence harder than to anything else except, maybe, a touch of leather.

"Montiero! Get in the conference room now. They're waiting for you."

Terry glanced at the console clock as Johnson's abrupt verbal message thundered in his ear. It was 8:15 in the morning.

"But I'm early. I thought..."

"Someone ahead of you canceled out. Get moving. We're paying the team by the hour."

Paying them a good four times as much as Terry made in a day, he thought.

That someone had decided to pass on the scan did not surprise Terry. Their employer could not legally fire or deny promotion to them because of it. But if Terry didn't get his raise, he couldn't prove why.

A frustrated ACLU had tried to outlaw scanning. But they couldn't explain to the middle-aged members of the Supreme Court, who had never had a pickup planted next to their skulls, and never played a coin-op VR game or lost their sight from poorly tuned equipment, how a scan really felt. There was no objective measurement for that kind of feeling. Besides, this wasn't a polygraph test. Terry's employer didn't really think he had anything to do with the security problem, only that he might have something buried in his subconscious that would help them find the guilty party. Or name a scapegoat?

Terry took a right turn at the glass-fronted machine room. Behind the clear wall and sprinkle of condensation, the Gateway itself, a compound entity of Digital and SG/C machines, worked silently, routing all the communication traffic on the East Coast, switching impulses to Michigan via satellite, overseas to Europe, underground to Boston, and to a matching gateway in Palo Alto. The whole world in a fish tank, Terry thought. Or all the world that counted. The building's architects left the computers visible because they really were beautiful. There was a symbolic map on the wall that showed traffic all over North America. Terry remembered after the big earthquake, when the lights tracing traffic to Boston had grown too bright to see as everyone phoned their relatives in that city to see if they were safe.

A harassed-looking secretary was working a transcription set outside the conference room. She glanced up and pointed to a

chair. Terry sat. And waited. He'd been told to hurry. Were they trying to keep him off balance? It was working.

Just before ten, the conference door clicked open. The secretary pulled her wire from under her hair and took her coffee up from the warming pad.

"You may go in now."

The conference room was paneled in wood, and could have held twenty. There were only two. One was partially hidden in a corner behind a bank of consoles and a box of donuts. The other was a woman, red-haired, dressed in a suit and heels just high enough to be formal. She stood as Terry entered and smiled the exact degree calculated to be soothing.

"Welcome." She came around the table and shook his hand. "Terry Montiero. I'm Louisa Arnold. Would you like some coffee before we begin?"

Terry hated coffee, but his mouth was dry. "Sure."

Arnold nodded. "Grey? Coffee for us both."

Terry glanced around. Grey wasn't a description of the coffee, but the name of the second person, who emerged from behind the consoles. He was small, dressed in denim, an old rock concert T-shirt, and a cowboy hat. Terry blinked. Technicians didn't have to dress up, but they usually did when paid as much as this pair was getting. He transferred his attention back to Arnold, who was taking her coffee from Grey.

"You should already have read the disclosure form on synch scan. We're going to ask you to read it again, and sign it."

Grey put the other coffee cup down on the table by a paper and indicated that Terry was to sit.

Paper was an expensive old habit of the federal government. Terry took a mouthful of the coffee, grimaced, and swallowed. The disclosure informed him in dry language that he was not entitled to sue for any damages caused by synchronized neural scan, and that any injury that prevented him from working was covered by his health insurance. Terry had read it before. He signed.

Grey took the paper and dropped it into a folder. The tech pulled a box out from under the table with his sneaker-clad foot, reached down, and picked up a handful of contacts. His hair was black and shoulder-length, Terry noted. Techs usually had a collection of skull sockets, and would either shave their heads to show them off or grow their hair for camouflage. Out of context, this tech would look like no one special.

"Please finish your coffee now," Arnold said.

Terry took another small swallow and then pushed the cup away.

Grey reached for Terry's right wrist. There was a shock at the contact. Terry jumped. It was just that, a shock from the dry air and friction on the carpet. He watched Grey's face as the other wet Terry's right wrist with saline from a squeeze bottle and clipped the band around it. Grey's eyes were blue and sharp under his hat. His mouth was softer, slightly open in concentration. He smelled faintly of soap.

Grey put a matching band on Terry's left wrist.

Arnold said, "Please leave your hands on the table."

Terry hastily put his palms upon the polished wood. The chair beneath him, he noted idly, was made of leather. This conference room was usually reserved for other, more honored guests.

A hand on the back of his neck encouraged him to tip his head forward. Instantly he felt something cold behind his right ear as Grey held a lead against the socket set in his skull. Something in Terry's brain clicked. He felt/heard the familiar whisper of data traversing the wire. He glanced up briefly. Arnold had taken a seat at the opposite end of the table and connected to the table console. Grey made his way back to the corner, dropped into a chair, and shoved his own wire into place behind his ear.

Instantly Terry's vision went blank.

"Please relax."

The voice was no voice, data on the wire. It didn't sound like Arnold, but then it didn't sound like anyone in particular.

Generic voice, genderless, constructed for a commercial. Nonthreatening. The blindness resolved to a soft fall of snow, as if seen through a window. Terry felt himself sitting back in the chair.

He gave a sharp, involuntary gasp as his welted back, almost forgotten, hit the upholstery. Instantly something cool dripped into his veins. Terry was safe. There was no pain. He was held as loosely as a puppet with no strings. He couldn't hurt himself, not even, in a fit of panic, rip the contacts away from his body and burn out the nerves. Time passed.

"We will ask you questions. You will answer them truthfully, and at length."

Terry nodded. Or something to that effect.

His assent was noted, recorded. Terry's brain, unoccupied, reported a scent of leather from the chair. Smell wasn't important. They'd left him that. This was like the time Daphne had left him tied to the bed in the dark.

"What is your name?"

"Terry Montiero."

"Where do you live?"

"1800 Kensington Street 14A, Silver Spring, Maryland."

"What is your job title?"

They would have this information in his file, of course. But they asked him anyway, to get a baseline response.

"Assistant to Daniel Johnson, director of Gateway East."

"What does your job entail?"

"I ... manage Johnson's correspondence. He dictates into a pickup, and I have to clean up his letters to text. I edit out the random thoughts about his kids, his feud with the Transportation secretary, and having sex with his wife. Johnson's wife, not the Transec's."

And such boring sex it was, too. So few people in the world really knew how much sweeter a kiss tasted after the sting of leather. Terry pulled his thoughts back on track.

"It's still supposed to cost less than having him type it out himself, even though the pickup records everything he thinks."

As you're recording everything I think. Do you hear this?

"Obviously," Terry continued, "my job requires a lot of discretion, as well as good comprehension of written English. I had a minor in literature in college..."

"Do you like your job?"

"Yes. It pays well..."

"Terry, we asked you not to lie."

Terry felt the first touch of real fear. Something tugged at his mind, like a trainer jerking a dog's choke-chain. It was a warning.

"Okay. I don't like my job. The hours suck. I'm not a morning person. And Johnson, for all that he's in charge of the most important computers in the Capital area, is a remarkable technophobe. He can't even reboot his own console. I'm not the least bit surprised that things don't always work quite right. It's frustrating, and often an insult to my intelligence. And if I hadn't fucked up my final exams last year—I broke up with a girlfriend and got drunk the night before—I'd be over in NASA programming something useful. Satisfied?"

"What do you think doesn't work right about Gateway East?"

Terry noted the condescension implicit in the wording. To criticize the Authority, even so obliquely, had the slimy taste of treason.

"We're generally over budget by a good seventeen percent. Johnson could have gotten the last cable laid though the Amtrak tunnel, but then he got in a fight with Transportation. It was all political. The consoles are all IBM models and cost too much and don't work nearly as well as the same thing made by Northern Telecom. They also crash the SG/C machines. Then there's the security thing. This is why we're here, right?"

"What security problems?"

This was the hard part. Terry thought, *I didn't do it.* He wondered if that made him look guilty.

"You know ... well, first there was the data leak. A certain amount of electronic mail just wasn't getting to its destination. As if someone was reading what was in them and accidentally messing up the addresses. That stopped really quickly after we noticed it. But then there was that bidding scandal over the new weather satellite, and we figured someone was still reading the mail. That's about all I know."

"Who do you think is doing it?"

"I honestly have no idea."

"Who do you know outside of Crystal City Communication Authority who might have the skills to crack government security?"

"No one."

"Who do you know who works with the Net on a regular basis?"

"No one. There's Daphne, my girlfriend, but she's still in grad school."

Terry thought about the player who had beat him at metachess.

There was a long pause, noticeable even in Terry's disoriented state.

It was scary, yes, but far from intolerable. Compared to Daphne's whip, synch scan was just a nuisance. Terry hated to beg for pain, and resented the possibility of mercy. Seen that way, this nonconsensual mental strip-search was almost interesting.

Terry told himself not to get too interested. He still had to finish up work for the day.

"Open your eyes."

Terry blinked. Grey was sitting still behind the console, chin on hand, staring at him. The other blinked once, then stood up. Arnold was keying her console. Grey got up and pulled the contacts off of Terry.

"That's it," Arnold said. "Thank you for your cooperation."

Terry stood up and stretched clumsily, never taking his eyes from Arnold.

"I hope you enjoyed it."

Arnold glanced up. "You may go now."

Terry gave a sarcastic bow and backed out the door.

▼▼▼

"Top of my class," Daphne was saying. "I really did it."

"Work was a pain today. After the scan, nothing went right."

"Um. How was it?"

"Like having my brains sucked out my nose."

Daphne nodded. The buzzer for the door downstairs rang.

"That's the sushi," she said.

After paying the delivery person, they sat down for dinner.

"So tell me about the scan."

Terry was startled a bit. Daphne didn't usually care enough about his life to ask.

"They asked me lots of questions, of course. There were two of them, a woman named Arnold and an assistant named Grey."

Daphne chewed and swallowed her tuna.

She said, "Grey. Short guy, wearing a Stetson?"

"Yeah. You know him?"

"They put one over on you. That was no assistant. That was d'Schane Grey."

"D'Schane ... oh." Terry swallowed. "Oh. Wow. I feel pretty stupid."

Daphne favored him with a rare smile.

"Yeah, he does that to people. He was a visiting professor at Georgetown, on leave from MIT, when I was a sophomore. Taught a class on security. One of the best classes I ever had, and the hardest."

She paused for another bite.

"First lecture he came in, in jeans and that hat, and told us that computer security was a myth. But a marketable myth. George Lucas got rich selling myth, and so could we. Our final exam was to find a security hole and to exploit it. Any security

hole. This one student charged $7,000 to Grey's Citibank card. Grey thought it was pretty funny, but only gave the guy a C because he figured out who it was without asking, though he let the money slide.

"His whole philosophy was that it didn't matter how well you knew your operating system, though knowledge certainly helps. If a computer is connected to the Net, any high school student can find holes faster than you can patch them up. It's all psychology and intuition. You have to know how they think before they hit you.

"Then he quit academics and went to work as a consultant. He's only twenty."

"And the government hired him to sniff out C3A," Terry finished for her.

"Looks like it. Who do you think did it?"

Terry shrugged. "I think Grey did it. He broke it, now he wants the government to pay him to fix it."

They ate in silence for a moment.

"The government of Mexico bought out my loan contract."

Terry blinked. "What?"

"I'm not working for Uncle Sam. I'm moving south of the border to program a nice new cellular system for the 'burbs of Mexico City. The rent on this place is paid up until the end of July. You can stay here if you want. I'm leaving in two weeks."

Terry sighed, feeling the strength go out of him with his breath. That was it then. He hadn't left her when he had the chance, so now she was leaving him.

"Well," he said, "have a good time."

Three weeks later, Terry finished up work and logged onto the metachess server for a game. Terry was using his own ID. This tended to discourage casual players who had lost to him before. There was a short pause as the server matched up a player good

enough to be a challenge, one who did not flash ID. Terry stiffened and felt his pulse pound distantly.

The metachess board looked much like a traditional chess board. The pieces were the same. The moves were simplified, but familiar. Only, one of the white pieces housed Terry's heart, and one of the black, his opponent's. Terry picked a knight.

It was possible to win metachess on the basis of strategy alone or on the strength of reflex and combat skills. Terry had both. Serious challenges to his chess abilities were both rare and welcome.

Terry moved a pawn, then, from his vantage point as the knight, watched black do the same. The first few moves were simple. Terry sent his king's bishop after a black pawn. There was a brief contest, a flash of light, and the pawn lay bleeding upon the board, then vanished. Which black piece was real?

Terry lost two pawns in rapid succession, then took out another black one. Metachess was faster than its parent game. The object wasn't to take out the king, but the mate piece, the one that held your opponent's heart. You couldn't find that out by accident. You had to know how your opponent thought.

A pawn slew Terry's bishop. There was a certain chance of this happening anyway, even with a real pawn. Terry risked another pawn to find out. But the black pawn, weakened, toppled before his own piece. It wasn't black's heart. It had just been lucky the first time.

Then Terry found the knight, his own heart, up against a black castle. It was an inevitable risk, for surrounding this piece with defenders would bring attention upon it, not to mention lose him a good view of the board. Terry blocked the castle's missile of light with an electron sword, moving his piece a half-dance to the side of the square. Castles were big, but slow. He forced himself to take a hit, a numbing shock that made his arms tingle, then landed a flurry of lunges. The castle crumpled.

Good, Terry thought.

All of black's pieces had moved, and none were obvious. It was a smooth job. Was this the same player who beat him before? It sure felt the same. Could it be Daphne, like a ghost in the machine, logged in from Mexico? It felt like her, just as it had that time three weeks ago. Wishing it almost made Terry certain. Daphne usually picked the queen.

Terry fired off a text note to his opponent. "Who are you?"

Two moves later, he checked for an answer, and found none. Terry got slow and careful. Avoiding small battles, he eased his queen into black territory, then closed with the black queen. The battle drew from him an admiring sigh. Deadly force, even in a game, had a certain beauty of its own. The black queen toppled.

Terry had guessed wrong. It wasn't the queen.

A black knight challenged his square. As Terry was bringing up his sword, the black piece laughed.

For two, maybe three seconds, Terry froze, just long enough for the black knight to strike him a damaging wound. The game wasn't supposed to do that. Someone had tricked with the server.

The black sword danced before Terry's vision.

The server warned him of imminent checkmate, then forwarded a yield request from black. That was the polite thing to do. Virtual death tended to cause a headache, though the visual effects were interesting.

Terry sent back, "Tell me who you are."

He received another one-word message: "Yield."

In another world, Terry bit his lip. "I'll do anything to know who you are."

A message from black: "Lounge, Crystal City Marriott, 21:30."

Terry yielded.

The game recorded mate.

▼▼▼

Daphne could have taken a jump-plane up from Mexico that quickly. Terry hated himself for wishing it. It wasn't Daphne. But what if it was?

Terry was in the lounge by nine, a half hour early. He got a cola and waited. And waited. By ten, no one had shown up. He wondered if this were a joke, but then reminded himself that the chess player had only said for Terry to be there, not that anything would necessarily happen. It was late, though. Terry had to work the next morning. He decided to leave at ten-thirty. If it was Daphne, she would just have to deal.

At ten-twenty, Terry glanced up in time to see a slight figure in a cowboy hat drop into the chair across his table.

"D'Schane Grey," he said.

Grey flashed a wide, feral grin. "You're quick on the uptake. Buy me a strawberry daiquiri." His voice, more than anything else about him, was startling. Terry hadn't heard him speak last time.

"What?"

"You heard me. I won't pass an ID check, and a drink is a subset of 'anything.'"

"Oh." Terry signaled the waiter and ordered. He could smell the merest breath of d'Schane Grey's scent, soap and sweat and denim. "You play dirty chess."

Grey's grin settled into a small, sweet smile. "Thank you. Just remember: the first time I beat you was a clean game."

"So what else does 'anything' include?"

"Haven't decided yet." Grey folded his arms on the table and leaned on them.

The daiquiri arrived. Grey sipped at it contemplatively.

Terry asked, "Why are you taking such an interest in me? You think I cracked the Gateway?"

"No. In fact, I know you didn't. Your girlfriend did."

"Daphne?"

"Daphne Lawrence. Unfortunately, she's in Mexico, so we can't indict her. Mexico doesn't recognize data theft."

"And they have her working on their phones?"

"That's what she told you? She lied. She hired out to the same combine she was working for when she cracked the Gateway. The Authority wanted to string you up in her place. But I know you didn't give her your password on purpose. If I push them, they can't do a thing to you with my data. License laws and all that."

Terry took five slow breaths under the burning glare of Grey's amusement. To be at someone's mercy like this was almost worse than knowing Daphne had tricked him.

"I ask you again. Why are you taking such an interest in me?"

"Because you went under my scan with fresh, hot whip kisses on your back."

Terry closed his eyes. "What do you want?"

Grey emptied the daiquiri. "Chill. Masochism isn't a federal crime, though you should watch out how you let people use you. For now, I want you to stop cutting your hair for a while. I'll let you know when I think of anything else."

"Why my hair?"

Grey wagged a finger at him. "You ask too many questions. Thanks for the drink."

Terry, feeling distinctly appalled, watched d'Schane Grey leave the lounge. The man walked like a twenty-year-old, loose and a bit hurried. And he dared order Terry around like that? Terry sighed. What did he have to lose?

Terry found a new apartment. It was even farther from the Metro than Daphne's had been. The fifteen-minute walk out in the open air did his health no good.

Nothing happened at C3A, not a whisper more about security problems. Terry got his microscopic raise on schedule.

He dated a woman named Janet for a month. Janet worked in another department, and was very nice. Too nice. Terry couldn't

face the inevitable look of horror on her face when he asked her to hurt him. So he never mentioned it, and neither of them was happy. They went out to movies, slept together on occasion, got bored, and stayed friends after it was over.

Terry mostly forgot about d'Schane Grey, but he did not cut his hair.

▼▼▼

One Monday in January, Terry was at work at C3A when his console cut out abruptly, leaving him blinking in the fluorescent lights. Terry looked up to see d'Schane Grey sitting on the corner of his desk, finger on the disconnect switch.

Grey held up a narrow leather strap. "Let me see your neck."

Terry interposed a hand. "No!"

Around him, people were pausing in their work to stare.

Grey was smiling. Terry was starting to hate that smile. He didn't say, as Terry expected, 'I could have you fired,' or, 'I could destroy your credit rating with a wish.'

"Are you good for your word, or aren't you?"

Terry bit his lip. "But..."

"Aren't you?" His blue eyes narrowed, hard and bright as diamonds.

"Yes."

Grey snapped the collar around Terry's neck. It was thin and soft, with cold metal along part of the inside surface and a D-ring set in the side.

"Come with me, or do I need to leash you?"

It was only two-thirty. Leaving work would not please Johnson, especially since Terry had three megs of notes to transcribe by tomorrow morning.

Terry stood and followed Grey from the office. Grey was the smaller of the two, Terry noticed with a start. They went first to the underground garage, to a nice new Pontiac parked in a reserved space.

"Get in the back. Do you have a preference for a radio station?"

"No," Terry said, and struggled into the seat harness. The upholstery was leather. Brushing his nails against it gave Terry chills.

Grey took the car out of Crystal City and onto 395. Once they had settled into the express lane, the highway's automatic navigator pulled them along gently at 110 miles per hour. Grey fiddled with the radio, then popped a chip into the player. Ten minutes later, they pulled off the highway into a far suburb of Virginia.

Terry glanced out the window. The streets were narrow and winding. Houses were set back on hills, surrounded by careful planting and kept lawns, brown with winter. These were luxury homes built back in the 1980s on what once was farmland.

Grey pulled into the driveway of a comparatively small house. It was built of brick and had a fantastic glass-sided tower at one corner. Grey shut off the car.

"Last stop," he said.

Inside, the house was empty of people and sparsely furnished.

"No servants?" Terry asked. He walked through a doorway into a large living area.

"No. I just bought this place. A housekeeper comes in once a week when I'm not here. Want something to drink?"

"Just water."

Grey vanished into the kitchen and came back with two glasses of ice water, handed one to Terry, and sat down on a couch.

"Now."

Grey wasn't smiling. Terry swallowed, feeling his throat move against the collar.

"Your hair is passable. See, I don't usually do men, though I was apprenticed to a male top two years ago. By the way, you can be sure anything I might want to do to you has been done to me at least twice over. I wanted to see if long hair would soften your face a little bit. I think it does."

Terry did not like the direction of this conversation.

"A couple of things about that collar you're wearing. It doesn't come off easily. It's leather, but with a mylar-and-steel core and a permanent snap closure. I figure if you want it off enough to take bolt cutters to it, then you can have it off."

"This is too far, d'Schane Grey. Tell me what you want."

Grey laughed. "You know what I want. And you know what else? There's a pickup chip on the inside of your collar. It's very sensitive. Needs no saline, just your sweat. And you're sweating quite a bit, aren't you, Terry? You can't fool me with your coy little protests. You put up a really good show of fighting the scan last summer. The whole time you were just itching for me to hit you harder. I would have done it, but the Authority wasn't paying me to get their employees off."

D'Schane Grey pointed to the ground in front of his feet. "On your knees."

In that instant Terry learned something Grey already knew. Terry knelt before one who was younger and smaller, but infinitely more sure of himself. Fingers tapped his chin.

"Look up. You have a pretty face, and I want to see it. That's better."

Terry looked up into the blue eyes, narrowed with concentration. A finger stroked Terry's cheek and circled the outside of his ear. Terry shivered. Grey set his hat aside and reached behind his own ear, checking for the lead that matched the one at Terry's throat.

Kiss me, Terry thought.

The corner of Grey's mouth twitched with amusement.

"I approve of your change in attitude. But I won't kiss you yet."

Grey hooked his finger in the top button of Terry's shirt.

"Nice arms. Nice upper body," he said, unbuttoning the rest. "What do you do besides sit in front of a console all day?"

"I swim, mostly. C3A has a pool."

Grey drew a line with his finger down the center of Terry's chest. The cold air tightened the flesh of his nipples. Grey took the shirt the rest of the way off and dropped it on the floor.

A hand supported the back of Terry's head as Grey leaned forward and brushed his lips against Terry's own. They held there for the longest moment. Grey kept his eyes closed when he kissed. His tongue gently pressed between Terry's lips and teeth and into his mouth. A hand stroked his back, trailing nails along his ribs. Grey tickled the roof of Terry's mouth and sucked on his upper lip, then broke the kiss.

"Let me see your back."

He turned Terry so he was draping his upper body across Grey's left thigh. Terry's mouth, empty, tingled. He licked his lips and circled the leg with his arms as Grey inspected the old scars.

"You've played rough. Daphne did this?"

"Yes."

Grey whistled. "Six months old and I can still see them." He tugged Terry's hair. "I will love you so much better than Daphne did. No matter how you cry, there will be no mercy."

Terry sighed and pressed his cheek against Grey's leg. Grey was reaching over. He hooked a finger through the ring on the collar, holding Terry pinned halfway over his lap. Something touched Terry's back.

He froze, trying to tell what it was from sense of touch. The hand on his collar kept him from looking. The touch vanished.

The first blow of the riding whip was louder than it hurt. Terry gasped. The muscles of his back tightened like bowstrings. Nothing happened for a moment, and Terry started to relax again. The second blow fell. Terry screamed.

Grey laughed, leaned over to kiss Terry's ear, and whispered, "You aren't as hurt as you are scared, you know that?"

The toe of Grey's other foot pressed between Terry's legs to the spot right behind his balls. Blows three and four fell abruptly. Pain and heat washed over Terry's skin.

Daphne used to whip until she got tired. Grey spaced it out more, letting Terry savor most of it, occasionally pushing him off balance with a flurry of blows that kept getting harder and harder as his resistance broke down. Terry wept and clawed at Grey's leg, twisting the flesh between his fingers. This was a mistake.

Grey peeled his fingers away and pulled him around by an arm. The whip bit Terry's chest, catching his nipple. Grey smacked Terry across the face twice, then concentrated on his chest and belly. The last blow fell upon Terry's crotch and the erection that pressed against his jeans. Terry's body snapped. He sobbed. Grey put down the whip.

Breathing hard, Grey forced his tongue into Terry's mouth again. The kiss was violent and sloppy. Grey was unbuttoning his jeans with one hand. With the other, he pushed Terry's head down to his crotch.

Grey's erect penis was much thicker than the handle of Daphne's whip. It was hot and tasted of salt and something sweeter. Grey gasped and swore as Terry went all the way down on it.

"I didn't think you could do this." He clutched at Terry's head. "Slower!"

Terry backed off and teased the head with his tongue, stroked the balls with his fingers. Grey took his hair and forced his head up and then back down. They both moved slightly, changing angles. Terry wrapped his arms around Grey's hips and sucked.

Until Grey's back arched and he cried out and his hips bucked so hard that Terry almost choked. He swallowed. Grey relaxed one vertebra at a time, slowly sinking back down into the couch.

Terry reached for where he had left the glass of water and drank, savoring the cold in his throat. Ice clicked against the side of the glass. Grey took the water away, then shoved Terry down on the floor.

"Your turn," he said.

Grey pinned Terry's hands over his head and unfastened his pants. Terry lost himself in the sensation of the carpet on the

rawness of his back until Grey's hand on his penis jolted his eyes open.

"Now don't move your arms," Grey said, "or I'll stop."

Terry's body twisted involuntarily as Grey stroked him. Grey tsked and took a swallow from the water glass. He bent over to suck on Terry's sore nipple, and his lips burned with ice. Grey licked his way down Terry's body, leaving a trail of cold water behind. It was so hard not to move. A hand clasped both of his, fingers intertwined, giving something to hold on to. Grey lay down next to him and touched him very softly, and then a little harder, until at last Terry came, crying into the mouth that kissed him.

Grey was shaking.

"I've never read anyone climaxing before. Ah. That was sweet."

They lay on the floor, silent, until the sun vanished from the window, leaving them in darkness. Grey stood up, flipped the light switch, and stretched.

"Well, I may as well show you the rest of the house. Like the bathroom. And I've got some food in the fridge. Are you hungry?"

An hour later, showered and dried, they were sitting on Grey's bed eating fried chicken. Terry felt the bruises on his back and chest when he moved, sharper than the sweet feeling of sexual satiety. He wanted to be held. Grey teased him with that comfort, stroking his hair until he sighed.

Grey was saying, "The pickup in your collar is keyed to the lead I'm wearing right now. It's short range, and I won't wear it often."

"So, Grey," Terry said, fingering his collar, "depending on Johnson's mood, you may have just gotten me fired."

"Was it worth it? Don't answer that. I'll have my pet lawyer draw you up a contract tomorrow, and you can join Grey Consulting Enterprises. By the way, my name is d'Schane. Use it."

"Don't do me any favors, d'Schane."

"This isn't a favor. I looked up your school records. The government isn't paying you half of what you're worth. And anyone I've fucked is entitled to call me by my first name."

Terry smiled. Daphne only got to work for data thieves in Mexico. They'd be on opposite sides of the business now. He knew how she thought. Perhaps their spoiled relationship would work to his advantage?

He wondered if d'Schane liked having tables turned on him, and how his lean, small body would feel pressed down on the bed, beneath Terry's weight.

D'Schane looked up sharply. The excitement and the fear in his eyes were clear to Terry, even without a wire to his mind.

"I'd like to see you try it, love. If you can checkmate me, well, then, you can have me."

The Melting
of the Snowflake

The harem mistress had belonged to the old king, who gave her to his son. By then she was past her prime of beauty. Prince Sharvic had dismissed her from his bed and put her in charge of his small flock of young concubines. It was her duty to keep the women cleaned, plucked, dressed, and made-up to the prince's satisfaction, fed but not too much so, and empty of children.

The prince's latest acquisition would be a challenge on most counts.

The mistress eyed Valmere, the former queen of Fel, where she stood in rent armor, dripping mud and a little blood onto the delicate Keshlan carpet. Valmere was tall and ice-pale, with cropped hair the color of fire-lit gold and eyes like cloudy gemstones. Her body, when the women had stripped her and washed away the marks of her last battle, was lean and taut as a bow. Her hands were nearly spoilt with calluses, and her skin marked by the steel claws of war. It was a waste of such rare beauty, thought the mistress, to send this woman into battle.

"Mind you please the prince," counseled the mistress, as two women trimmed the nails of Valmere's hands and one woman between her legs singed off her immodest brush of pubic hair. "Be pliant. Keep your eyes on the ground at his feet. Don't speak

unless he gives you leave. Endear yourself to him, and he will call for you again and again. Defy him and he will have you beaten."

Through all of this, Valmere was silent. The mistress began to doubt that the barbarian woman could even understand her speech.

The servant women dressed her in a gown of pale yellow, and softened her severe face and short hair with a fine net of gold and pearls. A string of pearls was hung also at her throat, and her rough hands encased in white gloves. They left her barefoot, for the prince preferred his women small.

"Hurry," the mistress urged her women. "We must present her to the prince before sunset."

They had Valmere completed, like a confection from the kitchen, just as the soldiers pounded on the outer door. The mistress stepped back to appraise her work. She called for a bit more powder to cover the cut on Valmere's cheek. Then as the mistress once more opened her mouth to admonish her charge, the words died unsaid. The once-queen's eyes had returned from the distance. Her gaze cut the mistress with such bitter-edged contempt that she might have used a sword. The mistress stepped back, stammering. Then the men outside were pounding upon the door again. The women of the harem opened it up and, hastily pushing Valmere out into the hall, slammed it shut before they could be seen.

The soldiers formed rank around Valmere, two in front, two behind, and four on either side. Their weapons were sheathed, for the once-queen was unarmed and barefoot, no threat to them now. Valmere had slain many of their comrades with her own hands, shaming the army utterly. Any of the soldiers would have given gold for the chance to shame her in turn. Well, that was the prince's privilege. They looked at her sideways to see if she would struggle and give them an excuse to lay hands on her.

Silent yet, Valmere stepped forward with them through the stone hallway. A heavy door separated the living quarters from the

rest of the palace. As they proceeded, their boots rattling on the floors and her bare feet making no sound, the inner walls of the small palace began to open outward. Great stone planters of winter trees grew larger and more elaborate. The unglazed windows, open to the cold sun, gave way to arched gateways of ivy and holly. The ceiling vanished. The paving stones beneath their feet bloomed into a delicate pattern of garden path, lined with small evergreens. At last the winter garden spread before them up to the very edge of the two-hundred-foot cliff that overlooked a frozen lake. Only a low stone wall separated tended walkway and fatal fall.

Prince Sharvic of Teluron awaited them on the terrace, framed by sunset and storm clouds. He wore black leather and chainmail under his red-emblazoned surcoat. His hair, a dark stallion's mane of it, stirred in the slight breeze. He was strikingly handsome and wanted everyone else to know it.

Sharvic was only twenty years old and already owned the world, or as much of it as he cared to. He had built this isolated castle into an impregnable fortress and trained the largest standing army seen in centuries. His father, the old king, would not approve. The king, however, was wintering on the coast, two week's hard ride away. His army was a mere ceremonial guard. If the king was wise, he would lend his retroactive blessing to Sharvic's ventures.

The blood of Sharvic's heart heated as he looked upon Valmere. With the conquest of her country, at last he had some land other than that grudgingly given by his father. He had acclaim, and notoriety, all the riches of plundered Fel, and women other than his father's castoffs. He'd caught himself a queen.

Sharvic extended a hand. One of the soldiers prodded Valmere, who stepped forward. She seemed to Sharvic more translucent than the snowflakes that had just begun to fall about them, silvering the terrace. She, once the Ice Queen, the leader of armies, was now merely another ornament in Sharvic's garden.

And if this one lacked the soft and pretty looks of his other concubines, then perhaps she would be well compensated in spirit. Valmere was a warrior. Breaking her would be a most delightful challenge.

Her feet left wet prints where the snow melted beneath her. She stopped a foot away from the prince's extended hand. Her eyes, he saw, were empty. Dazed.

"Welcome to the presence of your new master," Sharvic said. "From now on your only joy is to serve me. My smile is your sun. My displeasure is your darkest pain." He reached for her face.

Valmere snapped forward like a bough released from a weight of snow. One fist hammered Sharvic's ribs with a force that he felt even through the chain. The other slammed into his crotch. Sharvic howled.

His guard had drawn their weapons and rushed forward. Sharvic knew with a cold certainty that he had to finish this before they reached him, or be shamed forever in their eyes. His fists were mailed with steel, and one of them broke her shoulder. She kicked. Sharvic seized her and slammed her head down against the wall. A single drop of blood flew loose and vanished in the distance between terrace and lake.

"Yield, or I'll slay you now," he said.

Valmere spat.

Sharvic looked into her eyes, really looked for the first time. In them he saw the gleam of something burning, of steel, of fangs, and in fact nothing at all he wanted in his bed. As the guard reached him, he heaved Valmere over the wall.

The ice of the lake gave a thunderous crack, but held her body. A dark stain filled the fissures in the ice, sketching a bloody snowflake in the vanishing evening.

"My lord?" said the guard captain, then stepped back hastily as Sharvic whirled upon him. The captain swallowed and began again. "Would you like us to retrieve the body?"

"No. Leave her there." In the silence, Sharvic took a couple of steps toward the castle. "Send someone to bring my meal to my chamber," he called over his shoulder. "I'll dine alone."

▼▼▼

Queen Keluria of Avel was nearly six feet tall, though so proportioned that one didn't notice her height until standing beside her. Her hair was red and cut to shoulder length. She was not old, but her face was too worn with care to be pretty. Her subjects adored her, foreign armies feared her worse than plague, and the gods smiled on her with favor. Fair and generous, she had never been known to slay the bearers of ill news. At least, so the messenger hoped.

The messenger was panting hard, dripping sweat in the frigid hall. She knelt and handed a scroll to the queen. Keluria thanked her. Attendants stepped forward to usher the spent woman off to a bath and some food while Keluria read.

Artere watched her open the scroll. He was as pale and golden as Valmere, though a little older, and he lacked her warrior's grace. Artere struck the observer as decorative, but painfully nervous, as if he always expected to be beaten, and all the more so as Keluria frowned. Artere considered finding some dark corner in which to hide. Instead, he waited for her to finish and took the scroll in turn.

Fel was taken, it told him. Sharvic had slain Valmere. Artere's world had effectively ended.

Artere slumped against one of the glazed windows. His cheek melted the patterned frost. Behind him, the queen let out a long sigh.

"I will avenge your sister," she said.

When Artere did not answer, she laid gentle hands on his shoulders, and her lips on his neck. She smelled of horses, hay, and leather, he thought idly.

"Come with me."

Artere followed his queen a measured two steps back, which wasn't easy since her legs were longer than his. She brought him from the hall up to the living quarters, and even to the threshold of her chamber. The attendants hastily awoke and pulled open the door for them. One ran ahead to light torches and a fire.

The cold room came to life. Flames splashed from the mirror and the crystal. The attendants vanished swiftly, shutting the door behind them.

Any other time, Artere might have rejoiced at being invited to Keluria's bed. But grief was too sharp, and he wept when she kissed him. Her fingers skillfully undressed him upon the fur-covered bed, and at last she found means to still his tears, and make him cry in another way.

It was a most diplomatic transaction, Artere thought afterwards, when the queen thought he slept. She had done the one thing that might reassure Artere of his position at her side, though likely she wouldn't bear a child out of this lying-down either. Her orgasmic cries had been, as always, artfully faked. His hadn't.

Artere's life and happiness depended on his ability to please someone else. His mother had made that clear as soon as he could understand, and she had made sure he knew that someone wouldn't be her. She had wanted a daughter to take up her crown, and when Valmere was born, she had sent Artere out to foster. After their mother's death, when Valmere was queen, she had gotten her brother the best marriage in the land. Queen Keluria of Avel wanted safe passage to Fel's seaports for her rich caravans, and so Artere had been packed off to a foreign court to seal the bargain.

That Artere could not please Keluria made his hands shake with worry. She was fair enough to him, never beat him, and saw that her consort had almost anything he wanted. And if she did not often lie with him, she at least encouraged him to take lovers. He did, sometimes, preferring the men or the very young girls, who would be awed at the attentions of the queen's consort, and less likely to laugh at him.

Valmere was dead. This left Artere as the nominal heir of Fel, or what was left of it. Since he was married, the land would pass to Keluria's hands. Therefore she didn't need him anymore. She had borne no children to him. She was free to cast him aside and make another marriage.

Valmere had been kind to Artere. He missed her.

The queen had dressed and left. Artere stretched under the blankets, then leaned over the edge to snatch up his tunic. A tray of warm bread and meat had appeared at some point during their passion, or afterwards. He picked at the food as he dressed.

Keluria's chamber was rather small, the better to hold heat in the winter. Artere built up the fire and looked around. The horse tack that she cleaned and oiled herself lay in piles. There were boots against the wall, and bits of silver, and a row of whips hanging from pegs.

Artere took down one of the whips. It had a short, silver handle and supple leather tails, nine of them. Artere drew them through his fingers. That was odd. Keluria was an avid horsewoman, and he'd never seen her strike an animal. Carefully returning the whip, he shrugged and got his cloak. Keluria would be back that night, probably with her preferred bed companion, and would want him gone by then.

▼▼▼

Weeks passed, and Avel prepared for war. It would be a just and fitting war to free the sister land of Fel from cruel bondage and to avenge the death of a queen. Warriors vied for the honor of dying at Keluria's command. The priestess read favorable omens from the entrails of dead animals. The gods were pleased. The people were taking no chances, for this would be the first war of all Keluria's reign that presented a challenge.

Avel's armies were small, at best, so Keluria saw to the hiring of a company of Keshlan mercenaries. Though some of her captains expressed distaste, Keluria had chosen wisely. The Keshlani

were brave and loyal to those who paid on time. Though her armies disliked fighting on the same side as men, it was men who could negotiate best with Sharvic of Teluron. He had been known to dismiss unheard women sent as heralds. Besides, some of the Keshlani could be left to guard the stay-behind farmers against bandits and the desperate flank actions of a defeated army, leaving Avel's forces the glory of open battle.

Artere saw little of the arming, and less and less of Keluria. When she visited the palace, she would eat with him once, then vanish into her chamber. He passed his time with the bored mercenaries assigned to guard him, sparring with wooden swords.

Spring arrived.

▼▼▼

Unnoticed, the ice of the lake, no longer stained red but now dirty gray, broke apart in the warming sun. That which had been Valmere slipped through, into the water, vanishing without a trace.

▼▼▼

"If you'd been born into another life," said Sandry, "you'd have made a fine swordsman. You have the reach, and the eye. Look for me in Kesh if the queen ever tires of you."

"That isn't funny," Artere said, putting aside his wooden sword. The day was unseasonably warm, and both men were panting hard.

Sandry shrugged. "Suit yourself."

"Even if I'm not happy here, I won't leave for someplace where men keep women like sheep and cattle."

"Not all lands on the other side of the river are like Teluron, and not all men are Sharvic. In some places I've seen, men and women fight and farm and love as equals. I must say, I like those lands best of all. I'd rather have a girl please me for her own joy than out of fear. And the cavalry women always have the strongest legs." Sandry grinned widely.

It was hard not to like him. Like most of the Keshlani merce-naries, he was adept at blending into local custom, and drawing kind laughter in any language. Rumor had him bedding with a couple of the officers of the forward army, and those women had their choice. Artere enjoyed his company because he need do nothing to please him, only be well and safe.

Sandry pulled three knives out of his pile of cloak and cloth-ing. Tossing them spinning into the air, he wove them into breath-taking patterns.

"Aha!" Sandry declared, raining knives about his feet with seeming carelessness. "You do smile. And here I thought all roy-alty had their sense of humor removed at birth."

Artere's smile, suddenly made self-conscious, vanished in an instant. "I must bathe and dress now."

"In a hurry to leave?"

"The queen may ask for me tonight."

Sandry heaved the elaborate sigh reserved to address the self-deluded. "If you insist. Come by the weapons yard tomorrow, or the next day, and play."

After Artere had left, loneliness settled about his throat like an executioner's cord, cutting his breath and dimming his sight. The queen, as usual, would not be asking for him. But Artere had a plan to follow now, and even if it didn't work, it was something to do.

Who shared Keluria's bed, and what did she do with them? Chances were, most of the palace except Artere knew. He had only to persuade one of them to tell him. So he spent the next two days in and out of the kitchen, the laundry, the stables, asking innocuous questions, waiting for someone to come to him, and at last someone did.

Artere bought his precious information facedown upon the bed of one of the bakers. The man was rough, but not unkind, and he seemed to enjoy Artere more than Keluria did. After the pay-ment was tendered, the baker brought Artere up a back stairway,

through a narrow hall, and up to a small slotted screen. There the baker left him, telling him to wait and watch.

There was no light from the room on the other side of the screen. Artere crouched uncomfortably in the passage. Well after dinnertime, when his fingers had gone numb in the cool air, there came a noise of doors opening. Someone lit torches. Artere blinked, startled.

He was looking into the queen's chamber, through a latched doorway to one side of her bed. This was clearly the passage by which the kitchen staff made food appear or disappear, and perhaps where the laundry took the sheets away. Artere leaned forward and adjusted his eyes to the light.

The queen entered, and with her one of the young captains, a tall woman with thick, dark bronze hair. Her hair was long, and she was no less a warrior for this vanity. The two of them were speaking too softly to be heard. Both wore riding clothes.

Keluria walked toward the fire, out of Artere's line of sight, possibly to sit in one of the chairs. The captain stripped off her clothes. She was broad-hipped and small of breast, the sort of figure favored by artists who painted nymphs and young goddesses. It seemed she undressed for herself, for the mirrors to adore her, and for the firelight to caress her body. She brought her hands up toward her own nipples, which were already small and hard in the night air. A word of command stopped her. Grinning, she turned and stood at the foot of the bed, reaching up to hold the loops of the decorative rope that dangled tassels from the ceiling, incidentally providing Artere a breathtaking view of the front of her body.

Keluria appeared then behind her shoulder, holding the same whip that Artere had handled before. She reached over to tickle the woman's breast with the tails, and to fold her hair forward over her shoulder. Already the woman's head was thrown back, her breath deep and steady. Stepping to the side, Keluria measured the distance, and struck.

Artere covered his mouth with his hand. Clearly, the blow had upset him more than the woman, for she was grinning widely. He couldn't see her back, but such a light tap might hardly have reddened her skin. Keluria struck again and again, alternating blows with caresses. Her face was rapt, eyes narrowed and gleaming. The other woman panted. Her legs were spread wider now. The cords of the whip wrapped around and between her thighs, leaving pink stripes.

Keluria began to hit harder. Her partner sobbed. When the queen took that as a sign to slow down, the other said clearly, "More."

That word was repeated twice more, between screams and ragged gasps. The arc and snap of the queen's arm entranced Artere, who had never seen such beautiful cruelty. And when the woman at last let go of the ropes and collapsed into Keluria's arms, Artere was far more aroused than frightened. The two of them tumbled onto the bed out of Artere's sight, leaving him with nothing but their rising moans for company.

▼▼▼

"Artere, greetings. It's been near a week since I've seen you."

It was raining outside, and the queen was seated by the fire, drinking something hot. She wore a court gown half unfastened, as if she'd spent all day in the company of diplomats and courtiers, and only just had the chance to sit down.

Artere bowed, formally. It had taken him days of patience to get this audience, and he wasn't about to spoil it by being hurried.

"Are you well?" asked Keluria.

"I am most well. I missed you sorely."

She nodded. "The war is days away at this point. I'll be in the field tomorrow, and until we have won. This war is for your family's honor as well, so I appreciate your patience."

That, Artere knew, was a diplomatic sort of lie. Keluria never battled for honor. She wanted Fel, and Teluron if she could have

it. Ultimately, she sent her subjects to die so that she could have the pleasure of matching wits with a foreign prince.

"I am patient," he said, "and I ask only one favor before you ride into battle."

"And that is?"

Artere went to the wall when the tack was hung, and took down the silver-handled whip. The tails swished as he turned. His breath quickened as he steadied body and mind against the pain he would demand.

"Let no one say I cannot please you as you wish to be pleased."

Keluria's jaw dropped. She shot him a look of utter confusion. "Artere, no."

"Don't you understand?" he asked, his voice rising to an inelegant shout. "I'm nothing if not yours. If you turn your head from me, I may as well be dead as Valmere!"

Keluria's eyes were sad, her manner once more controlled. "You are not what I want."

Artere stepped forward and knelt at her feet. He lay his head on her knee and offered up the impossible weight of the whip with one shaking hand.

"Then punish me for my failing."

In a whisper of fabric, Keluria stood and slipped from under him. Moments later, he heard the door click shut. Only then did Artere raise his head and look at the mockingly empty room. He replaced the whip on its peg and left by the servants' door, where there was, thankfully, no one watching.

The war was fought in three days. Though many had denounced the prince of Teluron, none could fault his courage.

Sharvic's armies were caught in Fel, unable to retreat past the river rising in spring flood. His supply trains were rapidly decimated, and the hostile land yielded him no provisions. Still he fought, desperately and deviously, until his last troops

were surrounded on a little wooded hill with no water or food.

One fine and breezy morning, Sharvic rode out, unarmed and unarmored, to surrender himself to the captains of Avel. His men were all paroled. Sharvic himself was bound and tossed into a wagon for transport to Avel palace.

That was where Artere saw him at last, standing alone in the midst of the Avel hall of state. Sharvic was ringed by armed women, who acted more to keep the furious citizens from rending him apart than to prevent an escape.

Escape was the last thing they need worry about. Sharvic was caught, and he knew it. Ever vain, he had no wish but to die in a manner that might inspire an epic song. He would sooner be gelded than turn tail and run from his proper and destined end.

Artere watched from a place in the lower balcony of the hall with Sandry and the rest of the men who cared to watch but need stay out of sight. The Council of Barons was seated in full ceremony. Every woman who could fit had packed into the floor, hoping for a display of legally sanctioned violence. Keluria herself was seated on a bench at the sidelines, dressed in a simple tunic, britches, and boots. Anyone who didn't know to look for her would have missed the queen completely.

"They are the law keepers," Artere whispered to Sandry. "The whole Council is needed to pass judgment on a murder case."

"This is not much of a trial," Sandry remarked.

"Yes, but he surrendered, and that's a legal admission of guilt. Shh."

The Council president stood up and tapped a scroll on the table before her. When she spoke, her voice carried to the farthest corners of the perfectly shaped hallway.

"Your father, the august king of Teluron, has declined to intercede on your behalf."

There was a wave of laughter from the assembled crowds. The king had other sons, and must be delighted to have such a troublesome heir removed from the picture.

The president glared about in warning, and continued.

"This court has heard no pleas for clemency from any citizen. The oracles are silent. You are granted one final chance to speak in your own defense."

Sharvic raised his eyes. "I'll have no words with whores, and less than none with the queen of whores."

Not a word, not a gesture, not a brush of fabric on skin broke the stillness in the hall. Artere saw Keluria lean over to whisper to her captain, the same woman he'd watched her beat in the bedchamber.

The captain sped around the perimeter of the room and up the back of the Council dais. She whispered in turn to the president, who nodded. Then the captain raised her hand in a signal.

Two soldiers seized Sharvic's hands and bound them in heavy leather straps, then in turn to ropes that trailed from the center columns of the hall. They tightened the bonds until he stood nearly on tiptoe with his arms spread out widely. One of them ripped off his tunic. They left him standing in a square of late sun, with the sweetly proportioned muscles of his body racked and straining to best advantage.

Sandry tapped Artere's shoulder. "What are they doing?"

"Shh."

Someone had brought out a brazier set up on a tripod. It was filled with coals and glowed ever hotter as a soldier worked the bellows. At last the captain took up the long handle of the iron brand that rested in the fire.

Sharvic could not see, and neither did he try to turn. When the captain laid the brand against his shoulder, he moved only as much as someone stroked with a feather. An aroma of burnt flesh wafted through the hall. The assembled crowd murmured in disappointment.

The president spoke: "By the authority of this Council and the will of the gods, you are branded a murderer and remanded to the perpetual custody of the queen."

"How utterly barbaric," Sandry muttered. "They should have hanged him."

The captain handed the brand to someone who carried it away. She drew a long, curved knife from her side and laid it against Sharvic's throat. His head turned involuntarily as the blade stroked his skin. The audience was rapt, for so many of them would have begged to trade places with the captain. How many, ashamed and silent, would have wished for the fate of the captured prince? How many would have traded their souls to be so beautiful and brave, adored and hated?

The knife made love to the curve of Sharvic's shoulder before vanishing beneath his luxurious mantle of hair. His eyes opened wide with abrupt understanding, and he made a soft sound of protest. The captain flicked the edge of the knife backwards. Sharvic's hair fell about his feet like wisps of fine silk, and he screamed as though wounded.

The captain spoke: "That is payment for the insult you rendered the Council." She retired into the circle of warriors.

Keluria rose then, unadorned and splendid in her commanding height and manner. She stood before the bound prince and took from her belt a heavy, braided length of oiled leather. Forcing up his chin with the handle, Keluria said: "This is payment for your insult to me."

Sharvic met for the first time the eyes of the queen who had staged this entire scene, the woman who owned him now. There passed between them a moment of complete understanding. For were they not alike? They each loved cruelty, and a challenge. And each had found the one person in the world who truly deserved his or her most devoted attention. Sharvic bowed his head and kissed the whip handle in a gesture that passed unappreciated by everyone else in the hall.

Except for Artere.

"No," he said. "Not Sharvic. Not Valmere's murderer."

"What?" Sandry whispered.

Keluria had ducked under the binding ropes and uncoiled the whip with a snap. Sharvic let his head hang down and tensed his exposed, branded back.

Crack.

Sharvic went up on his toes, breathing a ragged gasp.

Crack.

The audience cringed.

Crack.

Sharvic was grinning, his body arched and eyes shut tight. He gleamed with sweat and the transfiguration of pain as the blows grew harder. His skin gave way and bled well before he broke and cried.

But by then Artere had pushed his way back out of the balcony and down the stairs. The sounds of Keluria's whip and Sharvic's screams grew fainter as he went.

Sandry was beside him in a flurry of footsteps. "What's wrong? I don't understand."

Artere sighed. "I do. It's only about time for it."

The gods consented to the annulment, and the legal details were swiftly hammered out. Artere was given a substantial amount of gold, most of which he left with a trusted trader who could provide him a note of credit.

Sandry's company was discharged shortly thereafter.

"I meant it when I told you to come to Kesh," he said. "It's quite nice this time of year, before the heat sets in." His horse pulled at the bit as its companions formed up in line in the courtyard.

Artere considered. "I'm going first to pay my respects at Valmere's resting place. It's quite safe to travel, and someone should say the prayers over her, even if she didn't get properly buried. But after that, who knows?"

They parted in a cloud of dust and galloping horses. Artere had packed, and the only thing between him and leaving was a final farewell to his queen.

She received him in her chamber, which was exactly as he remembered, save for the smoldering-eyed prince who sat at her feet, collared in black leather and diamonds, like some treasured pet.

Keluria stood and gave Artere her hand.

"I'll miss you," she said, "But I cannot tell you I'm sorry."

Artere shrugged. "I wouldn't want you to be. Shouldn't everyone get what they want thus, and be so happy with it?"

When no one answered him, Artere bowed and took leave of the queen.

Whip Hand

Dedicated to those who like to lose. Sometimes.

 D'Schane and Terry were necking on the couch. D'Schane, the smaller of the two, sat in Terry's lap, enthusiastically sucking on an earlobe. There was nothing particularly special about this, except that they were in the middle of an elegant shopping mall, seated right between Godiva Chocolates and Victoria's Secret. Shoppers would walk by, then miss a step as they realized that the couple by the fountain was two long-haired young men. The looks on their faces were making the two laugh, and Terry choked on a kiss at one point and had to pause to wipe the drool off his chin. This was their first day together after d'Schane's two-week conference in Chicago, and neither of them was feeling particularly discreet.

Mall security put up with this until D'Schane started unbuttoning Terry's shirt, giving the general public full view of Terry's collar. While the mall seemed prepared to put up with same-sex affection, the touch of leather at Terry's throat clashed with the sedate decor. A pair of uniformed guards very politely but firmly asked them to leave.

They were still laughing on the way out. The rain was drying off the zigzag brick pattern on the sidewalk. The new-washed sun reflected blindingly off the gold dome on an old bank. D'Schane seated his Stetson firmly back on his head and pulled the brim down to shade his eyes.

"Don't feed or tease the straight and vanilla people," Terry said when he could.

D'Schane snorted. "What makes you think I'm not straight myself?"

"Well, for one, you sleep with me."

"That doesn't make me queer. It makes me a lot of other things. An opportunist, for instance. Are you?"

"Straight? You aren't the only man I've ever slept with."

D'Schane actually looked startled. "I didn't know that."

Terry smirked. "Like you know everything just because you can read my mind. You never even thought to ask. It still amazes me how everyone seems to think I was born knowing how to deep-throat."

Terry stopped them to stare in the window of one of the little stores. He used to come there back when he was in school. It sold rude greeting cards, a little overpriced leather and a lot of T-shirts, mostly to high school students who wished they could afford the leather.

"Here. Open your mouth," D'Schane ordered.

Terry obeyed almost by reflex. D'Schane reached up and popped something into his mouth.

Startled, Terry bit down on the chocolate. D'Schane crumpled up a distinctive piece of gold foil and pitched it in the gutter.

"Hey," Terry said, swallowing. "I didn't see you pay for this."

D'Schane gave one of his most irritating grins, like a small child who has just killed someone. "That's because I didn't."

"You self-righteous case of arrested moral development..."

"Funny. That's what the shrink called me, too."

"What shrink?"

"My parents made me agree to see one a few years back. They were having a hard time dealing with my criminal lack of gratitude. Said I owed them for my education, my nauseatingly neo-romantic first name, my fucking DNA, and everything else. Wouldn't let me forget that the senior Professor Grey invented the

nerve splices that let us all plug in, that I'd be nothing without Mom's software company, and how dare I not come home for Thanksgiving? They're just pissed that I had lecturer status at MIT when I was younger than Dad had been. The shrink saw me once and asked them not to send me back. I think I scared him."

D'Schane never kept quiet, unless his mouth was busy with something else. Terry could think almost as fast as d'Schane could talk, and so often found himself absorbing a flood of words, all the things that d'Schane had wanted to say for twenty-one years but the rest of the world hadn't been smart enough to understand.

"And don't worry," he continued. "The place I stole the chocolate from is about to get an utterly inexplicable credit from American Express, as soon as I can find a console."

Terry sighed. "You're weird."

"Am I now? Weirder than my darling, who gets off on being held down and hurt? Honestly, sometimes I wonder how you got to be so delightfully twisted."

"I've had practice."

"Well, I found out what I liked early, and set out to find the best people to teach it to me, just like I'd learned everything else. Only problem was, I kept getting thrown out of leather bars until I turned eighteen. No one wanted to do time for blatant baby-fucking. I bottomed for a good year up in Boston, and I saw much more than I could ever do. I still think you're something special. You seem to have the most fun long after most practicing masochists would have called quits. It's not the pain levels you get off on, though I suspect a major pharmaceutical company could make a fortune off your neuroreceptors. It's how you like to be forced."

"Are you complaining?"

"Hell no. But I worry about you sometimes. I'm not sure you have the pride to keep the rest of the world from stepping on you. Letting your lover hit you is one thing. Letting yourself be used, really used, is another."

"You're just jealous of the rest of the world."

"And you're a slut."

They had stopped in front of a Sense Arcade. Inside the laser-painted darkness, school kids were competing against the latest generation of video entertainment. Some of them, lucky enough to have sockets, were tied into a dozen different worlds of magic, fear, and stars.

"Let's go in," Terry suggested.

"Why?" d'Schane asked, twitching his upper lip in a carefully cultivated gesture of distaste.

"They might have metachess."

"Hm. Is that a dare?"

"You bet it is."

They stopped to gawk at an ancient mechanical pinball machine before locating a metachess console in the back. The game was idling, blinking directions and disclaimers at the walls. An Arcade attendant took their money and set up the game. D'Schane pointedly touched the back of his head to make sure his link was hard-switched off. Reading his partner's mind would be a very rude way to cheat. They struggled awkwardly into the rented headsets and switched into a world the size of a chessboard.

Terry drew black and picked a bishop for a heart piece. He flipped back to visual to eye the spectators. They had begun accumulating as soon as he and d'Schane had connected. A couple of people were pumping tokens into view consoles so they could follow the action.

Terry and d'Schane spent about five minutes taking swipes at each other's pawns. Terry was playing conservatively, keeping his bishop covered, but not so much as to give it away. He let d'Schane take down a knight. If he did it right, he could get d'Schane to lose caution and give away his mate piece. One piece on each end of the cybernetic board would, in dying, lose the fight for either of them.

There was a game beyond the game. If Terry lost, he could count on being brought home and treated like captured property

for the rest of the night, taken hard and often until they both were sore. If he won, d'Schane might get mean.

Terry bided his time and watched one of his pawns kill a castle on a lucky stroke.

D'Schane slipped up. It was a hairbreadth miscalculation of combat that drew Terry's attention to the white queen. It didn't fight with quite the mechanical, if random, clumsiness of a computer. Terry sent his other bishop against the queen. The bishop lost, but by a bit too much.

It was tempting to flip to visual, to look at d'Schane. Terry didn't do it just yet. He didn't want to lose his concentration. D'Schane couldn't be sure that Terry had him figured out. Terry began creating a ring of black pieces around the queen. Keeping his bishop tucked safe in a corner, he started picking away at d'Schane's mate piece.

D'Schane, who had read Sun Tzu, liked to force an opponent to yield. Terry, who hadn't, liked to kill.

He let the queen wipe out a knight and a pawn. D'Schane must be getting tired. The queen, his heart, was powered only by his own skill and reflexes, and those were being drained by the relentless real-time combat. When at last the queen looked sufficiently wounded, Terry brought the bishop out of its corner. It was safer to let one of the dumb pieces kill the queen, but he wanted to feel this.

His bishop jumped to the queen's square. Instantly the game view clicked into encounter mode. The two combatants brought up lightning lances and struck at each other, one desperate, the other gleeful.

Terry mistimed just enough that the queen actually hit him once. He hit back, nearly wiping out her offensive capabilities with one stroke. At this point, it was usually polite to demand a yield from the fatally crippled party. Terry wasn't in the mood.

He took just a little too long to kill the queen. If d'Schane hadn't flipped out before the deathblow, he'd have a headache from the visual effects. Terry gave the console his ID to post with

the winner list. He then started disengaging himself from the headset.

D'Schane was glaring at him.

Terry smiled back. "Nice game."

"Get up."

The arcade rats milled about, uncertain what to make of the tension.

Terry obeyed, feeling his throat move against the collar. He wondered if d'Schane would hit him.

Instead, Terry was impelled out the door by an angry hand at his back. He tripped on the threshold and fell, catching himself with his hands. Terry got up with slow, nearly insulting deliberation. By now, he had probably racked up a couple of dozen lashes to be delivered when they got home.

Once they had reached the parking garage, Terry let himself be thrown against the side of the Pontiac. He could have knocked d'Schane over had he wanted. Terry was a little bigger, a lot stronger, and much more fit. But the part of him that was gleeful at d'Schane's rage would let him struggle only when he was sure he would eventually lose.

"Spread your legs," d'Schane ordered.

Doing so brought Terry down to eye level. The door trim was chewing on his spine. D'Schane leaned an angular hip sharply against Terry's crotch and scratched at his nipples through the shirt.

Terry's breath caught. D'Schane usually made sure Terry's nipples were good and sore so that a single touch made him whimper. Terry had almost forgotten the feel of d'Schane's sharp-edged nails.

D'Schane said, "You're being rather provocative today. Have I neglected you so badly?"

Terry opened his eyes. He hadn't realized until then that they were closed. D'Schane's expression was incongruously serious.

"Are you reading me?" he asked.

"No."

"If you were, you'd know the answer."

D'Schane twisted Terry's nipples between his fingers, dragging a ragged gasp from him.

"I want to hear you say it."

Terry shook his head silently. This was something he couldn't ask for, not even to release his lover from the uncertainty of walking a fine line between love and abuse.

A car door slammed. The echoes broke the mood. A woman was walking past them, staring. Terry flashed the bystander a strained smile over d'Schane's shoulder in a vain attempt to make her look less like she thought she should call the police. D'Schane reached behind Terry and keyed the car door open.

Terry climbed into the back and d'Schane into the front. Once he had shut the door, d'Schane fastened his seat belt and then slumped, pressing his head against the steering wheel. Seconds passed. Terry realized he was counting to ten slowly before he started the car.

The car engine turned over silently. The lights on the dashboard rippled. D'Schane pulled out of the parking space with a silent concentration that made Terry wonder if he was about to hit something on purpose. Terry struggled into his own seat belt. D'Schane always put him in the back when he was feeling particularly domineering.

The garage exit gate took d'Schane's credit card and spat it out a few seconds later after charging them for parking. D'Schane took a left turn over Key Bridge and got onto the highway. Terry sank back into the leather seats and wondered if they would be doing anything interesting on the road. It didn't look like it, though. Instead of ducking onto the express lanes, which would autopilot the car at a smooth 110 miles per hour, d'Schane kept them in the driving lanes with the rest of the slow older cars. D'Schane passed from lane to lane, cutting someone off abruptly and earning a sharp honk.

He seemed calmer, but only just, by the time they reached the house and left the car. Turning on all the lights, d'Schane disappeared into the kitchen.

"What are we doing now?" Terry asked.

He was answered by the sound of kitchen things being opened and closed.

"I don't know about you, but I'm eating dinner. What do you want?"

Terry walked into the kitchen. "I want to be your dinner."

"Sure you do." D'Schane threw two boxes into the oven. "I'm eating steak and fries. I know what it wants. It's dead."

Terry sat down at the table. "Is something wrong?" Food smells worked their way into his nose and made his stomach growl.

"No, nothing is wrong. Everything is fine. I'd just like to know what you want."

Terry thought about that.

"All of my friends live in Maryland."

D'Schane had started sorting dishes and putting them away. He stood on a chair to put the glasses in an upper cabinet.

"I'm your friend."

The oven sounded. D'Schane jumped off the chair, opened it, and pulled out the two steaming dinners, juggling them on the tips of his fingers. He dropped one in front of Terry.

"All of my other friends. We're fifty miles away in Virginia. And this place is nowhere near public transit. I haven't visited any of them in months."

D'Schane pried dinner open. "I can buy you a car."

"I can't drive."

"I can fix that, too."

"That isn't what I meant," Terry said, picking at the potatoes.

"Then what did you mean?" d'Schane asked over a mouthful of food.

"I wouldn't mind a little autonomy. I don't even have a job."

"Yes, you do."

"I work for you, Grey."

D'Schane looked up across the table. "Don't call me that."

"D'Schane. I work for you, I sleep with you, and I don't even leave the house unless you're around to drive me into town. You asked me what I wanted."

"I asked you to tell me what you wanted me to do to you this evening. I didn't ask for a lecture, especially on things I already know."

"But..." Terry bit his lip and let the conversation die of frustration. He ate about half the food and went to dump the rest down the trash.

There was a spider on the floor by the disposal. Terry shuddered and stepped on it.

"You don't like spiders."

Terry looked up irritably. D'Schane was switching on the cyberlink that read the thought impulses off of Terry's collar.

"You know I don't like spiders."

"You really don't like spiders. You're afraid of them."

"Is that a big deal?"

D'Schane smiled and got up. "Maybe." He pointed to the floor and snapped his fingers.

Terry edged away from the spot on the floor that had been a spider. "Not here."

"Are you disobeying me?"

"Yes."

"It'll cost you."

D'Schane was using that tone of voice that he reserved for his affronted-feudal-lord persona. Terry tried to figure out what he was up to. D'Schane smiled harder as he read Terry's confusion.

"I don't care."

"That's nice. I'll be in the bedroom in a few minutes. I want to see you on your knees on the floor facing away from the door when I get there."

Terry turned on the bedroom light. There wasn't much stuff in the room. D'Schane had moved all of the consoles, the vintage Macintosh (which didn't work), and the stacks of paper books into the downstairs den. That left the bed, a dresser, and a pile of dirty laundry.

Terry thought about taking his clothes off, but then didn't. D'Schane liked to strip him himself. He knelt by the bed and waited, enjoying the clawing edges of that velvet-pawed, half-safe sort of terror he loved so well. D'Schane took his time. Terry shifted from side to side, letting the blood back into his knees. He froze when he heard d'Schane come in.

Two hands, dripping wet, rested gently on his shoulders. Terry sighed and relaxed under the touch, until d'Schane abruptly threw him down onto his back and sat on him.

"You are afraid of spiders," d'Schane said, pinning Terry's hands up over his head. "What else are you afraid of?" His blue eyes were narrowed and his smile grew wider as Terry started to struggle.

Terry tried very hard not to think of the summer he spent living with Daphne, of the hot and airless closet where he had slept after she stopped taking him into her bed.

D'Schane said, "What if I tied you down and held a hand over your nose and mouth until you fainted? Try not to think about that, too. What else are you afraid of?"

Terry screamed.

▼▼▼

D'Schane called from Austin.

"It's funny how the smoother virtual communication gets, and the cheaper it is to hold a computerized conference, the more some sites want to pay me to actually show up."

"Are you having fun?" Terry asked. The scene behind d'Schane's face was a hotel room with an unmade bed and a console half-disassembled on the bed. D'Schane's face was pale

and sharper than usual. That could be the video quality, though.

"Sometimes. The job is sort of a pain. I'll tell you more about it when I get back."

Terry nodded. The com lines weren't secure, and if d'Schane was doing anything sensitive, talking about it would tip valuable information to any electronic thief who cared to listen in.

"Do you dream of me?" Terry asked.

"I haven't slept much."

"Got company?"

D'Schane smiled. "Sometimes. A woman I haven't seen since school stopped by. You'd like her. She's tall, blonde, and overbearing. What about you?"

"I got a couple I know to drive down, pick me up, and go out to dinner and a movie last night."

"That's good. I have to go now. I'll see you Friday."

"Maybe you will. I've been invited up to U Maryland for the weekend. I think I'll be going to see a friend's band play."

"I want you there when I get home. In fact, consider that an order."

Terry sat back when d'Schane broke the connection. He didn't need to obey. He could go anyway. Or maybe it was time for a little escalation.

Terry switched his console over to the documentation he was supposed to finish, worked on it, and thought.

D'Schane's plane was supposed to land at 6:35 p.m. His car arrived home at just before 8:00, right on time. The garage door slammed. Luggage hit the floor with a thud.

"Terry?"

Silence followed.

All of the lights were out. The house had old hand-switches in the walls. Terry could hear d'Schane trip in the sunless hallway as he turned on lights. Then d'Schane was standing in the bedroom

doorway, backlit, his lean profile and cowboy hat achingly familiar. A switch clicked. Nothing happened.

Swearing at all things mechanical, d'Schane hit the switch again.

"I need to talk to you."

D'Schane jumped. He reached up behind his ear for the link switch to Terry's mind.

"You know what I'm thinking now," Terry said from where he stood in the dark. "But I'm willing to bet that you can't avert it."

If d'Schane were smart, he would have backed up into the lighted hallway. But if he had retreated, he wouldn't have been d'Schane. He stepped into the room under the heavy tactical disadvantage of eyes unadjusted to the dark. Terry, unseen, slammed into him from the side. D'Schane staggered and slapped Terry across the face.

If Terry had been feeling a bit more submissive, the blow would have knocked him down trembling at d'Schane's feet. Instead, he caught the wrist, twisted the arm behind d'Schane's back, and lifted up.

D'Schane yelped.

Terry said, "You should think with your own head. Mine just confuses you."

D'Schane said nothing, but gritted his teeth audibly. He was no match for Terry in a fair fight, and knew it, so went limp and tried to disappear.

Terry pulled a pair of cuffs from his pocket and snapped one of them around the captured wrist. When he reached for the other hand, d'Schane's composure broke. He gave a soft whimper as Terry took away his freedom. Terry kicked him lightly behind the knee and lowered him to the floor, then went and did something obscure to the light switch.

They both blinked in the sudden light. D'Schane was kneeling, head bowed, hair messed. His hat had fallen to the floor. Terry eyed the arch of d'Schane's back, the bound wrists, and the blush

on his cheek. He realized his mouth was watering at this taste of power.

"I want to tell you two things," he said, sitting down on the floor before d'Schane. Terry felt the collar at his throat when he swallowed. It could not be removed, and housed the sensors that fed d'Schane's cyberlink. Ordinarily, it gave him a sweet sort of "owned" feeling. Now it provided an artistic touch of irony.

"The first is that if you beg, I'll stop and let you go."

D'Schane stared fixedly at the floor. He would, Terry knew, rather die horribly than beg. Yet the offer was tendered, and d'Schane couldn't blame Terry for forcing him if the game were played to conclusions.

"The second is how good you look like this. I should top you more often."

He stroked d'Schane's face with a finger, touching his lips, the cords of his throat, the soft part behind his ear. D'Schane hadn't moved. His breath was shallow, and his eyes half-shut.

"Still playing nobody home?" he asked.

Even though d'Schane knew it was coming, he still cried out when Terry slapped him.

"You've forgotten what this is like, haven't you?"

Terry hit him again.

"You've watched my mind dissolving as you shredded my skin, but you couldn't feel the pain."

Again.

"Until now."

Again.

"You should do this more often. You'd be less of a coward about it."

Again.

D'Schane tried to bury his face in his own shoulder. Terry paused. His palm burned. He reached out and stroked D'Schane's reddened cheek. The sudden arbitrary gesture of tenderness made him dizzy. He could make d'Schane feel anything he wanted.

"Turn it off."

Terry blinked. "What?"

D'Schane's eyes were still fixed downward, hidden behind hair.

"The cyberlink. I can hear you thinking. Please turn it off. Please."

Terry smiled. He thought about how much he was enjoying the position of dominance. The pleasure of it warmed him like sunlight. He would sit in judgment of d'Schane, and he planned to show him just enough of hell that anything else would look good. D'Schane would weep with gratitude at the slightest kindness. After all, d'Schane was the one who showed Terry how to do it, and should be proud of how well his student had learned.

D'Schane looked at him for the first time that night. His eyes were wet.

He said, "Then tell me you aren't doing this because you hate me."

Terry leaned forward and touched d'Schane's lips with a finger.

"I don't hate you. Not ever. I promise."

"Thank you. I won't cry."

"You're crying now."

Terry watched with fascination as d'Schane trembled. Tears leaked from his eyes and down his cheeks.

"Kiss me," d'Schane said.

Terry slapped him, jerking his head back.

"In case this is news to you, you don't get everything you want."

D'Schane glared at him, and his eyes were bright as sparks. He would need that fire soon. Terry abruptly grasped that one special pleasure of topping. He could watch. D'Schane often blindfolded him, or he was too distracted to see what was done to him. Now he could study his victim's changes of expression, each drop of sweat, and every tiny twitch.

Terry got up and dug in the dresser for the things he wanted. When he returned, d'Schane was still sniffing. Terry held a tissue to d'Schane's nose.

"Blow."

D'Schane obeyed awkwardly. Terry wiped the corners of his eyes and put the tissue aside. Reaching up, Terry unbuttoned d'Schane's shirt.

Terry took d'Schane's nipples between his fingers and stroked them until he squirmed and sighed. Then he reached down for the heavy chromed clips.

"I'll bet these hurt you more than they hurt me," Terry said, "because I'm used to them and you aren't."

D'Schane gasped as the clips bit his nipples. Terry cradled d'Schane's face in his hands and held him that way while he sank into the pain. He touched his fingers to d'Schane's lips, letting him take them into his mouth and suck on them. Terry probed the back of d'Schane's throat with a finger, trying to make him choke and bite, and so provoke Terry into the mood for further violence. But d'Schane was quite still and meek. Somehow that was provocation enough. Taking out a Y-shaped chain, Terry attached one end to each clip, leaving the third to dangle free. He tugged the loose end, making D'Schane whimper.

"I'm going to unfasten your hands," he said. "I want you to know how sorry you'll be if you give me trouble."

D'Schane nodded. "I know. I won't."

Terry unlocked the cuffs and pulled off d'Schane's shirt.

"Put your hands behind your head," he said, then gave the chain another tug. "Stand up."

D'Schane obeyed. Terry unbuttoned his lover's jeans and helped him step out of them.

One of the things he dearly loved about d'Schane was his instant, electric response to every touch, even as distressed as he was now. He squirmed as Terry bit his neck. D'Schane's penis was soft. Terry took it in his hand and stroked it. He had sucked it often

enough. This time it seemed that no velvet touches on those sensitive parts were going to make d'Schane hard just yet. Terry made him dance against the chain and gasp when it pulled.

There was an eyebolt set in the underside of the bed. Terry had set it up that morning and covered it with a draped corner of sheet so it wouldn't be noticed until he needed it. It was at exactly the right height that Terry could bend d'Schane over and clip the end of the chain to the bolt.

Almost the right height.

Terry nudged d'Schane's feet apart and forced him lower. D'Schane rested his head and shoulders on the bed and clasped his hands at the back of his neck as Terry fastened the last link to the bolt. It would have been so much kinder to tie his wrists. Now he must hold them still himself. If he moved much, or even took too deep a breath, he would give the nipple chain a very sharp jerk.

"Clever," d'Schane muttered into the blanket.

Terry brushed a hand against d'Schane's bare flank and trailed his fingers over the tense muscles of his back, stroking every rib, ruffling his hair, and running a fingernail down the crack of d'Schane's ass. He took one hair between his fingers and tugged. D'Schane jumped, froze, and then moaned. Terry stripped off his shirt, bent down, and picked up the riding crop. He laid it gently against d'Schane's ass and watched his body go taut and trembling.

D'Schane had, as far as Terry knew, few hang-ups. He did seem to suffer from delusions born of reading, at an early age, too many indifferently written sword-and-sorcery novels in which the heroes were tied up by their hands and flogged across the shoulders by thoroughly evil yet attractive villains. Romanticized tales conspicuously lacked the mess and bodily fluids (except for an artistic streak of blood) of a real-life torture scene, and the hero's breeches were always left on for some obscure plot reason. Terry suspected that this was why his back would be whipped raw and his ass scarcely touched. D'Schane showed little interest in the

ramming end of anal sex. To strip away someone's dignity that completely, to have to bother with lubricant and cleaning up afterwards just held no appeal for him.

Terry did not suffer from any such delusions.

D'Schane knew it, and he was starting to cry again, before Terry had even struck him.

The force of the first blow startled even Terry. D'Schane cringed. Terry examined with clinical interest the mark across his ass. He never knew skin had quite that many colors. The shaft of the whip was fiberglass and left a thick red welt as if it were a cane. The loop of leather on the end had wrapped around D'Schane's skinny hip. Terry laid a second mark diagonally across the first. D'Schane kicked, earning himself a welt across the calf. He had so little body fat, Terry realized, that it was hard to find a spot to whip that wouldn't instantly bruise.

Terry would have liked to leave a symmetrical lattice of welts like d'Schane sometimes did, but it proved to be too much trouble. Terry concentrated on the tender flesh just beneath d'Schane's buttocks, which were rapidly becoming so sore that a light touch made him moan. He bit at his own arm to stop the noise. Terry clipped him across the shoulder.

"You're not allowed to hurt yourself."

Dropping the crop, Terry pressed up against d'Schane's ass. The skin was so hot that he could feel it through his jeans. Terry decided that he was wearing too much clothing.

His jeans joined d'Schane's on the floor. Terry picked a tube of lubricant out of the drawer. His skin was tingling with arousal, and his penis was almost half-hard already. When he looked back, d'Schane had turned his head to watch him. Terry reached down and tugged the nipple chain, making him cry out.

"Ever been fucked in the ass?" Terry asked.

"Yes."

"Then I don't have to tell you how much more it hurts if you resist."

Terry started working a lube-covered finger into the tightness of d'Schane's anus. He probed past the muscle, pressing downwards. D'Schane sighed suddenly as Terry found his prostate. His slack genitals showed some sign of life. Terry pulled his fingers out and reached for more lube, smearing it over the head of his own penis. He fumbled just a bit finding the exact right angle. Apparently, d'Schane had decided not to resist. The head of Terry's penis went in slowly but smoothly. He gave d'Schane a moment to lean into it, to thrust back and open himself up to be taken.

Terry had spent too much time thinking about what he was doing to d'Schane. The full sensory force of what he was doing to himself, when it finally caught up to him, nearly made him pass out. The heat and the tightness were squeezing his heart. Dizzy, Terry leaned down and licked the sweat from d'Schane's back. He pulled out and thrust back in again just a little too fast. D'Schane made a pained noise and tossed his head. Terry wrapped his arms around him tightly. Reaching down, he sprang the clips and was rewarded with a ragged scream. D'Schane shook and melted into Terry's arms, his moans rising in pitch as the thrusts grew harder and harder against his sore flesh.

Then something at the base of Terry's spine ignited. He clawed d'Schane's back, leaving red marks all the way down. Terry's knees buckled, bringing them both tumbling to the floor.

Little by little, their pulses sank back to normal. Terry disentangled himself from d'Schane, reached up, and pulled the blankets down off the bed to wrap them both. Then, as the sweat cooled on their bodies, he kissed d'Schane on the mouth and licked his tears. D'Schane's body was stiff with unaccustomed stresses and the pain of being taken. Terry felt him soften under the gentleness.

Terry said, "Remember how you said I shouldn't let people step on me?"

D'Schane very pointedly reached up to the back of his head and touched the switch of the wire to Terry's mind, turning it off at last. Holding Terry tightly, he whispered, "I'm sorry. It's so hard being God for you sometimes. I had to run away. I'm sorry I didn't try to talk about it. But I can have you a job somewhere in town by next week. It's another favor, I know, but you'll have something you can keep on your own merits. I can even find you an apartment..."

Terry was shaking his head. "That's not what I want. Ask me what I want."

"Okay. Terry, what do you want?"

Terry reached up and touched his collar. "I belong to you and I want to stay that way. That isn't what's wrong. But I wouldn't mind if you sold this house and we moved to Georgetown."

"Is that all?"

Terry ran his tongue along d'Schane's throat. "No. I want you to tell me that you love me."

"I love you."

When Terry whispered the words back, they both lay still for a moment, not looking at each other, just a little frightened by it.

Terry kissed d'Schane again, tickling the roof of his mouth and biting his lips. He licked his way down to the sore nipples, making d'Schane wince. He tasted the taut skin of d'Schane's belly, then took into his mouth that which grew hard and twitched all of its own. D'Schane lay back, breathing hard, one hand twined in Terry's hair.

"You're going to get it tomorrow night."

Terry freed his mouth. "I know. I'm looking forward to it."

About the Author

Lauren P. Burka lives in Cambridge, Massachusetts, with her two rats. She smiths silver as well as words. She is the author of the short story "Divinity," also included in this omnibus, and her stories have appeared in *Absolute Magnitude* magazine, *By Her Subdued* (Masquerade Books, 1995), and *S/M Futures* (Circlet Press, 1995).

TELEPATHS DON'T NEED SAFEWORDS

by
Cecilia Tan

Acknowledgments

Thanks to Ian, corwin, D!, Lauren, Elf, Regis, Flynn and FF, and many others who have read various drafts of these stories, and who have been supportive friends throughout all this.

Introduction

I sometimes stop to think while I am reading a science fiction or fantasy novel, and wonder why it is I don't see more erotically driven material than I do. There are a number of possible reasons. Perhaps there isn't that much written. Or perhaps I'm just not looking in the right places. Or perhaps the right places still don't exist.

It makes me wonder only because erotic and sexual fantasies are among the most powerful and universal fantasy experiences human beings have. It seems only logical to me that the literature of wildest fantasy, f/sf, should be not only full of sex and eroticism, but focused on it. (Some excellent examples do exist. I highly recommend *The Enchantments of Flesh and Spirit* and the other Wraeththu books by Storm Constantine (Tor Books) and *Stars in My Pockets Like Grains of Sand* by Samuel R. Delany.)

In this little volume I am pleased to present some of my own vivid fantasies, which are both erotic and science-fictional in nature. I am self-publishing them for a number of reasons. First of all, these stories have no ready-made outlet in the world. Typical erotica and pornography publications shy from science fiction, and many will not publish bondage. Typical science fiction publications will not deal with such explicitness. And of the bondage publications, most deal with same-sex fantasies exclusively, or do not publish fiction, and look askance at the science fiction content as well. They are half-breed outcasts caught between two

narrowly guarded market ghettos, and so must make their own way however they can.

Second, these stories are my link to a sexually aware and adventurous community of SM/bondage/leather aficionados I know through the computer networks. Many of them first came to know me through these stories, earlier versions of which are still floating around in electronic form on the Net. The Net circumvents all predetermined demographics, target markets, and consumer groups. It is a natural gathering place for the outcasts and the forward-thinkers of tomorrow. Knowing this scattered and roving tribe does exist, I publish this collection as much for them as for me.

Third, as a writer, I want to see my creations go out and play in the world. There are still those out there attached to hardcopy, to the printed word, for whom the lightning data ghost of a story on the Net is not enough, or who do not have access to that cyberspace underlayer in which some of us increasingly live. Writing is creation, and for me the creation ends with publication, with printing, with seeing it in my hands. In that way, writing itself is like sex for me. In an SM scene or other equally mind-blowing sexual experience, participants may realize new depths of themselves, experience catharsis, exercise their imagination, and gain immense satisfaction, all at once. The same can be said of writing a story, even a nonerotic one. However, it is especially true of these stories, which do tap my deepest fantasies.

These stories are a testament to the immense power of fantasy. "Telepaths Don't Need Safewords" was written after Arisia 91, a Boston-area con at which I met Arshan in the flesh. My lust for the fellow in question expressed itself through the story, since I could not, at the time, express it to him directly. When we met again many months later, that lust was requited. A dream I had about him later resulted in "Cat Scratch Fever," which I think will become a novel in time. Most powerful of all, though, was "Heart's Desire." I wrote this story the night after meeting corwin

at an SM party (being hosted by my Arshan model, coincidentally ... small world). I can say now that I do believe in love at first sight, though at the time I dismissed my intense feelings as mere lust. The next morning I awoke and wrote "Heart's Desire," with the intention of exorcising my sexual frustration onto the page. However, you'll note that the story is not about sex, but about love. To make a long story short, corwin and I fell in love and are now bound as master and slave. This collection is dedicated to him.

Cecilia Tan
March 1992
Boston, MA

Telepaths Don't Need Safewords

Arshan tugged on the leash and gave me a bare-toothed smile, insistent and yet as catty as if he had winked. I replied with a sullen look, half a sneer really, saying with the look what I thought—*You know how much I hate this leash and you know how much I love this scene.* He dangled the leash over his shoulder, leading me across an open plaza toward the Hall. I kept my eyes down, not out of submission but to watch his feet. Arshan stands about six feet four. With the leash over his shoulder, I didn't have much room to avoid his long legs. I may have been playing the slave, but the last thing I wanted was to look like a klutz. I could feel him smiling.

At the door we exchanged looks again, and he thought, *It's been a while.*

I know. But I'm up for it if you are, I assured him, making a last mental check on our costumes. He carried no weapon, no instrument, no tool, save pieces of his costume, which had more than one use. We'd worked hard perfecting it, the belts, the waist-length cape, the boots. His colors, as always, were black and dark green. My own costume had fewer elements, just a basic black halter stretched over my breasts and black midcalf dance tights, bare feet. Oh, and the leash. I draped myself against him as he presented our pass to the door man. We donned simple eyemasks,

and proceeded down the carpeted hallway. *Think people will remember us?*

▼▼▼

The ceiling of the Hall is at least fifty feet high, perhaps higher, with one long wall made entirely of glass, overlooking the Galdarin River. Echoes of laughter came down from balconies on the opposite wall, and crystals and lights and chandeliers flickered everywhere. Arshan made his way straight for one of our old friends, Cleopatra.

She dripped with black beads, completely covered, yet not covered at all by a complex network of beaded strands, hanging in long wings from her arms and cascading down her back from her black hair. She turned from the conversation when she saw us, throwing up her hands and kissing Arshan on the cheek. "Arshan! You've arrived! We've missed you, you know. And you, Mriah," she added, turning to me. "It got very dull here for a while." She sighed, fluttering her eyelids. I love Cleo's act. And she loves ours.

Arshan smiled. "It's good to be back."

"Easy for you to say," I said, tossing my head.

He turned on me, shortening up the leash and speaking harshly. "I am trying to converse with the Lady Cleopatra. Now, will you be quiet, or will I have to cut your tongue out?"

I gave no answer at all except to nod my head toward Cleo.

She smiled. "As I said, it was getting very dull around here."

▼▼▼

We were lounging by the pool later, with some people we knew and some we didn't, when Arshan slapped me at last. Maidi and Bivon had been taking turns whipping Danielle, and when they were done, she thanked them for it on her knees. Gallen, a blond-haired fop that Cleo favored, started in with "She's a proper pretty one. All slaves should behave so well, don't you think, Arshan?"

"She's very beautiful," Arshan said to Cleopatra.

Cleo swallowed a bit of plum. "I believe she's for sale."

"Oh?" Gallen sat up a bit in his lounge chair. "Maidi, how much?"

Maidi and Bivon sat on the grass, coddling Danni between them. "No, she's not for sale," Maidi said.

"I'd say she's worth forty thousand," Gallen continued. "Whereas I wouldn't pay more than five thousand for one like yours, Arshan."

"Not that I would go with you, anyway," I replied from where I sat at Arshan's feet. Arshan jerked on the leash.

"You haven't broken her yet?"

Cleo laughed. "Arshan likes them with their teeth intact."

Gallen was unfazed. "Imagine that. I think she needs a lesson."

I sneered. "From you? I'd rather put out my own eyes."

Arshan jerked the chain so hard I pitched forward onto my hands. "That will be quite enough, slave." He sat up in the lounge chair a little, then settled back, shortening the chain so I remained on all fours. "I can handle her myself, thank you." He smiled obsequiously at Gallen.

"Oh, it's no fault of yours, I'm sure." Gallen picked up a plum from the bowl between Cleopatra and him. "Still, I can see why she's talking back. You don't even have a bat for her."

"I've never needed one."

Cleo applauded the point by tapping her own crop in her gloved palm. "Arshan has many methods."

"Still, I wonder how she would respond to some of my own." Gallen stood, placed himself in front of me, snapped his fingers. "Look at me, slave."

I drew my eyes up his leg, stopped at his crotch. I let half a smile onto my face.

"I said, 'Look at me.'"

"I am."

He lifted my chin with his boot. I held his gaze for a moment, then dropped back down to admire his groin again. There wasn't

much to see really, at first. But as he grew more angry, he grew. I watched the bulge thicken as he made a fist. "You have to put fear into her, Arshan. Like this." He drew back his foot to kick me.

Arshan was up in an instant, between us. "Think again."

Cleo laughed, tugging on Gallen's velvet sleeve. "No one strikes her but Arshan, dear, and she obeys no one but him."

"Well, what good is she, then?" Gallen said sullenly, sinking back down into the chair at Cleo's side. I was already holding onto Arshan's leg. I let my hands run up and down his thigh. I closed my eyes and rubbed against him with my cheek. *That was close.*

He's obviously an asshole. I'd let you bait him more except I think he's dangerous.

I don't know... I drew my hand between Arshan's legs to caress his crotch, letting the heat from his stiffening penis flow into my fingers. *Shall I show him what good am I?*

Arshan made some meaningless small talk with Cleo as I came around his leg to kneel in front of him. The loose-fitting pants he wore didn't end in seams on the inside. And Arshan never wore underwear. I had his cock in my mouth then. "You see," he was explaining, "she is extremely loyal. And always grateful." I would have added something of my own, but my mouth was full. Using my lips, I squeezed some precome into my mouth and swallowed. I let my tongue work the underside, the tender cleft just at the base of the head, until he was having trouble keeping up the conversation. I felt him start to go, his hips began to buck, and then I ducked.

Semen shot out over the grass, a fair bit spattering the golden edge of Gallen's green waistcoat. Arshan recovered immediately. He grabbed me by the chin and scolded me. He gripped the halter at the center and pulled it over my head; with two knots, he tied my hands behind my back, using it instead of rope. Then he knelt in front of me, holding my head still by the hair at the base of my neck, and slapped me with his right hand across my cheek.

Do it again, I thought.

He raised his hand high this time, and I tried to flinch, but his other hand held me still. "Don't you move, now," he said, almost growling, as he brought the slapping hand down to fondle my bare breasts instead. He squeezed the nipples between the knuckles of his first and middle fingers, then forced my head down to the grass. The blades prickled against my chest, cool and rough. "Are you ready to apologize?"

"I'm sorry, Master."

"You needn't apologize to me. Apologize to this gentleman, whose finery you've ruined."

I kept my mouth shut. Gallen was on his feet now, towering above us. Arshan stood, picking up the end of the leash again. "Slave." He gave it a jerk and I sat up. But I kept my head down. "Slave," he repeated.

"Screw you," I said.

You're pushing it. "Maybe I haven't made myself clear," he said, wrapping the leash around his hand, until he held me fast by the neck. "I think you owe this man something, and I intend to see he gets it." He laid me on my back in the grass, leading me by the neck. "Gallen, may I borrow your knife?"

"Certainly."

He handed down his pearl-handled dagger. Arshan slipped it deftly under the waistband of my tights and, with one stroke, ripped them open from my belly button downward. Uncoiling the leash, he wrapped the other end around my right ankle, binding my foot near my head. The left leg he bound with one of the belts from around his own waist, by wrapping my knee to my shoulder. I felt my own wetness drip down the crack of my ass as my pussy was now open to the wind. "Gallen, I believe this slave owes you something. So long as you do not strike her, you may do as you will."

What? I started to object. But Arshan didn't answer me. Gallen opened a cockslit in his own tights and brandished his penis. "With

pleasure," he said, as he motioned for two male slaves to lift me up onto the table. He pressed the head of his cock against my ass. "I will gladly spill some seed in return," he said, and with that he rammed into me. He got about an inch in, holding me by my thighs. His cock was so dry, it burned as he thrust deeper in. I saw his face twist and wondered if it was unpleasant for him, too. But then I felt his balls against my ass, and he started pumping. I clenched my teeth tightly, staring him in the eye as he worked. I don't think he liked that, but it didn't matter, because soon his eyes were shut. The motion became smoother as precome leaked out of him, but I kept my teeth bared and didn't relax. As he began panting, I growled, and he came inside me, shooting hot white blood up into my insides. I looked away while waiting for him to recover. He opened his eyes, and nodded to Arshan. "Well," he said, his dick still inside me. "She is good for one thing." I opened my mouth to speak, but he clamped a hand over it. He pulled his leather gauntlet off the other with his teeth, and began stroking my pussy. His index finger probed down between our stomachs. He brought it out from my vagina, moistening my labia with the juices there, then stroked my clit upward a few times, smiling as I shivered involuntarily.

He worked his large, rough thumb back and forth. I tried to fight him, but struggling only increased the contact. My hips began moving with him as I hungrily sought my release. I bucked forward, trying to increase the pressure, when I felt his shrunken penis slip from my ass. "Ohh, looks like I'm done," he said, stepping back from me. "I hate you," I whispered between clenched teeth. With my hands behind my back, there was no way I could finish the job he had started. He was laughing. "The poor little thing, look at her struggling. Ha!"

Arshan released my legs and made me stand up. I trembled, tried to rub up against his leg, but he slapped me again. "Down. You're a mess. I think you need a walk through the pool." As he led me to the edge of the water, he asked me, *How are you doing?*

Loving every minute. I still don't like Gallen, though.

He winked. *Yeah, but at least I got the knife away from him.*

▼▼▼

We mingled near the buffet for a while. Arshan picked at bits of bread and fruit. Occasionally he would drop something into my mouth as he made his point or changed the tide of a conversation—when he wanted me shut up. My thighs hummed with the energy Gallen had built up. It made me quieter than usual; all I could think about was Arshan's penis, which I had held in my mouth not so long ago. From time to time, as we circulated though the crowd, I met the eyes of guests, willing them to touch me. *Look at me—how can you resist me? My breasts bared for you, my hands tied, the gaping rent exposing my mound—how can you not bring your hands to me?* But they touched only with their eyes, some with curiosity ("Wish I'd seen that scene") or disdain. Very few were masked like us, I realized. Perhaps we were outdated. Finally, bored, I began nuzzling Arshan's shoulder. I rubbed my breasts against the woven fabric of the short cape, feeling the nipples contract to become rock-hard.

"I think the civil unrest will resolve itself," he was saying to a man I didn't know, who also had a slave on a leash. The slave, a male, was wearing nothing at all, and posed and pranced after his master like a show horse. Arshan held me still with his gaze. "Haven't you had enough? No favors for you until I'm finished eating."

The other man chuckled. "Poor thing, she looks like the hungry one."

I tried to rub my head on Arshan's chest, but he backed up a bit. I lowered my head, then, and went for the man, pressing my chest against his side and begging silently with my eyes. "Oho! Arshan, I do believe you have been depriving the girl."

"Ah, she gets like this sometimes, uncontrollable. But she hasn't deserved me yet. What shall I do?"

The man stroked his mustache. "Slave," he said to his own slave, "kneel." The slave obeyed. To Arshan, as his eyes examined me still pressing against him: "I believe we might have some amusement?"

"By all means."

Arshan handed the leash to the man, who held me from behind by my shoulders. He untied my hands as he moved me forward, until I was less than an inch from his kneeling slave's face. The slave licked my stomach. "Lie down," he said, pushing me down as he said it. He held my wrists fast above my head, and called for two other men to hold my ankles. Two other guests gladly did, spreading my legs in front of the slave. "Now, slave," he said, speaking to his own, "follow my instructions very carefully.

"First, run the backs of your fingers up the insides of her legs, but stop about half way up the thigh. Good. Again. Keep that up. Now move forward on your knees, run your hands up her stomach, cup her breasts. Take each nipple into your teeth, the right one first."

I twisted as he bit, not hard enough to draw blood but enough to send goosebumps down my whole right side. I moaned when he took the left.

"Now pinch them both with your fingers, keep your thumbs over the tips of the nipples, rub as you would a lucky coin. Ah, she's moving now. Fetch ice from the table. Good. Now take one cube in either hand, and hold it against her breasts. Rub. Good. Now with the ice, down the center of her sternum, down to the belly button, slowly now, slowly down the center of her abdomen, stop. Leave the ice there."

I felt the cold water melting down over my pubic hair.

"Now take some ice cubes in your mouth. With a cube in your right hand, slowly draw a line from the floor, up past her anus (I shivered again) up to her vagina, stop. Can you push it in? It has melted already? Get another, now up, up, press it to her clitoris, slave. Do not rub, simply press."

I gasped. The rubbing Gallen had given me seemed to flood back into me; I felt my labia swelling, and my clit begin to throb under the ice.

"Now, keeping the ice in your mouth, extend your tongue, touch her clitoris."

The rough surface of the tongue, as cold as ice, made me jump. The slave began a circular motion with the tongue, then switched to a straightforward lapping. I couldn't stop moving my hips. I tried to pull my legs free—I wanted to wrap them around his head and keep his icy tongue there forever, but the men held me fast. I began moaning.

"Now, slave, please immerse your penis in the ice. After this." He pulled a cock ring from the pocket of his brocaded jacket. The slave had trouble at first, but finally succeeded in putting it in place. Good. I wanted him long and hard and inside me. Even if it would be ice cold.

The long frozen shaft penetrated my throbbing cunt one millimeter at a time. I moaned, trying to move up farther on his pole, but he kept the distance where he, or, rather, his master, wanted it. When he was all the way in, they held more ice to my nipples, and then he pulled just as slowly out, and iced his cock some more. Then he came back in, slowly, and out. More ice. Then slowly in ... I thought I would go insane. He tickled my clit with the icy tip then, and a spasm ran up my spine. So close! Then he plunged into me, and began grinding in a wide circle. I moaned loudly, but kept my eyes on the man holding my wrists. After all, it was really him fucking me, through his slave. I imagined it was Arshan inside me then, and I gasped. The slave began pumping in and out of me so fast, I was just beginning to wonder how long he could keep that up when I came and came and came. One leg came free as I spasmed, and they all let go and I clung to the slave with all my limbs, holding him deep inside me. I rolled him over onto his back and sat up, riding him. I threw my head back and began rocking, pushing immediately for that second explosive

orgasm I knew I could have. It blossomed quickly, the energy traveling out my limbs and up through the top of my head as I cried out.

I slumped forward, and Arshan lifted me off the slave's still-stiff penis. There were people applauding politely, I think. He bound my hands in front of me then, and let me lean, eyes closed, against him, covering my shoulder with the corner of his cape. "There now, much more docile, you see."

"So I do see," the man was saying. Then to his slave: "Well done." He removed the cock ring. "He has been instructed not to have an orgasm or ejaculate until I say he may," he explained. "I am pleased."

We moved off into the crowd then. *Thank you,* I thought dreamily.

You're welcome. But you're not done yet, are you?

I sent him the image in my mind of his penis probing the very dark corners of my soul, of the fire spreading up my limbs and back through him with a kiss, building and spreading through every pore in both our bodies. *In time,* he replied. *But I think I am going to let one more scene pass.*

He rarely gave me hints about what he was planning, unless that was a part of it all.

Yes, I think I'll trade you for someone else for a while.

What?

Trade you.

Arshan, I don't like the sound of that.

You can tell me to stop anytime. We'll go home.

I bit my lip. *Not yet.* Even through his thoughts I was unsure if he was serious. Aftershocks from orgasm were making things jump in and out of focus. He held me tight as he led me to a place to sit, a chaise lounge along one wall.

When I looked up, he was smiling. *It's just I have a few interests,* he thought.

Oh? I haven't seen much worth fishing for...

He shared with me the image of Cleo, black beads covering them both. *Ha. How do you think you're going to maneuver that? Cleo doesn't do public displays anymore.*

Who said it would be public? But not just now; I'm thinking of more ready game. You remember Mor?

How could I forget him. Mor was an old party-goer who had played with us a few times. He had luscious dark brown skin and long, black straight hair. *But he's...*

He's here tonight, as a slave. I don't think I'll have to trade you for him, but I do want him.

I returned the smile. *Let's go for it.*

▼▼▼

I had to admit Mor was stunning. I had always seen him heavily adorned in black leather. But tonight he wore only body paint, in elaborate and colorful designs. His hair drawn back in a long topknot, he seemed a bird out of a jungle paradise, alien and irresistible. His master we also knew, Martin, who had once been Mor's student. I suspected this was a sort of graduation gift. Mor's and my eyes met while our masters talked. If I hadn't known better, I would have thought he had me hypnotized. I admitted to myself I wanted him, but he was Arshan's choice. The thought of his body and Arshan's together warmed me all over. A crowd was gathering.

Suddenly Arshan dropped the leash. Martin picked it up, and I was pulled outside of the circle that was forming. I resisted the urge to call out to Arsh. I couldn't see him, and a knot of panic started growing in my stomach. I looked at Martin. He smiled, remembering me, and it calmed me. Arshan could take care of himself. But I still wished I could watch. Martin shrugged and let go the leash then, and pushed his way back into the crowd. Free, lost, I circled the knot of onlookers.

I'm not sure when it happened. At one point I could sense, even though I could not see, Arshan approaching orgasm. Perhaps it

was at that moment when the leather-gloved hands covered my mouth and nose, a strange smell invaded my brain, and try as I could to think, to send a message, I could only slip down into the darkness.

I awoke what couldn't have been more than a few minutes later. Gallen leered as he closed the last binding on my ankle. I was spread-eagled on a cross in one of the small playrooms. I sensed other people behind me—three? four? From their breathing, they sounded like men. Gallen straightened his gauntlets and crossed his arms.

Arsh? Arshan! There was no response. I could sense him fuzzily—no telling if it was the drug that made me weak or if he was just too busy to hear it, or both. Like me, he was always weakest after an orgasm. I looked Gallen in the face. "What do you think you're doing?"

He didn't answer, except to pick up a short whip and come to lean against my side. I was at about a forty-five-degree angle to the floor. He caressed my breasts with his leather-covered hands, and my nipples stood up defiantly. I didn't have a shred of costume left now; even the collar was gone.

Arshan, did you plan this? Arshan! But there was still nothing. I cursed at Gallen in Ardric, now only half acting.

"Screw you," he replied, but mildly, as he tickled my nipples with the tip of the whip. He ran the leather under my chin, bringing up goosebumps, tickling the inside of my ear, making me shudder. "There now." He used the tip like a feather, searching me all over for ticklish spots, until he ended by tweaking my clit upward with it, not quite hard enough... I moaned. I was becoming wet. I hoped Arshan had set this up earlier...

Gallen lifted the end of the X, and it locked into place with me parallel to the floor. Twisting my head, I could see the others, three men I didn't know. I was going to hiss at them, when I felt the handle of the whip enter my cunt.

I looked up at Gallen. The handle was rough, and though I was wet, it did not go in and out smoothly. He smiled as he fucked me with it. It was the smile that frightened me. I tried to read him more closely, but his mind was sealed tighter than shrink-wrap.

"You like that don't you?" He twisted it back and forth, never pushing it far enough in to touch my cervix. Just enough to make me moan again. "You like the whip," he said, more to himself than to me. He pulled it out then, and tasted the wet end of it. Then his tone changed and his smile disappeared. "I promised you a lesson, didn't I."

"You've had your fun," I spat. "Let me out of here."

"Such a feisty act you two have. Let's see how long you can keep it up." He cracked the whip, and I, and the spectators, jumped.

"If you lay that whip on me, I'll kill you," I said matter-of-factly. "Believe me, Gallen, if I don't, then Arshan will."

He raised his eyebrows at the use of his name, and cracked the whip again.

"Gallen," I repeated, "stop it, now."

He circled me, rotated the X again so that I was upright. The blood was rushing from my head as I tried again. *Arsh, get your ass in here!* I struggled against the bindings, but they were as real as they looked. "I am going to kill you!"

And he struck me. The whip lashed me on the chest, just above my left breast. Pain and adrenaline flooded me. *Arshan!!*

Yes?

I tried to tell him what was happening, but all that came through to him was a white-hot burst of pain as I was struck for only the second time in ten years by anyone other than he. Perhaps that got the message through more clearly than anything. I was panting. "You will die," I said. Gallen lashed out again, and again. Sweat broke out all over my body as I fought to contain the pain. I tried to breathe deeply, but I shook too hard, and he gave me no respite between strokes. He tricked me, cracking the whip into the

air sometimes, or raising his arm and then stopping. I did not scream.

And then Arshan's voice in my head: *The door's bolted. Hang on!*

"Please, stop," I was saying. I looked at the three spectators. "Someone, make him stop!" One of them started forward, but Gallen cracked the whip in front of them. He struck me again, on the cheek. I think tears ran down my cheeks with the blood. "Gallen! Stop!"

He was laughing. He let a few more strokes fall, each one seeming harder than the last, and then he threw the whip down and unsheathed his penis. He pushed the table back flat and stood between my legs, rubbing his penis against the inside of my thighs with his hand. I mustered up the strength to spit at him and he thrust into me. "Still warm, I see," he said as he fucked me vigorously. Trembling, I tried to pretend he wasn't there. I closed my eyes this time. *Arshan...?*

We're almost through..., he answered. I could almost feel the clenching of his teeth.

Gallen must have heard the door beginning to give, for he redoubled his efforts and was exploding into me just about the time Arshan came exploding through the door. Arshan leapt straight over the table and knocked Gallen flat on his back. One of the spectators pressed the release and tipped the table forward. I stumbled to my knees, shaking life back into my arms. The two of them struggled. I saw Arshan thrown backwards and Gallen stand up.

I tackled him in the midsection, forcing him back against the wall, and swept his feet out from under him. Once on top of him, I smashed my fist into his face. And again. "I could just drive your nose up into your brain and kill you instantly," I heard myself say. "But I'd rather beat you like this." I held on to his collar, lifting him up with my left hand and then beating him down with the right. His face felt fleshy, crunchy, knobbly all at once. I pulled

him up to a sitting position and switched to backfisting him, then roundhousing him, then backfisting him... The resounding smack of meat was all I could hear.

Mriah! Mriah! Stop it! Arshan finally grabbed my wrist and I wondered how long he had been trying to get my attention. He pulled me off of Gallen, and I collapsed, sobbing. Gallen just lay there.

Arshan picked me up gently, wrapping me in his cape. I couldn't think at all; I just cried for a while, and he rocked me in his lap, humming a song softly in his throat. He kissed my bruised cheek, smoothing my hair with his hand and holding me. At some point, I realized we were in the car, the smallness of the space comforting me. I kept my eyes closed as he caressed my face. I kissed him, drawing his energy deep into my chest as I inhaled. *I love you* was the first thing I could think. I drew him down on top of me then, kissing him and kissing him, not opening my eyes even once. He seemed to touch every part of my body then, the whole and the sore, warm and soft. I felt his skin, the long smooth plane of his back under his shirt, and the bony curve of his hip against mine. *Come inside me, heal me,* I said. He held me tightly, arms circling my rib cage completely. He came into me gently, probing as I opened for him. I tucked my legs behind his back, bonding us together, one animal. *You make me whole.* I felt the energy building in my womb. Our minds open, I shared it, felt the waves of blood-warm pleasure feeding back to me. Up and up we went, until, shuddering and shaking as one, we passed the peak and slipped back down into oblivion. As I was drifting into sleep, I heard him say, *Now I remember why we stopped party-going.*

In his arms, I smiled. I answered, *But now I remember why we started...*

Cat Scratch Fever

 There is something erotic about the feeling of fur, admit it. Especially when under the fur there is taut muscle, the warmth of blood beating under it. I ran my hand over her back, smiling as her tail lifted just a twitch as I reached the base of her spine. The fur was thickest on her back, but thinned down her sides and her front, just a downy covering on her stomach. I scratched her under the chin and rolled her over gently, letting my hand slide down between her breasts and over her stomach. She rubbed her head against my knee while I beheld her. Such a gorgeous creature, she had all the outlines of a woman but for the tail, her brown eyes bright against the blackness of her fur.

I wondered if I looked as fine to her, in my canvas and boots and gauntlets and shirt of cotton. She took my hand in her mouth carefully. As I did every night when she awoke, I let her rake the skin with her sharp teeth, drawing just a little blood, and then drew back from her, trying to measure how much time had passed, trying to guess how long I could continue to tarry in the woods, my Keep possibly languishing without me. Well, they could wait a week or two, perhaps even more if that is what it would take. Dara could hold things together until I returned, or so I hoped. I rested my hand on the lovely she-cat's head and was amazed and gratified to hear something unmistakably like a purr.

Some of my men had brought her out of the forest—it had been a hectic time. I had ordered them on ahead with the hunt

while I stayed behind at the Keep to administrate some lordly matter. I never dreamed they would succeed in snaring something before I arrived.

When I rode into the camp, I could already tell something had happened. They were a dozen men altogether. Danton took my horse by the reins as I dismounted and headed for the first trailer. But I did not have to enter it to find them, for the rest were circled around something on the ground. They were making a lot more noise than I would have expected. Then someone shrieked in pain and I charged forward, breaking their circle.

Guilty-sounding explanations of innocence barraged me as I surveyed the scene. One man was on the ground bleeding from one eye. Another, Hillard, was nursing a crudely bandaged arm. I held out my hands for silence, opening my mouth to demand what had happened...

...and I left it open as I saw her. She was crouched low, but I could see her hands and feet were bound together and a chain hung from her neck to a stake in the ground. She was growling low in her throat, her eyes burning as she flexed her claws. We stared at each other for an age and a half. And then I remembered to ask, "What the hell is going on here!"

Hillard told me one thing, about how they'd hunted her down that morning and were just trying to tame her before I got there. But later Danton told me the truth, that they had kept her there for two days.

"Why didn't you radio me!" I was shouting, pacing in the dark, cramped space of the trailer. But it wasn't Danton I should be angry with.

He did not explain. His eyes said what I knew, that Hillard had the true answers.

I burst out of the tiny trailer to find Hillard pissing against its wall. He backed away from me, dripping, not lifting his hands to brush the strings of dirty blond hair from his eyes.

"I take it you heard, then, what our friend Danton has said."

"That's true, milord Calidare." He stopped backing away to talk, but kept rocking back and forth from one foot to the other. "We just didn't want to upset you."

"Upset me!" I slapped my leather gauntlets into my left palm. "Lying to me upsets me, Hillard, as does withholding information from me."

He was looking behind me, as if searching for some rescue, his eyes falling on Danton from time to time, finding no pity there. All the others seemed to have disappeared. "We didn't mean any harm, sir, really. We just thought you'd be angry if you found out you missed the hunt..."

"Do you think I'm out here to hunt? Is that what you think?" *Of course*, said a small voice in my head, *you've kept them all ignorant of your real reason for coming out here...*, but I silenced it with the business at hand. I stepped up to him, my nose hanging just over his forehead. "If I had known you had accomplished what you set out to do, I would have ordered you back yesterday. I wouldn't have left the Keep at such a crucial time." I cracked my favorite cruel smile. "But I'm truly astonished that you bumbling idiots managed to succeed." I don't think he was listening to me anymore, just trembling. I suppose I was glad he had already run out of piss. "You've done your job. Now get back to the Keep and tell Dara we're on our way back."

I did not move as he stepped back, bowing his head once, meeting my eyes as he did so. I noted the lopsided twist of his mouth. So, he wasn't entirely cowed, after all. Still, at least I got rid of him.

I turned back to Danton, who had watched the whole thing with his arms crossed. A little smile came onto his face, and then he turned away, too. In that way, he reminded me of myself ten years ago. No, not even that long ago. Young, his straight dark hair cresting his shoulders, he spoke very little. There was a time when I didn't speak so much, when I didn't have so many questions to answer, when I didn't have as much to say.

Our prize hissed at me when I went to check on her and bring her some meat. She eyed me suspiciously, but eventually took the mutton I offered. Then she slept curled up upon herself, peacefully, which is more than I can say for the fellow whose eye she put out. That night he broke out in a raging fever. By the time it became light enough for Danton and two others to travel with him back to the Keep, he could no longer speak but for incoherent jumbles and would not answer his own name. Danton returned while I was watching her pacing in the clearing, to inform me that he was dead. I bit my lip and wondered how Hillard fared. The she-cat batted an insect out of the air.

▼▼▼

By the end of that week, she would accept meat straight from my hand, always well encased in leather to prevent her scratching me. Soon after, she would let me touch her, gentle strokes on her shoulders and the back of her head. The hair on her head was long and straight like Dara's, only black as midnight. Of course it was my own impatience that did me in. Unable to resist the feel of her fur any longer, I pulled off my right gauntlet and luxuriated in that hair, so much finer than any I'd held before. And then she'd batted down my hand and bitten it. I knew better than to pull back and enlarge the wounds. She regarded me as she sank her teeth a little deeper, and then her jaws relaxed. She seemed almost to approve as I drew my hand away, and she turned to grooming her hair herself, combing it out with her claws in a wholly womanly gesture. I regarded the red lines and punctures on my skin, and then called for some hot water.

Within hours, I was feverish, my red skin tender to the touch. I imagined the water would steam off of me as Aston plied it on with a cloth, but it did not, only sent me into fits of shivering. Danton sat by me, muttering and occasionally saying, "Calidare," to see if I would respond. And then he began ranting about a damn fool's errand for a man's pride. I tried to stop him, tried

to explain why I'd taken the risk, but my words began to slip from me. It seemed to me I slept after that and dreamed of cats and goddesses.

▼▼▼

In the morning, I was still alive, dehydrated, queasy, unsteady on my feet. But I pulled on my clothes, and marched out to the center of the wagons. She was still awake, waiting for me. I crouched down at her level, and held out my hand. She smelled it cautiously, and then, assured it was me, bit down just a millimeter into the skin. I withdrew my hand with a nod. "I thank you, my lady, and now may I fetch your breakfast?" She sat back on her feet, tucking her tail around them.

I was half-delirious most of the next few days, unable to keep much food down, and sleeping between fragments of dreams only. Aston began tearing out his hair every time I went near her. But I went near her more and more, until I began to spend every evening sitting on a stump near her, singing to her and telling her the stories of my childhood, waiting for her to wake up from her diurnal sleepiness. After all, what else was there to do out in the middle of nowhere? The men were beginning to question my sanity, I think, but men are often more like wolves than cats. A few well-placed arm-wrestling bouts and some biting commentary kept the pecking order straight. The time wasn't right, not yet. I wasn't even sure what it was I had to wait for; I only hoped it wouldn't be too long. I watched the moon rising over the tops of the trees.

She was still purring. I rested my hand on her head and realized she had wrapped her tail around my ankle. I knelt down next to her and began scratching the base of her neck, under her long mane, and the purring became a mewling in her throat and she began to rub against me. Without thinking, I cooed back some sweet nothing, the kind of babble Dara called baby talk, even though it hadn't produced any babies for her yet.

As she ran her head up my thigh, I realized she'd put my boot between her legs. Her tail waved from one side to the other as she continued rubbing against me, her head on my thigh, her stomach on my shin, and the tender part between her legs against my boot. I turned her chin up with a finger, and looked into her eyes. There was a flicker there, an intensity I hadn't seen before. I might have imagined it, but I could swear she gave the slightest nod. Dara will tell you, at great length even, about how I never let an invitation go unanswered.

I took her shoulders in my hands and gently rolled her onto her back, the chain on her neck clanking. As I lowered my weight on top of her, I felt my erection press between us. She growled, but did not fight me. I hesitated a moment, not sure what kissing her would do. I rubbed my nose against her nose—she writhed and the purring began again. I licked her lips and let my tongue into her mouth. I felt the extra sharpness of her teeth, but other than that, it was like any other woman's mouth, wet, warm, and inviting. I felt her claws through the cotton of my shirt, the points grazing my skin, digging a bit deeper when I took to nuzzling her neck. *Am I going to have any back left?* I wondered. I hadn't built up a perfect tolerance to her scratches yet, and I knew she could seriously injure me. For just a moment I considered whether this was some ploy on her part to get rid of me. But deeper down, I could not even think that. Lifting myself up on my arms, I nudged her to roll over.

I settled back into place on her back and she writhed even more. *Perhaps,* I thought, *this is the way Cats do it.* I buried my face in her thick, black fur, surprised at the sweetness of it, but that's pheromones for you, I guess. I drank her in. Now, with her legs spread, I could smell her desire as strong as my own. I stroked her underside with one hand while fumbling with my pants with the other. My erection was almost painful as I sought to free it. She bumped me with her hips again and again, pushing her tail up into the air.

The night air was cool against me as I slid my pants down to my ankles. She purred and mewled and thrashed and would not stay still enough for me to enter her. I had to use both arms to hold her under me, and then I did not have a hand to guide myself. She bucked and nearly threw me off as I reached back with one hand, anyway. I dug my teeth into the fur of her neck, waiting for her to thrash, but it seemed to paralyze her. In her throat, she whimpered, shivering, her hips still moving slightly. I fingered where she was wettest and led my penis there, pressed it against her. She moved a little and I bit down harder. She froze again and I slipped inside her, falling against her as I did so, gasping.

Inside her was a heaven I had only dreamed of. We moved together, stroke after stroke, until I could no longer tell where her growls ended and my grunts began. I could see nothing but flashes of black by the moonlight, yet I felt every curve of her body, every muscle responding to my every motion. For all her thrashing, I had expected it to be rough, but it was smooth, now slow, now rapid, but smooth. I do not know how long we were like that; I never wanted it to end and I prolonged it as long as I could. But then she was beginning to thrash again; she cried out and arched against me—I felt contraction after contraction ripple through her, squeezing me from deep inside and pushing me closer to climax myself. Now she cried out with each thrust, throwing her head back in a frenzy—I feared I would slip out of her as she bucked. I clamped my teeth down on the back of her neck again and held her still as I drove the five long, hard strokes into her. That was all I could stand before I began to fly in and out, unable to control my own hips, until at last I matched her cry and emptied myself into her, holding her furred frame against my chest as I shuddered with the last waves of it.

She rolled out from under me immediately. She licked a little sweat from my upper lip and shivered, yawning. I swear she almost smiled. And then, after making sure I was watching, she undid the clip on her collar with her deft fingers, and let it fall to

the ground. While I blinked, aghast, she curled up against my stomach and went back to sleep. I had no doubt I would return to the Keep with her. But I wondered, now, whether she was still mine, or if the tables had been turned. With her fur filling my senses, I decided it didn't make a difference. And I slept, too.

.

Heart's Desire

Sometimes, looking around my bedchamber before I sleep at night, I am awed by what I have. Could I really have achieved, garnered, realized all of these desires? Around me, the largeness of the house seems to grow, twenty or more empty rooms between mine and that of the nearest servant, filled up with the silence I have hoarded. It seemed like hardly any work at all. But thinking deeper, before dreams begin to creep up under my eyes, I realize that while it may not have seemed to be such a conscious effort, subconscious desire is always at work. What was it that made me invite Glinda to that party?

She and I had never liked each other particularly. We got along well, based on our mutual respect for each other's talents, and certain shared tastes. But we differed in a few opinions and were never friends. Still, I never wanted to do anything to hurt her. Let me stop kidding myself and you. I invited her because I secretly hoped she would bring Corwin.

The party itself was unremarkable as these things go—the usual beatings and humiliations, and a good deal of wine spilled (much less than was consumed). As host, I mostly watched that night, detached from my guests by my stature. But by the time the fire grew low, we were five women in the drawing room: myself, three others, and Glin, with Corwin. Their act had gone uninterrupted since they first arrived, late, at the front gate.

They had made a grand entrance into the main hall, her driver announcing, "The Lady Glinda Trisel, Duchess of Alaming."

She swept forward into the room, trailing a gold-and-black dress and crinoline almost as stunning as her flaming red hair. She fanned herself gently and raised her voice. "And may I present my consort, Corwin, Prince of the Panatans." She turned back toward him. The driver shoved him forward into the room. He stumbled and nearly fell to his knees, chains clanking, but recovered, eyes smoldering. He was a gorgeous sight to behold in a blue velvet tunic, the square collar exposing the gentle curve of his collarbone, his long brown hair bound behind him in a matching ribbon, and topped by a silver circlet. His hands were bound in front of him with bright silver chain. She beckoned and he followed her farther into the room, his head held proudly. It was easy to forget she was a designer and he a programmer—I saw a noble lady and a prince.

They greeted me, their hostess, first. Glin and I exchanged some niceties, and I complimented her on the scenario. We had many people come in costume, enacting everything from movie characters to wild fancies of their own. But I have a soft spot for that medieval fantasy period. And Corwin, the roundness of his face, the fullness of his lips—I would have thought him beautiful even if he had been a woman. I could not take my eyes off him.

Neither could many others. So even at that late hour, when Glin slapped him in the face (I missed what he had said to deserve it), they had an audience. As she forced him to kneel and pushed his head to the ground, unbuttoning the tunic in the back, Marella turned to me and whispered, "Do you think she'll let us each have a turn?"

"Goodness, I hope so," piped in Celine, licking her lips.

I simply nodded, unable to take my eyes off them. She stripped away the tunic and fastened his hands behind his back, standing him up by his long hair. Now he wore only tight black leggings, his perfect chest exposed. "Cleo? Where shall we put him?"

I resisted the urge to touch him. "The drawing room archway." I led them to the gilt doorway, met Corwin's eyes as we

chained him into it. I looked away. Hooks the perfect height for him. They had originally been placed for a woman my size, which is small, and Corwin was just about my height. Glin put a collar around his neck, clipping the long ends of the chains to it. He made a delicious picture like that, the fire backlighting his spread-eagled figure, the chains shining in the flames. She put a pretty black clip onto each nipple and stepped back. I could have sat and admired him for a few more minutes, but she wasted no time, going to work on him right away.

She started with a cat-o'-nine-tails, passing it deftly from hand to hand as she worked up a rhythm. She fairly danced around him as she heated up his skin. The cat was too light to leave marks, but his skin began to glow in the firelight. She switched to a leather paddle, and we began to hear him. His voice was as sweet and beautiful as his face. In his pride he tried to choke off the cries, but when she began using a stiff leather thong, he coughed out a note with each stroke. The thong bit into his skin, raising a blue welt where it fell. I realized as I was watching his fists clench in the cuffs, I was clenching my own. She did not stop. He thrashed in the chains, his hair coming loose from the ribbon and hanging down over his chest.

"Milady," he gasped out between blows.

She did not answer him.

"Milady, please stop. Ah!" His eyes were shut tight and he sucked his breath through his teeth as he tried to keep speaking. "Milady, please!"

"He means nothing to me," she said to the rest of us, the motion of her arm continuing. "He is but a spoil of war, like a good horse. A fine possession which I will use, or misuse, as is my privilege."

His chest heaved with pain and also, I could see, anger. I suddenly wondered what their safeword was. He opened his eyes again and I looked away. Was she drawing blood?

"Come on, Glin," I said. "Let us see the rest of your prize."

She stepped back, smiling. He hung limp for a moment, resting, while she stripped the leggings down to his ankles. There was an appreciative sigh from us. The rest of him was as perfectly formed as the upper half, his strong legs lightly dusted with hair, and the family jewels hanging delectably between them. In the light I caught the glint of metal. He wore a ring around them that matched the circlet in his hair. His legs quivered as she stepped him out of the leggings and then reattached his ankle to the door frame.

"May I?" Marella stepped forward, dangling her cat from her hand.

Glinda bowed graciously and stepped back. "Please. Make him sing."

Marella was even more graceful than Glinda, with more variation to her rhythm. My palms were sweating. I felt my teeth clench as each blow fell. He did not open his eyes now, trying to melt into the pain. Glinda tweaked the nipple clamps with her fingers and he screamed. Marella gave him no breath to go limp. My heart jumped as she gave him a final extra-hard whack. I wanted to leave the room, but at the same time, I couldn't bear to leave his presence. Celine got up next and went to work on him with clothespins. Each of the women had a turn with him, Glinda making suggestions as they went along, as though they were setting a table or making a flower arrangement. They blindfolded him. They chatted among themselves as they marked him.

Glinda flicked the nipple clamps off and he screamed. But she had turned away from him, to look at me. "Would you like a turn, as well?" she was saying, but I barely heard it over Corwin's song of agony. My goosebumps sprang up and I could barely maintain the act to nod my head.

"Take him down, onto his knees." They released the collar first, then his hands, and he slumped forward into me. He tried to regain his feet, but I lowered him gently to the carpet. I could feel

his back with my hand, hot, corrugated. I held his head back with my hand wound in his hair and whispered into his ear.

"You are the most beautiful creature I have ever seen." I pinched a very sore nipple and he shook in my arms. "You are truly, truly a beauty. Do you know why I do this?" I slapped him in the thigh and he gasped.

"No."

"Pain is a gift from me to you," I continued, working on the nipples more. "In exchange for your beauty. At this moment, you are the most precious thing to me on Earth."

I held him to my chest then, as he broke down sobbing.

"You are a prince," I whispered. I looked up then and met Glinda's eyes. She glared, a hint of disbelief on her face. I don't think she heard anything I said.

She broke character for a moment. "Well, Cle', do you think he's had enough?"

I shrugged. "Ask him."

She raised an eyebrow, crossing her arms.

I spoke into his ear. "Corwin, Corwin, are you all right?"

He would not look up from where his face was buried in my chest. I shrugged at her.

She walked over, knelt down, her hair sliding down her shoulder to touch his. "Come on, Corwin, let's go."

He clung to me. She said again, "Let's go." This time she used her bare hand on his back. He wasn't the only one who gasped. "That is an order, princeling," she added, as if that could reestablish the scene's rules. But it was she who had broken them.

He covered his ears and she raised her hand again.

"Wait," I said, grabbing her wrist. As our eyes met I could not tell what she was thinking. I did not want to play this wrong. "Duchess, how much do you want for him?"

She raised an eyebrow in surprise. "Oh, he's not for sale."

"I thought you said he meant nothing to you." Corwin sobbed silently in my lap, his voice spent. Perhaps it was true.

"You are right." She stood up and tapped him with her boot. "I suppose I could set a price."

"Name it." I swallowed, unable to tell where this scene was going next.

"Twenty-five lashes, hard enough that we might hear them in the next room," she said, her voice cold. She held a whip out to me, daring me. "On him. You deliver them."

I looked into his eyes.

He nodded. I began lifting him up. "Give me the whip." They put him back up in the frame and Marella went into the other room to keep count.

"I do this," I said, drawing my arm back, "because I love you."

My first stroke wasn't hard enough for Marella to hear, but it was hard enough to make Corwin scream. I pressed the whip handle to my forehead, praying. I said, "I love you," and let the second one fall. Marella shouted, "One!" from the other room.

On the next blow I drew blood. Corwin was whimpering. I let another blow fall. Tears sprang to my eyes as he bit down on a cry. Sweat broke out on his skin as I struck him. We were both crying. My arm began to hurt. By the time I got to twenty, I didn't know if I could give him the last five. I was panting, the whip hanging limp as I had to look away from his tortured skin. *You have to do this*, I told myself, *or she'll finish it for you*. But I could not steel myself to raise my arm again.

"Cleo!" he said, his head hanging. "Finish me!"

By the time the last one was delivered, Glinda had already gone.

I let the whip fall and sank to my knees, unsure when exactly the line had been crossed between play and reality, waiting for the scene to end. But there was Corwin in my arms, kissing me.

Now I lie here at night, before I fall asleep, admiring his hair falling over the pillow. Some nights, like tonight, I'm happy to watch the moon shining on his skin, but other nights, I'll wake him gently and make him talk to me. My prince.

About the Author

Cecilia Tan began her career as a published author with the chap-book *Telepaths Don't Need Safewords*. Since that time, dozens of her stories have appeared in magazines from *Penthouse* to *Ms.* and in anthologies such as *Herotica 3* (Plume 1994), *On a Bed of Rice* (Anchor, 1995), *Looking for Mr. Preston* (A Richard Kasak Book, 1995), *Dark Angels* (Cleis, 1995), and *Best American Erotica 1996* (Simon & Schuster, 1996). She has edited over twenty anthologies of erotic science fiction for Circlet Press, with more on the way. She lives with the real corwin and a cat named Zot! just outside of Boston.

Permissions

Forged Bonds

"Elceleth" is excerpted from the novella of the same name by Pencildragon & Paperdragon, and published by permission of the authors.

"Slaver's Luck" is excerpted from the novel *A Gift of Thieves* by Tanith Tyrr, and published by permission of the author.

"By Their Works Shall Ye Judge..." is excerpted from the novel of the same name by Deborah J. Wunder, and published by permission of the author.

Mate

"Mate" and "Whip Hand" were first published in electronic form in 1991, in different versions.

"The Melting of the Snowflake" was first published in electronic form in 1992, in a different version.

Telepaths Don't Need Safewords

"Telepaths Don't Need Safewords" was first published in electronic form in March 1991, in a different version.

"Heart's Desire" was first published in electronic form in November 1991, in a different version.